Jennifer Wood

Jennifer Wood

Seoras Bàn. George Bain.

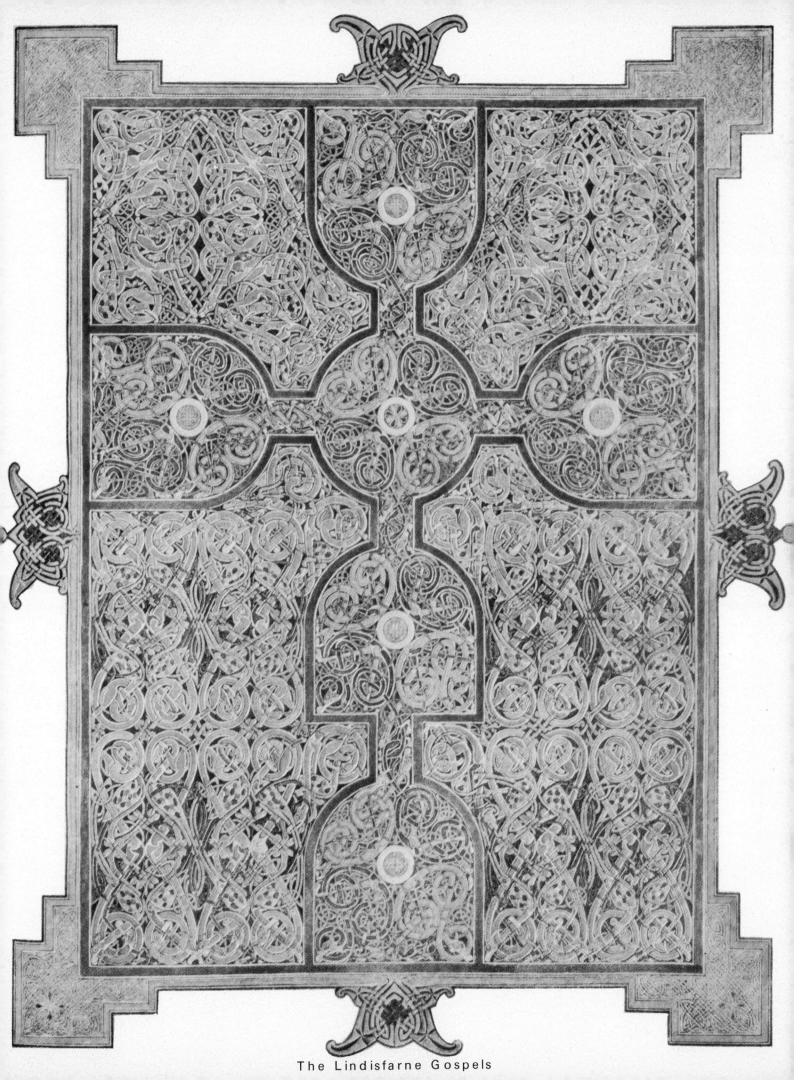

The Lindisfarne Gospels

The
Tara Brooch

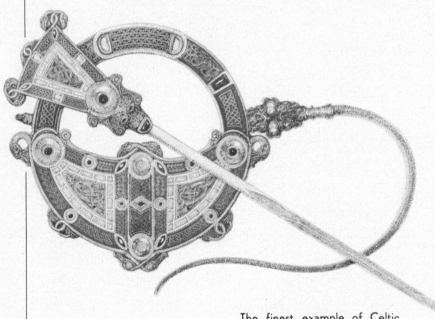

The finest example of Celtic
jewellery, outstanding for
design and workmanship. This
reconstruction by George Bain
completes the probable key
panel designs that have been
lost.

Celtic Art

The Methods of Construction

by

George Bain

CONSTABLE LONDON

First Impression 1951
Second Impression 1972
Third Impression 1975
Fourth Impression 1976
Fifth Impression 1977

Copyright © Harvey Menzies Johnston 1977

Hardback edition published by
Wm Maclellan Publishers (in liquidation)
9 Woodside Place
Glasgow G3 7QT

Paperback edition published by
Constable and Company Ltd
10 Orange Street London WC2H 7EG

ISBN 0 85335 196 1 (hardback)
ISBN 0 09 461830 5 (paperback)

ACKNOWLEDGMENTS

The Trustees of the Wallace Art Gallery, Liverpool for permission to reprint the Portrait of Henry VIII

Printed in Great Britain by Lewis Reprints Ltd., member of Brown Knight & Truscott Group
London and Tonbridge.

Dedicated to my friend
the late HUGH A. FRASER, M.B.E., M.A.,
Drumnadrochit,
who first introduced me to the works of J. Romilly Allen
and sent me on this most
engrossing quest.

" Theory may inform but Practice convinces."

" The Lord hath filled him with the spirit of God, in wisdom, in understanding, and in knowledge, and in all manner of workmanship, and to devise curious works, to work in gold, and in silver, and in brass, and in the cutting of stones, to set them, and in carving of wood, to make any manner of cunning work."

" Them hath he filled with wisdom of heart, to work all manner of work, of the engraver, and the cunning workman, and of the embroiderer, in blue, and in purple, in scarlet, and in fine linen, and of the weaver, even of them that do any work, and those that devise cunning work."

EXODUS, CHAP. 35, VERSES 31, 35.

" And now I have sent a cunning man, endowed with understanding—skilful to work in gold and in silver, in brass, in iron, in stone, and in timber, in purple, in blue and in fine linen, and in crimson; also to grave any manner of graving, and to find out every device which shall be put to him."

CHRONICLES, CHAP. 2, VERSE 31.

" Many years may be spent in the search after knowledge, but if the right path is hit at first, it may be attained in a little time."

" By minds already stored with information, whether it be acquired by the instruction of others or by dint of personal application, preceptive books will be frequently rejected. What has been diligently attained is too often assiduously hoarded ; and pride and envy co-operate with avarice to render the progress of knowledge difficult and expensive."

ANONYMOUS, 1795.

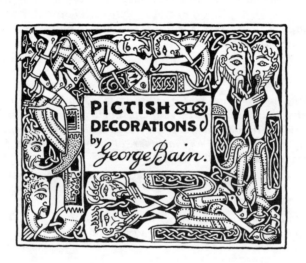

PICTISH
DECORATIONS
by
George Bain.

Contents

KNOTWORK BORDERS

KNOTWORK PANELS

SPIRALS

KEY PATTERNS

LETTERING

ZOOMORPHICS

ZOOMORPHICS CONTINUED

PLANT FORMS

HUMAN FIGURES

APPLICATIONS OF CELTIC ART

George Bain

RETROSPECTION over the past quarter of a century, when the author first commenced to apply, for experimental purposes, some of the knowledge of the methods of construction used by the ancient Celtic Artists, that he had then acquired, to the Art Curriculum of the Schools of an area where he was Supervisor of Art, shows that such an opportunity greatly helped him in the production of this book. The ready response of all pupils from infants to higher secondary and evening art schools was remarkable.

To the so-called backward pupils, those who had not been taught how to look and those who had failed to understand how to look at three-dimensional things so that they could be represented by copying the visual facts, the Celtic methods brought the joys of creation and permitted the exercising of individual tastes in arrangements, rhythms, colours and uses, often awakening interests in the ordinary representational forms of art that had chief place in examinations. Some of the results from the schools of that period may be seen in the two full-page illustrations in the section dealing with modern application of Celtic Art.

The co-operation, enthusiasm, untiring energy and taste of Miss Jane Lundie, a teacher of needlework and embroidery, made possible the production of beautiful works by individual and communities of pupils, who, by the conditions that then existed in the Scottish Schools, were mainly girls waiting until they reached the age of 14 to be freed from school.

The author's real interest in Celtic Art began after he had been many years in Art colleges, including a few in the Royal College of Art, London, as a National scholar in drawing and painting. During the whole of his Art student period the study of Celtic Art was distasteful to most Art students, for no instructions could be given. The only way was to attempt to copy an example, so that by comparison no "mistakes" could be found by the teacher, whose knowledge of the subject was merely that of ability to classify it with other Arts by general appearances. Original designs were considered impossible and were rarely attempted. Adaptations by copying was the only use.

That such is still the attitude to this great native art of Britain and Ireland in the system of Art teaching under the guidance of the Education Departments of England, Scotland and Northern Ireland requires no furnishing of proof by the author of this book, unless to state, that the only opposition during the past quarter of a century to his self-imposed attempt to spread a knowledge of the Celtic Art culture amongst the peoples of Britain and Ireland, has been from a few holders of Art College diplomas, that had allowed them to become recognised as teachers of Art. Resenting the introduction of the study of a form of Art of which they knew nothing, except the few copies of fragments that they had been compelled to do for historic ornament examination purposes, they sum up the attempt to make a modern use of the principles of the construction methods of the Celtic Artists, of which they have no knowledge, as useless for "it can only be done by copying."

In contrast to this attitude numerous letters from artists, craftsmen and scholars from all over Britain, Ireland, Europe, Canada, U.S.A., South America, South Africa and Australia have contained congratulations and expressions of sincere interest and best wishes to the endeavour to call attention to the greatness of the Celtic Art cultures of Britain and Ireland. It exceeds his power of words to find expressions for his pleasure when he found that he could attach his studies to those of a small group of the most famous artists since the middle ages, who, during lives of great productivity in many forms of art, had devoted some of it to the study

of Celtic interlacing knotwork and the Celtic continuous line, the Symbol of "Eternity," Leonardo da Vinci's "Concatenation," Albrecht Dürer's "Sechs Knoten" and Michelangelo's pathway or labyrinth in the quadrangle of the Capitol, Rome, as it was in 1569 are shown in the section of modern and ancient application of Celtic Art.

As a book illustrator from his late 'teens, the author acquired the necessary knowledge of drawing for reproduction that has enabled him to display the materials of this book for the benefit of the enquiring student. During this long period of figure, costume, animal and general illustration work, his constant creative activities (usually without the use of artist's models) required to be kept in good condition, otherwise the result was staleness.

To prevent this the author gave himself a "hobby." It was to find out from examples of Celtic Art, from the Pictish stones, Celtic MSS. etc., the various stages that had been necessary for the designer to produce his completed design on the material. It did not follow that he would always also be the craftsman to complete the work, though he would, by necessity, watch over all of its developments.

A self-imposed restriction was necessary if chaos was to be avoided. That was to keep away from everything else; purposes, meanings, races, religions, etc. for each could become a path from which return would be difficult. This precaution proved to be of great value for it permitted the accumulation of masses of materials, that, as years went by, demanded to be recognised for their meanings, even although it could only be done by guess-work. Later when the publication of some of the work in booklet form commenced, the publisher desired that some of the meanings obtained by conjecture should be given.

After consultation with an eminent pre-historical Archaeologist, his advice to publish the meanings that the evidences suggested was accepted, with the qualification that if others could bring evidences to prove other meanings, agreement to such would benefit truth. In such a way, the art which was communicative and ornamental might regain its original communicative purpose.

A few months after the publication of some of the series of booklets, the author received among other congratulatory letters one from Dr. Ananda Coomaraswamy of the Boston Museum of Fine Arts who was perhaps the foremost scholar of Asiatic and Eastern Mediterranaen Art and Literature, giving proofs of the correctness of the guesses, with quotations from the early Vedic literature and other Asiatic sources of information. Dr. Coomaraswamy continued to correspond with the author, whom he supplied with copies of the engraved plates of interlacing knotwork designs by Leonardo da Vinci and Albrecht Dürer and a publication by him concerning these works. The author gave to him Michelangelo's design of the continuous pathway for the quadrangle of the Capitol, Rome and drawings to show the application of Leonardo's and Dürer's designs to the garments and hangings in the portrait of Henry the Eight by the School of Holbein the Younger.

Death has removed this very important contact and source of confirmation and information in the problems of the beginnings of the great art of the Celts in which he was greatly interested. He affirmed that its beginnings were mainly Asiatic and that its primary use was philological. Two of his letters are included in this book. The dual-purpose of Celtic Art was retained throughout the whole of its development cumulating in its use as sacred embellishments for the world's greatest manuscript *The Book of Kells*.

In common with other Asiatic peoples where the Art of the Celt had beginnings thousands of years before Christ, representations of the works of the Almighty Creator were forbidden and have continued to be in some degrees with certain peoples to the present time.

By the laws of the recapitulation of the life history of the species in the life of the individual, "Modern Art" is sometimes a form of atavistic groping and the tendency of some European artists, when the power of realistic representation has been attained is to no longer accept this as the final achievement of Art. The inability to change is death in Art; the power to change is life. The atavistic searchings of the modern European artist are merely the reversions to the mental traits of remote ancestors rather than immediate progenitors. Hence such gropings, usually done in a state of acute consciousness, lead subconsciously to abstractions that may be inherited racial memories of the great Celtic cultures and of the still earlier race of palaeolithic Aurignacian hunter-artists who were probably the first of modern European man.

Picasso passed through the natural stages of an art development in an artistic environment, led by his own desires and achievements from infancy with the result that by the age of sixteen years he had acquired full maturity of draughtsmanship and painting in the manner of the impressionist school that had then gained recognition after years of condemnation and

opposition. What could he do for the rest of his life? Many others had reached maturity in their early youth in the kind of drawing and painting that was recognised at the time.

Michelangelo, Raphael and others did so and each found that there was much to change in Art to carry it to greater heights. The Scottish painter MacTaggart and his country-man Peploe changed their desires and manners of representing them throughout their whole lives. Picasso's early art life had been devoted to realism in all of its hitherto accepted forms and the new revelations of impressionism had crowned it with an understanding of atmosphere, colour juxtaposition, selection, light, movement, suggestion and many new forms of painter's technique that all together gave new life and yet another aspect of the realism of which Picasso was a master. It was unthinkable that this was to be the end-all of his art. Duty to art is partly religion to such artists who will deliberately set aside all that they had previously valued in search of the change that *must* exist to allow art to live.

Sir John Millais reached maturity about the same early age in the manner of draughts-manship and painting that had then gained recognition in England. Millais's development in art had then come to its end. He felt justified in using the skill that he had acquired, to paint for the remainder of his life, the subject pictures and portraits that met popular and fashionable approval, with the result that he became more adept in completing the numerous commissions that occupied the rest of his lifetime.

There are many artists whose works fall into the same categories as those of Picasso and Millais. Fortunately the imitation of the skill and art knowledge that made possible the pro-ductions of Millais, could only be attempted by persons possessing similar talents and skill that had resulted from years of hard study and practice.

It was not so with Picasso's productions after his eschewal of realism. The merest novice may now by-pass all ordinary art study and with effrontery, because of Picasso and others, claim protection for anything he cares to do, with full support of bewildered press representatives. Hence there are legions of imposters who vie with each other to attract attention to their eccentricities and vulgarities.

To return to the subject, after these digressions that on the surface may appear to have no connection with it, the author states that Picasso and the other present day great artists who have forsaken realism in most of its forms have no knowledge of the methods of construction necessary for some forms of Celtic Art though their searchings have penetrated into the regions of Celtic abstract representa-tions of the creations by the Almighty, that conveyed facts concerning them without copying them. Recreation of the kind contained in the Celtic methods of construction will be beneficial to most artists whose works are creative. It is so much removed from the methods required for other forms of creative art, that it may serve to banish staleness. As stated elsewhere, the absent-minded or otherwise mentally engaged educated doodler, the child and the uneducated female with pipe-clay decorations on the doorstep are merely giving way, subconsciously to atavistic tendencies with beginnings at the dawn of human appreciation that later took forms through the intellects and tastes of Celtic progenitors.

When some of the methods of the Celt as shown in this book have been assimilated, the various stages appear in an entirely different perspective and things happen with the ease that a mouth opens when a spoon is raised to it. Instruction is not necessary to know which muscles are to be used and how and when. The ancient artists, of necessity, must have arrived at stages in the uses of their art that have not yet suggested their existence to the author, although he has no longer to consider a few of the stages that were so necessary at the beginning.

The great Celtic artists must have had the power of visualising beforehand a completed work in its final state and materials. That ability, as in all forms of art, has to be acquired by experience. The fact that there are no apparent difficult structural problems in some forms of Celtic patterns or in the formations of the so-called Pictish symbols is the explanation of their absence in this book.

Some of these unique examples of Celtic pagan religious symbols are to be found nowhere else in Europe, Britain or Ireland except in Scotland and mainly in the north-east. They are often single or in groups on otherwise unornamented stones, and are also found with additional embellishments of matured patterns of knotwork, keys and spirals on a few of the finest examples of the richly ornamented cross slab-stones. They are not to be found in the Celtic MSS. of Durrow, Kells and Lindisfarne although these have every other form of the Pictish Celtic Art.

Their chief purpose was undoubtedly philological and connected with religion. The author has read much concerning them and

what they may signify and he has given much thought to their purposes and meanings, yet he has formed no opinion concerning them other than that the answers may be found in the beginnings of Asiatic religions. He had hoped to get some light and information on this subject from Dr. Coomaraswamy to whom he had sent a complete set of drawings, with the intention of including them and any information concerning them in this book, but unfortunately death intervened. The opinions held by some that these symbols are all, in one way or another, connected with phallic worship is as unthinkable to the author in regards to the Celtic Pagan Rites as it is to those of Christianity.

That this book may help to provide materials that will make possible the opportunity to use again the methods of this great British art for new achievements and to modern application's in art and industry is the chief motive of its author and publisher. It is a further wish that it may arouse interest in the other numerous co-eval cultures of the British Celts without which this great art culture would have been impossible and so eventually lead to a placing, historically, of the Britons along with the very highest civilized nations of all times, where they belong, if by art alone.

The unique methods of construction and the motifs of the British and Irish schools of Celtic Art as shown herein by pictorial demonstrations of good examples are for the use of artists, art-craft workers and designers in industry. Many of these demonstrations do not require wordy explanations or arguments. They prove themselves conclusively like theorems and are capable of endless varieties from simple beginnings and have possibilities of further developments by new methods of the mathematical formulae and geometrical skill that produced such great achievements of Celtic Art over a thousand years ago.

A knowledge of these methods will shed a new light upon many problems concerning the Celts in Britain and Ireland. They will reveal many falsehoods that should no longer be taught as the history of Britain or Ireland. It is not the intention to deal with these in this book, yet the complete absence of references to what the evidences in the art can prove, may suggest to the perceptive student that the author is ignorant of the implications.

The term Pictish is used throughout this book to describe the Cruithne, the ancient Britons whose art owed much of its perfection and beauty to the uses of mathematical formulae for construction. The finest examples of orna-

mented stone monuments, metal work and jewellery have been found in the areas of Britain and Ireland that had, at one time, been inhabited by the " Cruithne." The term is now applied to some of the Britons of the parts of Scotland beyond the Roman Walls where some southern tribes of Britons, rather than submit to Roman rule joined and merged with the northern Britons, who, before the Roman invasion had also peopled a part of Northern Ireland.

The nickname Pict given by the Roman soldiery to these northern Britons was a descriptive one. It referred to fondness for colours as a characteristic and to their amazing skill in firing enamel colours on metal ornaments for the warrior, his horse and chariot. In battle, the Britons, for unhampered movements, discarded all clothing and decorated their bodies in colours with tribal symbols, charms and patterns.

The ornaments in the Books of Durrow, Kells, Lindisfarne, St. Chad, MacRegol, and MacDurnan are similar to those of the Pictish ornamented stones of the east coast of Britain from Durham to Shetland and to the ornamented stones in the Pictish area of North Ireland. In the remaining parts of Britain and Ireland the Celtic ornaments of the stone monuments are different and belong to a variety of schools of Celtic Art. A few fragments, that survived the thoroughness of Augustine and his Church in the carrying out of the order of Pope Gregory the Great to completely destroy the early British Celtic Christian Church, are evidences that the Picts returned to the midlands of England after the fall of Rome. The political purpose of the Synod of Whitby was to give the glory of the civilizing and Christianizing of the " Savage Britons " to the Church of St. Peter.

In Iona and the West of Scotland, late Romanesque forms of Celtic Art, that are not included in this book receive homage from Pilgrims as relics of the beginning of Christianity in Scotland. Tradition has it, that in Iona and district over 200 Pictish ornamented cross slab-stones were destroyed and flung into the sea. That Columba had nothing to do with the making of the " Book of Kells " or the ornamented cross slab-stones on the east of the mountain range of Scotland can be proved by the study of the methods of construction of Celtic (Pictish) Art. " The calf may belong to the cow and the copy of the book to the original (the verdict of the judge who tried Columba for making a copy of a borrowed book and claiming to be the owner of that copy, this

being one of the reasons that compelled Columba to leave Ireland) but the ornaments on the stones in Iona attributed to Columba's mission do not *belong* to those of the Books of Kells, Durrow and Lindisfarne. Those on the Pictish stones of east Scotland and some in north-east England have ornaments identical to those in the Books.

There is no other evidence to support the opposite view apart from what has been built upon the statements in the *Life of Columba* (with no references to the Art) written by Adamnan a successor of Columba in the Iona Mission about a hundred years after his death, who became a fervid worker for the Augustine Church of St. Peter. When Columba came to Iona he did excellent work from there in the West of Scotland in continuing the work of his Christian predecessors in these areas. His greatest misfortune was to have his biography written by Adamnan.

In the light of our new knowledge of Celtic culture, the old picture will no longer satisfy of the hairy savage, smeared in woad, so beloved of British educationists intent on proving that only imported cultures and forms of governments have made it possible for us to reach our present cultural level from such primitive beginnings. When this inadequate impression of our British ancestors, who fought so bravely against the aggressive conquest of Rome is eventually corrected through the accumulation of greater knowledge, then, indeed may we mark the commencement of a new era for the British race.

The Celtic Version of
"The Wolf shall also dwell with the Lamb"
Isaiah. Chap.11.Ver.6-9. Chap.65.Verse 25.
Christ Monogram page. Book of Kells.

Correspondence
from Dr. Ananda K. Coomaraswamy

MUSEUM OF FINE ARTS,
BOSTON 15, MASSACHUSETTS,
February 26th, 1947.

DEAR MR. BAIN,

I have been a curator in this Museum for 30 years. I have seen with a great deal of pleasure your excellent booklets on Celtic Art (the first two only ; and am sending you separately a paper of mine published in the *Art Quarterly* which will interest you and perhaps suggest the meaning of the " continuity " that you speak of. I would suggest that you look up certain of my references, especially Ringborn mentioned in Note 45 and Guénon mentioned in Note 49. The discussion on safetypins (fibulae) referred to in Note 46 is now more easily available in my *Figures of Speech or Figures of Thought* published last year by Luzac, London.

For the outline mazes in Malekula and India see also Layard in *Folklore* 47 (1936) and in *Folklore* 48 (1937).

Yours very truly,

A. K. COOMARASWAMY.

MUSEUM OF FINE ARTS,
BOSTON, MASSACHUSETTS,
June 13th, 1947.

DEAR MR. BAIN,

Many thanks for your letter of May 24th. I have asked Luzac to send you a copy of my *Figures of Speech or Figures of Thought* for your library.

Regarding your Alesund design, the two birds are correctly thought of as a symbol of friendship in the highest sense, that is to say of friendship between the inner and outer man, or spirit and soul in everyman, hence of friendship in general, since in the truest sense " *Charity* begins at home." You may often have observed the *two* birds on a tree in traditional design ; sometimes also united, so that we have the bird with one body and two heads. In the Rgveda (1-164-20) and Mundaka Upanisad (111-1-2) they represent the universal and individualised selves (true self and Ego)—(that *duo sunt in homine* is universal doctrine, Hindu, Islamic, and Christian). The resolution of internal conflict, or self-integration is the purpose of all true psychology—" This self lends itself to that self, and that self to this self ; they coalesce (or are wedded together). With this aspect he is united with this world and with that aspect united with yonder world " (Aitaremya Aranyake 2-3-17).*

Mrs. Goble (of Godalming) lately made a wood cut of the two birds on a spray, intentionally illustrating the Vedic idea.

The Upanisad passage begins " Two birds, fast bound companions, clasp close the selfsame tree " (the tree of life) of also Philo Judaeus, *quis heres,* 126.

Very sincerely,

ANANDA K. COOMARASWAMY.

*Ephesians 2-15 " to make of himself of twain one new man, so making peace."

Introduction

THIS elementary text book is prepared specially for use in elementary and secondary schools. It will also serve to give instruction to Art Students, Artists and Art workers in a multitude of crafts. There is much that will be useful to the archæologist and the historian, although I have refrained from dealing with such problems, for the primary purpose of this book is to give to others the results of my many years of research into the methods used by the ancient artists. In a larger work on the more advanced methods of the Celtic Art worker and his various media, I give my own conclusions and the evidences on which they are founded and their bearing upon historical, archæological and racial matters.

Realising the meagreness of the written language, especially when used by me as a medium for the clear transmitting of instructions on the partly artistic, partly geometrical and partly mathematical method peculiar to many forms of Celtic Art and particularly to that of the Pictish School, I have put the onus of understanding upon the student by compelling the close observation of every stage of the methods with very few words to hinder or to assist. Many years of experimenting have led me to believe that when once this slight initial difficulty has been overcome in this manner of reading, to dispense with words is beneficial. There are a few important rules. The first and most important is that in the creation of a Celtic design, each stage must be completed throughout the design, before the next one is commenced, otherwise confusion will result. After the methods shown on a plate have been assimilated, original designs by the same methods should be attempted and the ultimate aim should be the application to some form of craftwork.

The mere copying of the ancient work is as valueless as it is impossible, but by understanding the methods, new designs and even new methods in this peculiar art may be produced. If the methods and their stages that are shown in this book are not those used by the ancients, then they can only prove to have been simpler,

perhaps more ingenious but not more difficult. With genuine humility gained by years of research into the possible methods of the great intellectual artists and craftsmen of the Pictish nation, who produced the great art of the cross-slab stones of East Pictland and their counterparts in the Books of Durrow, Kells, and Lindisfarne, the Tara Brooch, the Ardagh Chalice and other masterpieces of the Celtic jewellers' art, I present the results of my studies, particularly to the inhabitants of the Highlands and Islands of Scotland and of Ireland in the belief that with an understanding of the ingenious and simple mathematical basis of the art of their ancestors, a great national art may be re-born to make fresh growths and thus influence and enrich the lives of the people. The extreme minuteness of the art of the MSS. and the impossibility of ordinary eyes perceiving much of its contents show, conclusively, that the artists did not display their skill for human eyes and human applause.

They were imbued with the idea that the eyes of God would detect errors and that they worked solely to glorify Him.

Their aids to eyesight and the tools that enabled them to draw lines with an exactness beyond the skill of moderns may never be known. Referring to a page of the " Book of Armagh," Professor J. O. Westwood wrote, " In a space of about a quarter of an inch superficial, I counted with a magnifying glass no less than one hundred and fifty-eight interlacements of a slender ribbon pattern formed of white lines edged with black ones upon a black ground. No wonder that tradition should allege that these unerring lines should have been traced by angels." One of the aims of this book is to show that there is nothing marvellous in a design having not a single irregular interlacement. Indeed a wrong interlacement would be an impossibility to a designer conversant with the methods. One might as well marvel at a piece of knitting that had not a mistake in its looping. This does not retract from the marvellous inventive skill and art of the Pictish designers. The beauty of their art

would be unaltered whatever the scale although that of many of its details would certainly be more perceptible if enlarged.

When I compare the little that I have found out during all these years of study with that of which I know nothing, my only source of satisfaction is that my work may show the way to an aspect of the art of the Celtic peoples, that has hitherto been unexplored, although some previous searchers found keys to open some of its doors and thus allowed me to enter. I pay tribute to the great work of J. Romilly Allen, the original pioneer of this form of research. Others including Eoghan Carmichael, John Duncan and Dr. Galbraith of Dingwall have kept his lamp burning and passed it on to me. In " My Schools and Schoolmasters," chap. xi, Hugh Miller, the geologist, writes about his poor consumptive friend, the housepainter's apprentice, William Ross, in the Parish of Nigg, who " anticipated the labours of our Antiquarian Societies by his elaborate and truthful drawings of an interesting class of National Antiquities " (the Nigg, Shandwick, Hilton of Cadboll and other cross-slab stones) and " looking with the eyes of the stone cutter at his preliminary sketches, from the first meagre lines that formed the ground work of some involved and difficult

knot, to the elaborate knot itself," Miller felt that with such a series of drawings before him he, also, " could learn the complex ancient style in less than a fortnight." Poor William Ross, of whose works nothing has survived but these words by his friend Hugh Miller, must be numbered among the real pioneers. Westwood, Robinson, Anderson and others have gathered much material that has assisted research. The " Studio " publication of a number of the best pages of the " Book of Kells " in colours and the British Museum photographic reproduction of parts of the " Book of Lindisfarne," edited by Dr. Eric Miller, Keeper of MSS., are works of immense value. The Spalding Club's publication " The Ancient Sculptured Stones of Scotland," edited by John Stuart, owes much of its value to the excellent drawings by A. Gibb of Aberdeen. Most of the drawings by P. A. Jastresbski in the same volumes, should never have been published, for the artist had no knowledge of what he tried to represent. In expressing gratitude to all past and present scholars for the contributions they have made, I feel assured that in the near future a multitude of gifted workers will clear up most of the problems that in the meantime hide this and other great cultures of the Pictish People.

GEORGE BAIN.

September, 1945.

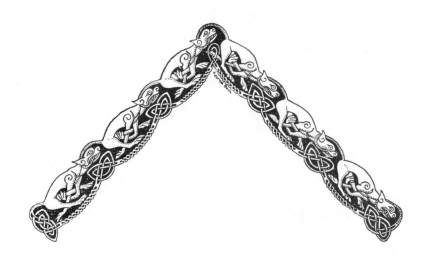

Elementary Knotwork Borders and Panels

THE Chronology of the ornamental symbols commences with spirals. Chevrons and step patterns make an early appearance, along with key patterns that are really spirals in straight lines. Interlacings arrive later and are followed by knotwork interlacings. The imitation of the three dimensional arts of plaiting, weaving and basketry is the beginning of interlacing and there are few races who have not used it as a decoration for stone, wood and metal. The last phase of its use is that of the scribe who represented the third dimension by painted outlines and dark backgrounds. Knotwork interlacings are peculiar to the Pictish School of Celtic Art. Though this text book is concerned with the problems of the constructional methods of the Pictish artist-craftsman, and all other aspects of his art are reserved for another book, yet reference may be justifiable here to the similarity of the types of key patterns, requiring great geometrical and mathematical skill, that have been found in the Ukraine and Yugo-Slavia dating from 20,000 B.C. to 15,000 B.C. to those of the Pictish School. Many centuries lie between the earliest gropings and the high standard of achievement at this stated period. The imitation of the works of God was forbidden to many races and until the Christian Era even vegetation was tabooed as a motif for ornament to the Pict, hence his concentration upon geometry, mathematics and abstractions that were not copies of created life. Interlacing borders and panels based upon plaiting and basketry are to be found in the art of most peoples surrounding the Mediterranean, the Black and the Caspian Seas. Egyptians, Greeks, Romans, Byzantines, Moors, Persians, Turks, Arabs, Syrians, Hebrews and North African tribes have used this form of ornament in some way or other. A few thousand years B.C. the Chinese used small interlacing symbols. The finest achievement of knotwork interlacing are by the Pictish School. Interlacing limbs and bodies of humans, animals, birds and reptiles each with interlacing top-knots were developed in East Pictland and in Ireland to migrate at a later date to Scandinavia to become a decadent art.

As a symbol of continuity, interlacing knotwork is found on the ornamented cross slab-stones of East Pictland from Durham to Shetland and in the metal work and the earlier MSS. of Durrow and Kells. Continuity of interlacing knotwork is not insisted upon in the later period of the Lindisfarne and St. Chad MSS. and in the stone work of the same school. From Perthshire to Caithness there are many beautiful examples of intentional continuity of knotwork that form part of artist-sculptors' creations. Other stones show that the designers entrusted the carving to workmen who blundered, and there are a few stones by untrained designers and inferior carvers. The art of Iona and the West of Scotland is a Romanesque Celtic similar to the stone monuments of Ireland with the exception of the Irish Pictish work of the North-East. The work of Scotland east of Drumalban is similar to the finest of the MSS. Durrow, Kells and Lindisfarne. Different localities have different treatments. An incised line in the middle of the band was the fashion from Durham to St. Andrews. In Cumberland, Westmoreland and south-west Scotland the tendency was to break the plaiting into interlacing rings. Wales and the Midlands around Wolverhampton must be considered as greatly influenced by, if not part of, the Pictish School. The "St. Andrew's Cross" is the beginning of most circular knotwork of the Scottish and Irish Pictish interlacing panels. Interlacing knotwork is sometimes inspired by spirals and is sometimes in straight lines.

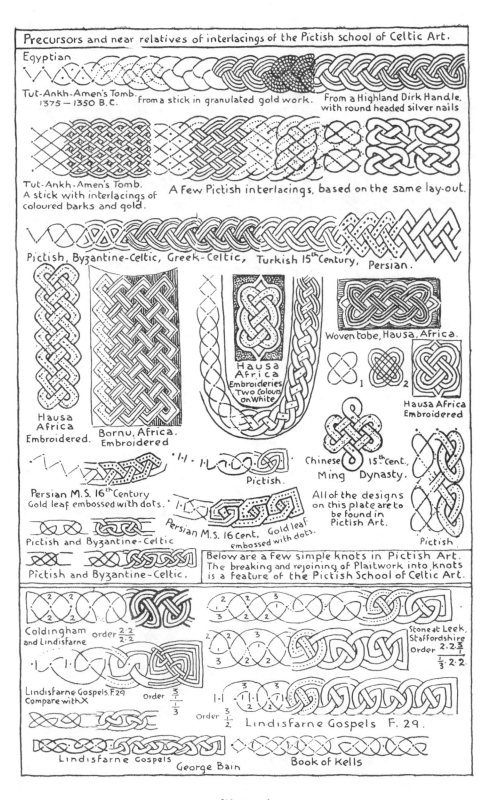

Precursors and near relatives of interlacings of the Pictish school of Celtic Art.

Egyptian

Tut-Ankh-Amen's Tomb. 1375 — 1350 B.C. From a stick in granulated gold work. From a Highland Dirk Handle, with round headed silver nails

Tut-Ankh-Amen's Tomb. A stick with interlacings of coloured barks and gold. A few Pictish interlacings, based on the same lay-out.

Pictish, Byzantine-Celtic, Greek-Celtic, Turkish 15th Century, Persian.

Hausa Africa Embroideries Two Colours on White

Woven tobe, Hausa, Africa.

1 2

Hausa Africa Embroidered

Hausa Africa Embroidered. Bornu, Africa. Embroidered

Chinese 15th Cent., Ming Dynasty.

Persian M.S. 16th Century Gold leaf embossed with dots.

Pictish.

All of the designs on this plate are to be found in Pictish Art.

Persian M.S. 16 Cent. Gold leaf embossed with dots.

Pictish and Byzantine-Celtic

Pictish

Pictish and Byzantine-Celtic.

Below are a few simple knots in Pictish Art. The breaking and rejoining of Plaitwork into knots is a feature of the Pictish School of Celtic Art.

Coldingham and Lindisfarne order 2·2 / 2·2

Stone at Leek, Staffordshire Order 2·2·3 / 3·2·2

Lindisfarne Gospels. F.29 Compare with X Order 3/1/3

Order 3/2 Lindisfarne Gospels F. 29.

Lindisfarne Gospels George Bain Book of Kells

Plate A

27

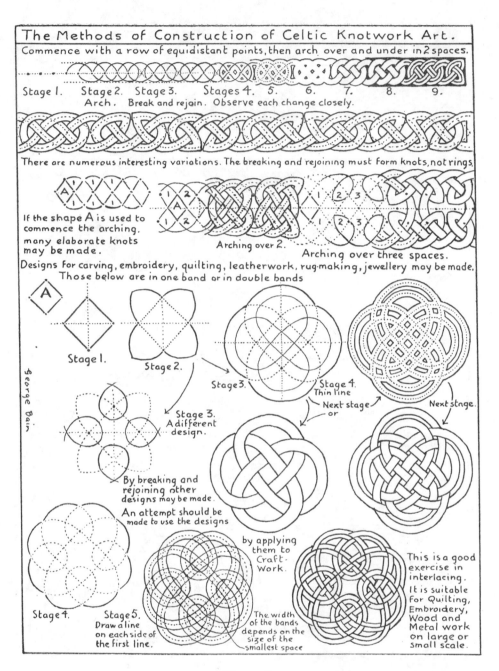

The Methods of Construction of Celtic Knotwork Art.

Commence with a row of equidistant points, then arch over and under in 2 spaces.

Stage 1. Stage 2. Stage 3. Stages 4. 5. 6. 7. 8. 9.
Arch. Break and rejoin. Observe each change closely.

There are numerous interesting variations. The breaking and rejoining must form knots, not rings.

If the shape A is used to commence the arching, many elaborate knots may be made.

Arching over 2.

Arching over three spaces.

Designs for carving, embroidery, quilting, leatherwork, rug-making, jewellery may be made.
Those below are in one band or in double bands

A

Stage 1.

Stage 2.

Stage 3.

Stage 4.
Thin line

Next stage
or

Next stage.

Stage 3.
A different design.

By breaking and rejoining other designs may be made.

An attempt should be made to use the designs

by applying them to Craft-Work.

Stage 4.

Stage 5.
Draw a line on each side of the first line.

The width of the bands depends on the size of the smallest space

This is a good exercise in interlacing.

It is suitable for Quilting, Embroidery, Wood and Metal work on large or small scale.

George Bain

Plate B

The general principles for designing Celtic Knotwork. (Pictish School.)

Freehand knotwork bands may be done if two lines only are crossed at one point and if each of the enclosed shapes is large enough to allow for the desired width of the band to be drawn.

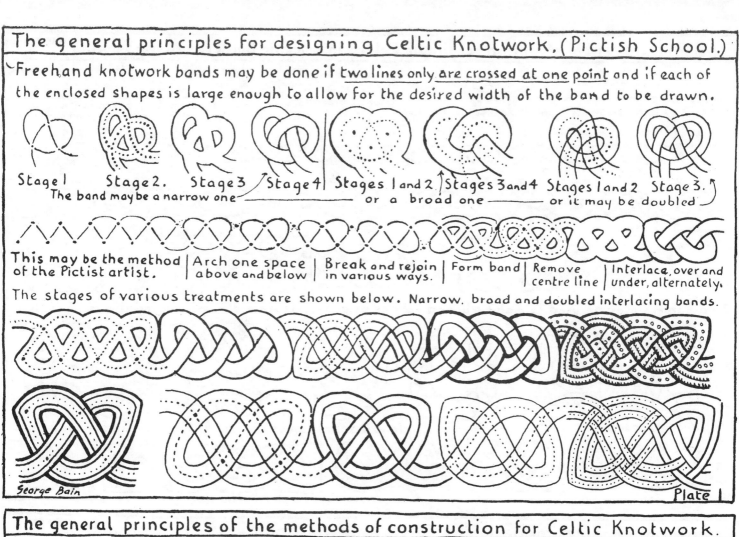

| Stage 1. | Stage 2. | Stage 3. | Stage 4. | Stages 1 and 2 | Stages 3 and 4 | Stages 1 and 2 | Stage 3. |

The band may be a narrow one ————— or a broad one ————— or it may be doubled

| This may be the method of the Pictist artist. | Arch one space above and below | Break and rejoin in various ways. | Form band | Remove centre line | Interlace, over and under, alternately. |

The stages of various treatments are shown below. Narrow, broad and doubled interlacing bands.

George Bain

Plate 1

The general principles of the methods of construction for Celtic Knotwork.

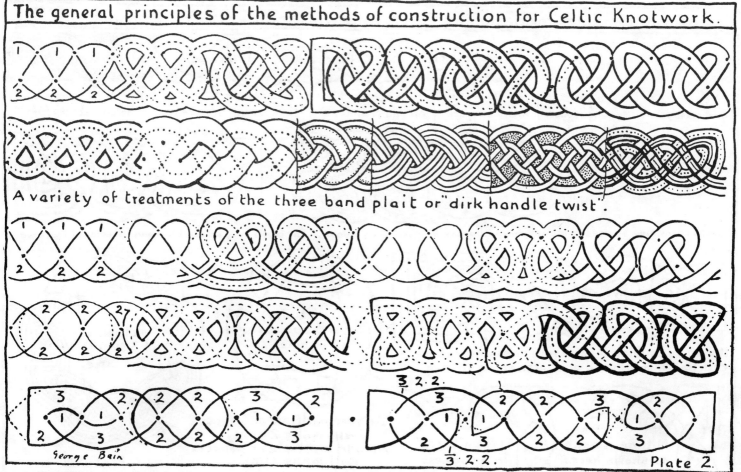

A variety of treatments of the three band plait or "dirk handle twist".

George Bain

Plate 2.

29

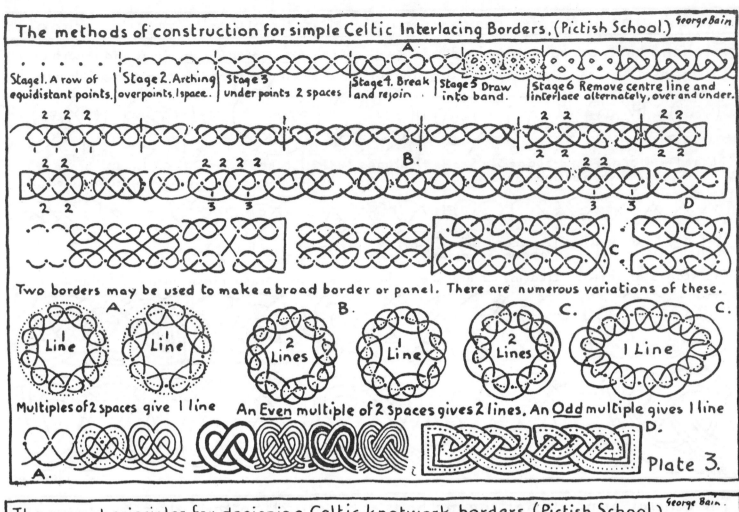

The methods of construction for simple Celtic Interlacing Borders, (Pictish School.) *George Bain*

Stage 1. A row of equidistant points.
Stage 2. Arching over points. 1 space.
Stage 3 under points 2 spaces
Stage 4. Break and rejoin
Stage 5 Draw into band.
Stage 6 Remove centre line and interlace alternately, over and under.

A.
B.
C.
D.

Two borders may be used to make a broad border or panel. There are numerous variations of these.

A. 1 Line
A. 1 Line
B. 2 Lines
B. 1 Line
C. 2 Lines
C. 1 Line

Multiples of 2 spaces give 1 line
An Even multiple of 2 spaces gives 2 lines. An Odd multiple gives 1 line

A.
i
D.

Plate 3.

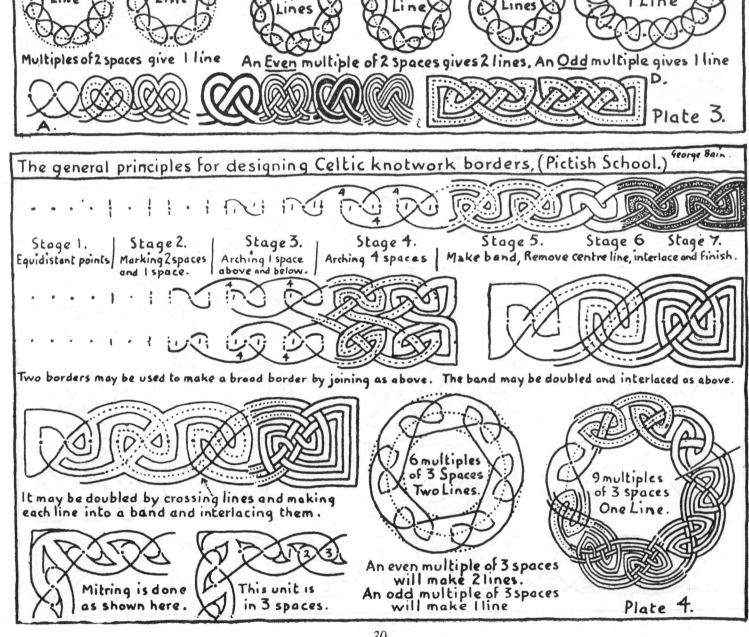

The general principles for designing Celtic knotwork borders, (Pictish School.) *George Bain.*

Stage 1. Equidistant points
Stage 2. Marking 2 spaces and 1 space.
Stage 3. Arching 1 space above and below.
Stage 4. Arching 4 spaces
Stage 5. Make band, Remove centre line, interlace and finish.
Stage 6
Stage 7.

Two borders may be used to make a broad border by joining as above. The band may be doubled and interlaced as above.

It may be doubled by crossing lines and making each line into a band and interlacing them.

6 multiples of 3 Spaces Two Lines.

9 multiples of 3 spaces One Line.

Mitring is done as shown here.
This unit is in 3 spaces.

An even multiple of 3 spaces will make 2 lines.
An odd multiple of 3 spaces will make 1 line

Plate 4.

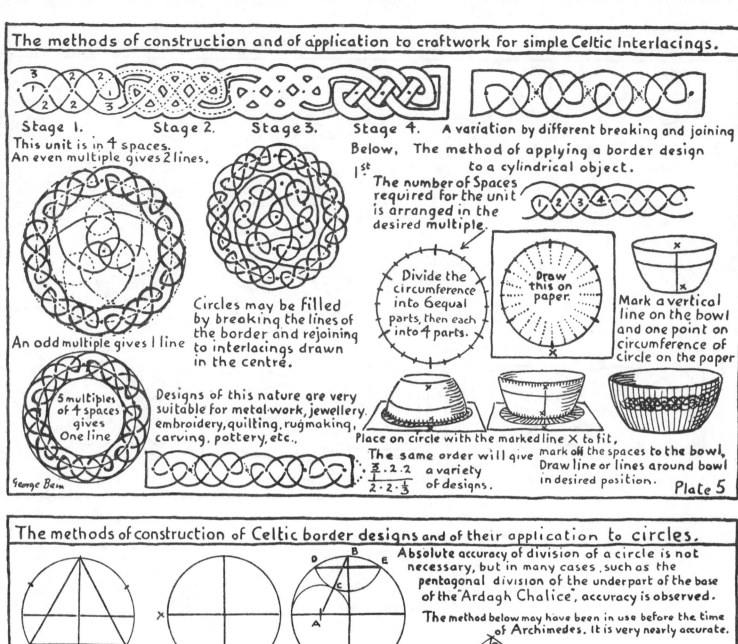

The methods of construction and of application to craftwork for simple Celtic Interlacings.

Stage 1.
This unit is in 4 spaces.
An even multiple gives 2 lines.

Stage 2.

Stage 3.

Stage 4.

A variation by different breaking and joining

An odd multiple gives 1 line

5 multiples of 4 spaces gives One line

Circles may be filled by breaking the lines of the border and rejoining to interlacings drawn in the centre.

Designs of this nature are very suitable for metal-work, jewellery, embroidery, quilting, rugmaking, carving, pottery, etc.,

Below, The method of applying a border design to a cylindrical object.

1st The number of Spaces required for the unit is arranged in the desired multiple.

Divide the circumference into 6 equal parts, then each into 4 parts.

Draw this on paper.

Mark a vertical line on the bowl and one point on circumference of circle on the paper

Place on circle with the marked line X to fit, mark off the spaces to the bowl. Draw line or lines around bowl in desired position.

The same order will give a variety of designs.

$\dfrac{3 \cdot 2 \cdot 2}{2 \cdot 2 \cdot 3}$

George Bain

Plate 5

The methods of construction of Celtic border designs and of their application to circles.

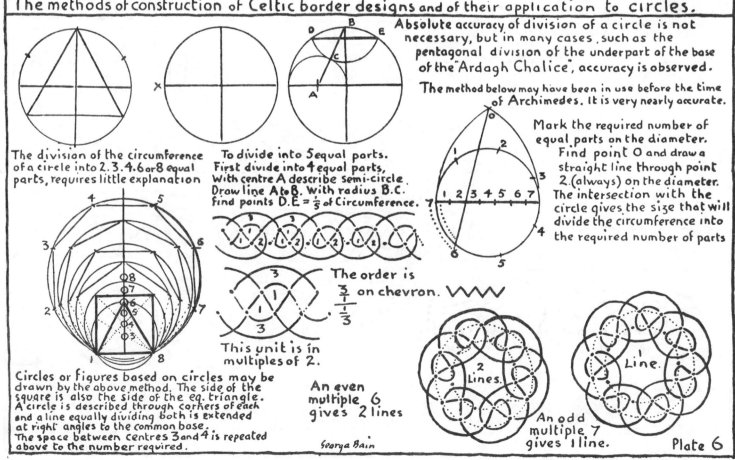

The division of the circumference of a circle into 2, 3, 4, 6 or 8 equal parts, requires little explanation

To divide into 5 equal parts.
First divide into 4 equal parts, With centre A describe semi-circle. Draw line A to B. With radius B.C. find points D.E = $\frac{1}{5}$ of Circumference.

Absolute accuracy of division of a circle is not necessary, but in many cases, such as the pentagonal division of the under part of the base of the "Ardagh Chalice", accuracy is observed.

The method below may have been in use before the time of Archimedes. It is very nearly accurate.

Mark the required number of equal parts on the diameter. Find point O and draw a straight line through point 2 (always) on the diameter. The intersection with the circle gives the size that will divide the circumference into the required number of parts

The order is
$\dfrac{3}{1}$ on chevron. VVVV
$\dfrac{1}{3}$

This unit is in multiples of 2.

Circles or figures based on circles may be drawn by the above method. The side of the square is also the side of the eq. triangle. A circle is described through corners of each and a line equally dividing both is extended at right angles to the common base. The space between centres 3 and 4 is repeated above to the number required.

An even multiple 6 gives 2 lines

George Bain

2 Lines.

1 Line.

An odd multiple 7 gives 1 line.

Plate 6

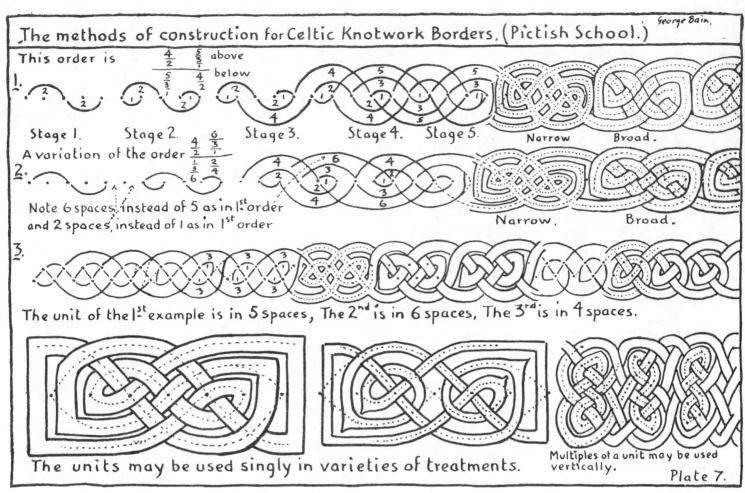

The methods of construction for Celtic Knotwork Borders, (Pictish School.)

George Bain.

This order is $\frac{4}{2}\frac{5}{3}$ above $\frac{5}{3}\frac{4}{2}$ below

1.

Stage 1. Stage 2. Stage 3. Stage 4. Stage 5. Narrow Broad.

A variation of the order $\frac{4}{2}\frac{6}{3}$ $\frac{1}{3}\frac{2}{6}$

2.

Note 6 spaces, instead of 5 as in 1st order
and 2 spaces, instead of 1 as in 1st order

Narrow. Broad.

3.

The unit of the 1st example is in 5 spaces, The 2nd is in 6 spaces, The 3rd is in 4 spaces.

The units may be used singly in varieties of treatments.

Multiples of a unit may be used vertically.

Plate 7.

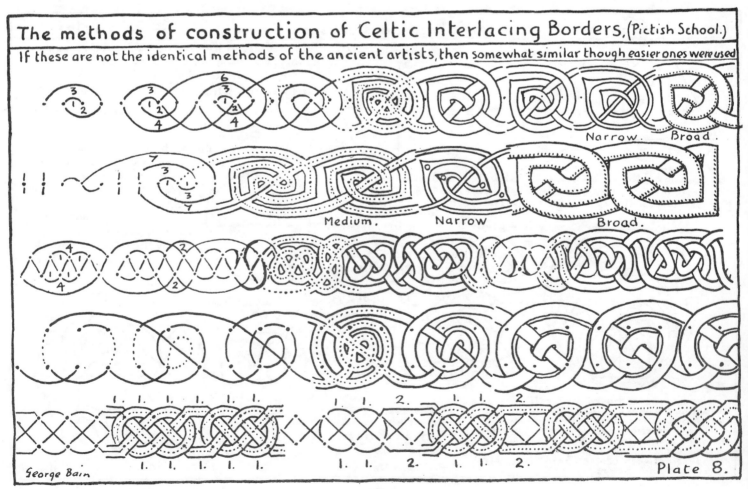

The methods of construction of Celtic Interlacing Borders, (Pictish School.)

If these are not the identical methods of the ancient artists, then somewhat similar though easier ones were used

Narrow. Broad.

Medium. Narrow. Broad.

George Bain

Plate 8.

This is a variation of Nº 1 Plate 8. It is an adaptation of a spiral to interlacing.

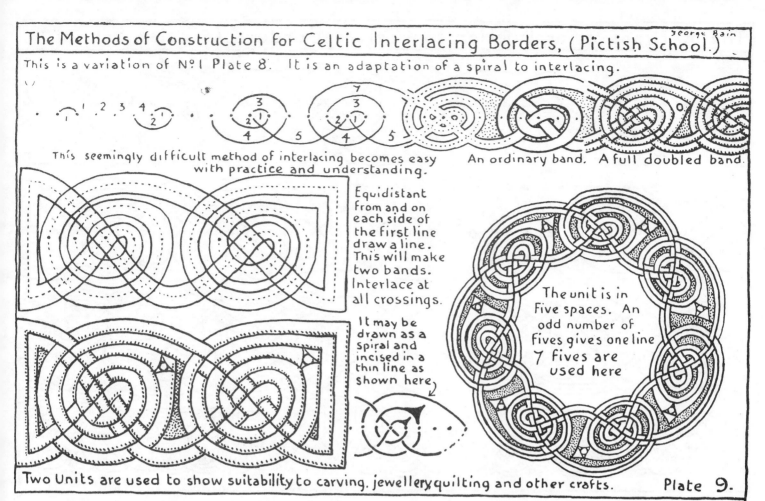

This seemingly difficult method of interlacing becomes easy with practice and understanding.

An ordinary band. A full doubled band.

Equidistant from and on each side of the first line draw a line. This will make two bands. Interlace at all crossings.

It may be drawn as a spiral and incised in a thin line as shown here.

The unit is in Five spaces. An odd number of fives gives one line 7 fives are used here

Two Units are used to show suitability to carving, jewellery, quilting and other crafts.

Plate 9.

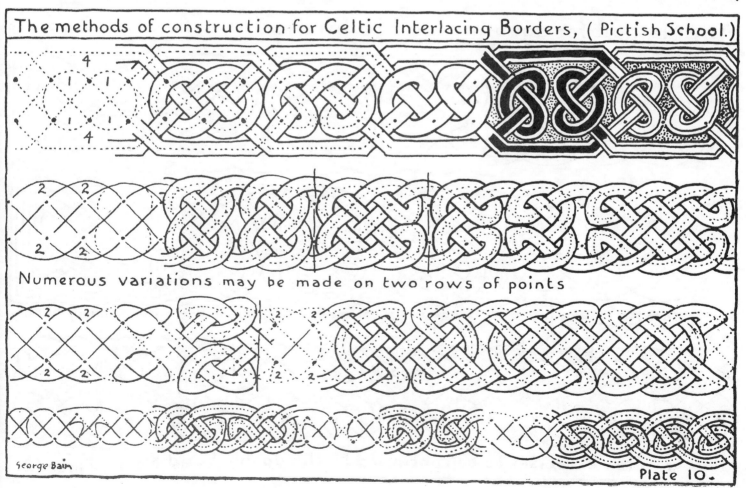

Numerous variations may be made on two rows of points

George Bain

Plate 10.

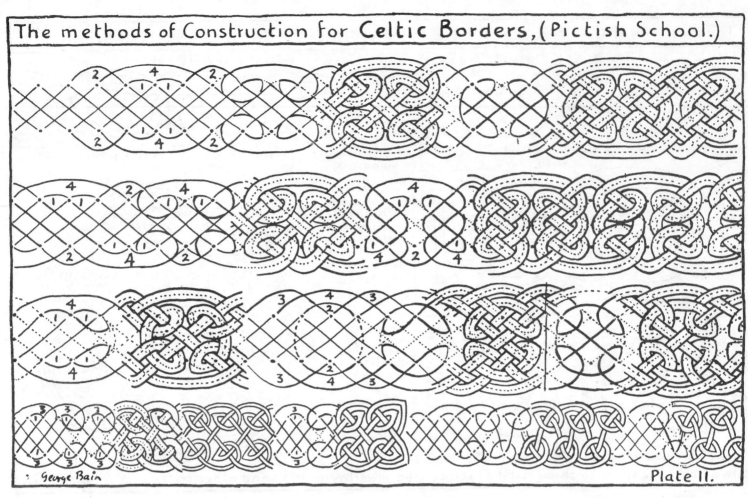

George Bain

Plate 11.

The Method for doubling Celtic Interlacings, (Pictish School.)

George Bain

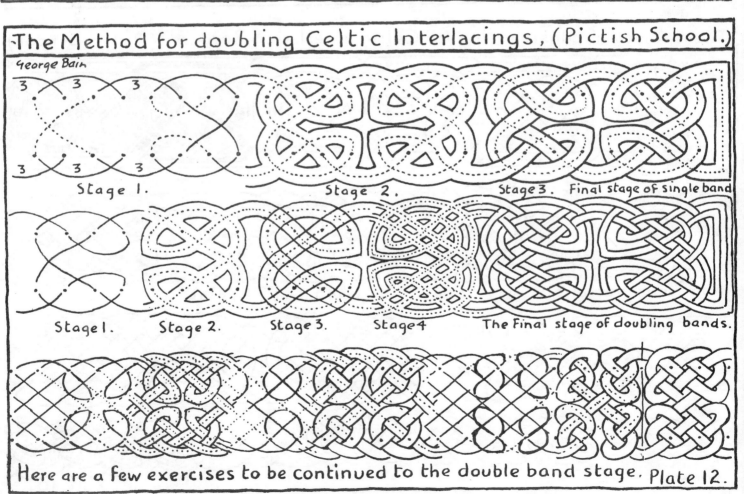

Stage 1. Stage 2. Stage 3. Final stage of single band

Stage 1. Stage 2. Stage 3. Stage 4 The Final stage of doubling bands.

Here are a few exercises to be continued to the double band stage. Plate 12.

The methods of mitring Celtic Knotwork Borders, (Pictish School.)

Mitring may be done by a reversed action turnover at 45° or any angle. Adjustments will be required.

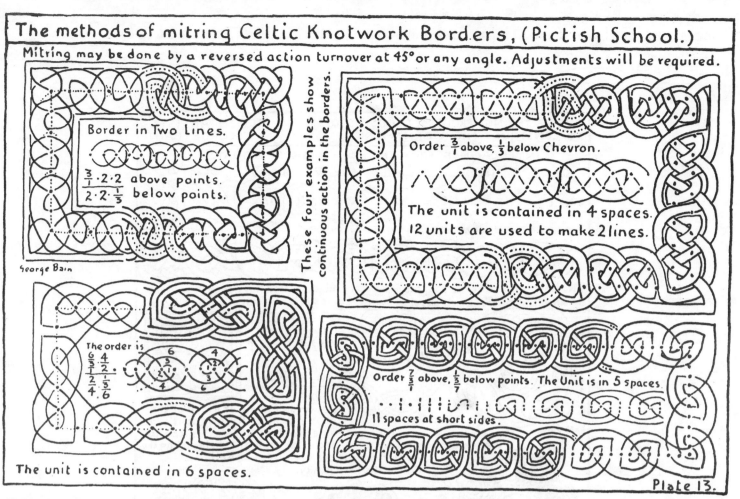

Border in Two Lines.

$\frac{3}{1} \cdot 2 \cdot 2$ above points.
$2 \cdot 2 \cdot \frac{1}{3}$ below points.

George Bain

The order is
$\begin{array}{cc} \frac{6}{3} & \frac{4}{2} \\ \frac{1}{2} & \frac{1}{5} \\ 4 & 6 \end{array}$

The unit is contained in 6 spaces.

These four examples show continuous action in the borders.

Order $\frac{3}{1}$ above, $\frac{1}{3}$ below Chevron.

The unit is contained in 4 spaces.
12 units are used to make 2 lines.

Order $\frac{7}{3}$ above, $\frac{1}{7}$ below points. The Unit is in 5 spaces.

11 spaces at short sides.

Plate 13.

The methods of mitring Celtic Knotwork Borders, (Pictish School.)

George Bain.

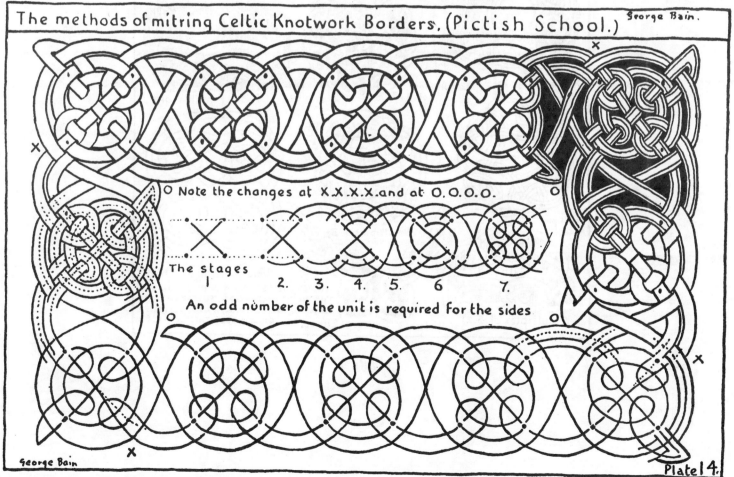

O Note the changes at X.X.X.X. and at O.O.O.O.

The stages
1 2. 3. 4. 5. 6 7.

An odd number of the unit is required for the sides

George Bain

Plate 14.

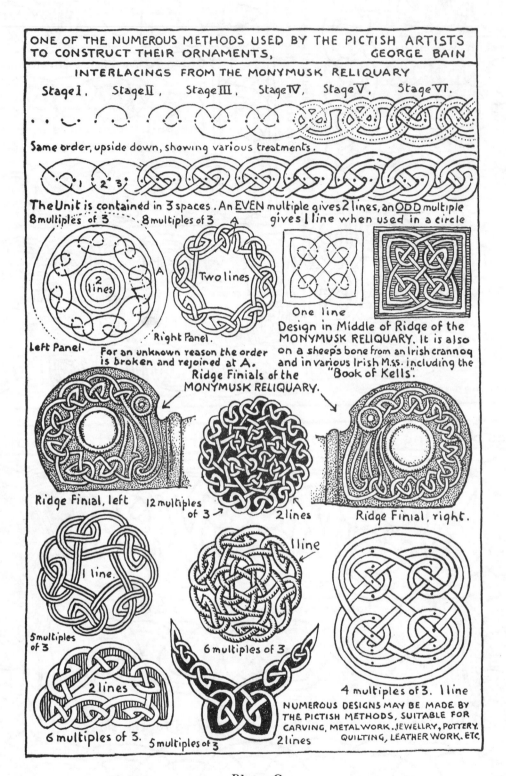

ONE OF THE NUMEROUS METHODS USED BY THE PICTISH ARTISTS TO CONSTRUCT THEIR ORNAMENTS, GEORGE BAIN

INTERLACINGS FROM THE MONYMUSK RELIQUARY

Stage I. Stage II. Stage III. Stage IV. Stage V. Stage VI.

Same order, upside down, showing various treatments.

The Unit is contained in 3 spaces. An EVEN multiple gives 2 lines, an ODD multiple gives 1 line when used in a circle

8 multiples of 3

8 multiples of 3

2 lines

Left Panel.

Two lines

Right Panel.

For an unknown reason the order is broken and rejoined at A.

One line

Design in Middle of Ridge of the MONYMUSK RELIQUARY. It is also on a sheep's bone from an Irish crannog and in various Irish M.SS. including the "Book of Kells".

Ridge Finials of the MONYMUSK RELIQUARY.

Ridge Finial, left

12 multiples of 3

2 lines

Ridge Finial, right.

1 line.

5 multiples of 3

1 line

6 multiples of 3

4 multiples of 3. 1 line

NUMEROUS DESIGNS MAY BE MADE BY THE PICTISH METHODS, SUITABLE FOR CARVING, METALWORK, JEWELLRY, POTTERY, QUILTING, LEATHER WORK, ETC.

2 lines

6 multiples of 3.

5 multiples of 3

2 lines

Plate C

36

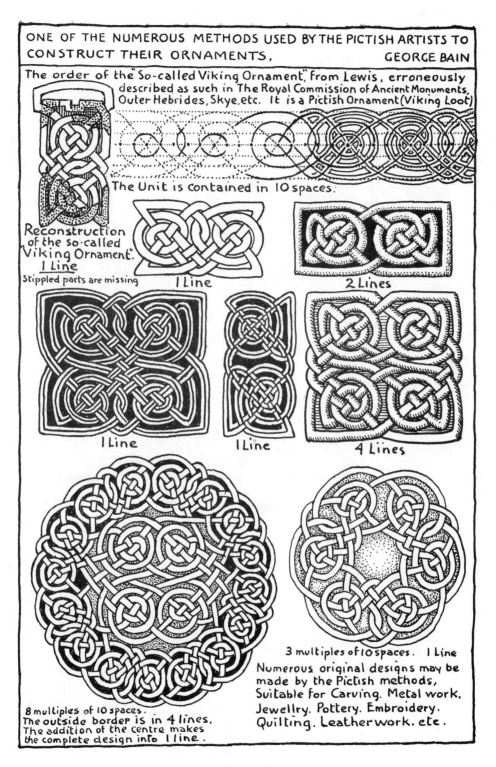

ONE OF THE NUMEROUS METHODS USED BY THE PICTISH ARTISTS TO CONSTRUCT THEIR ORNAMENTS, GEORGE BAIN

The order of the "So-called Viking Ornament," from Lewis, erroneously described as such in The Royal Commission of Ancient Monuments, Outer Hebrides, Skye, etc. It is a Pictish Ornament (Viking Loot)

The Unit is contained in 10 spaces.

Reconstruction of the so-called "Viking Ornament".
1 Line
Stippled parts are missing

1 Line

2 Lines

1 Line

1 Line

4 Lines

8 multiples of 10 spaces.
The outside border is in 4 lines.
The addition of the centre makes the complete design into 1 line.

3 multiples of 10 spaces. 1 Line
Numerous original designs may be made by the Pictish methods, Suitable for Carving. Metal work. Jewellry. Pottery. Embroidery. Quilting. Leatherwork. etc.

Plate D

Knotwork Panels.

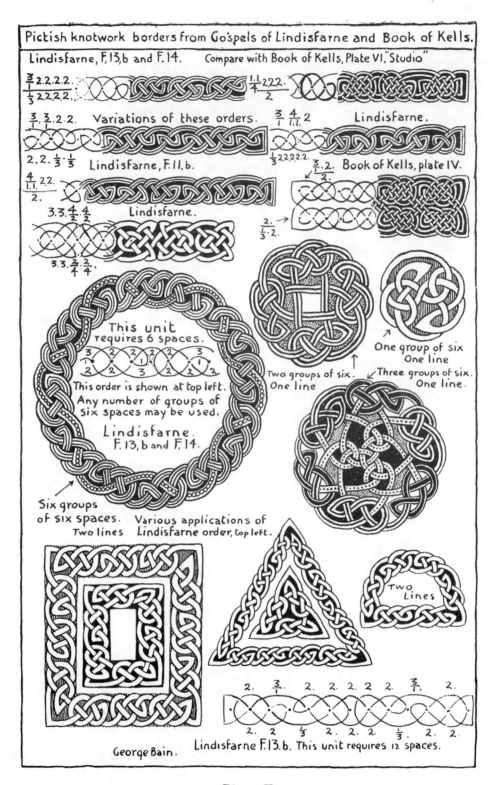

Pictish knotwork borders from Gospels of Lindisfarne and Book of Kells.

Lindisfarne, F.13,b and F.14. Compare with Book of Kells, Plate VI,"Studio"

$\frac{3}{1}$2.2.2.2.
$\frac{1}{3}$2.2.2.2.

$\frac{1.1}{4}$2.2.2.
2

$\frac{3}{1}.\frac{3}{1}.2.2.2.$ Variations of these orders. $\frac{3}{1}.\frac{4}{1.1}.2$ Lindisfarne.

2.2.$\frac{1}{3}.\frac{1}{3}$ Lindisfarne, F.11.b. $\frac{1}{3}$2.2.2.2. $\frac{3}{1}.2.$ Book of Kells, plate IV.

$\frac{4}{1.1}.$2.2.
2.

3.3.$\frac{4}{2}.\frac{4}{2}$ Lindisfarne. $\frac{2.}{\frac{1}{3}.2.}$

3.3.$\frac{2}{4}.\frac{2}{4}$

This unit
requires 6 spaces.

This order is shown at top left.
Any number of groups of
six spaces may be used.

Lindisfarne.
F.13,b and F.14.

One group of six
One line

Two groups of six.
One line

Three groups of six.
One line

Six groups
of six spaces.
Two lines Various applications of
Lindisfarne order, top left.

Two
Lines

2. $\frac{3}{1}.$ 2. 2.2.2.2 2. $\frac{3}{1}.$ 2.

2. 2. $\frac{1}{3}$ 2. 2.2. $\frac{1}{3}$ 2. 2.

George Bain. Lindisfarne F.13.b. This unit requires 12 spaces.

Plate E

40

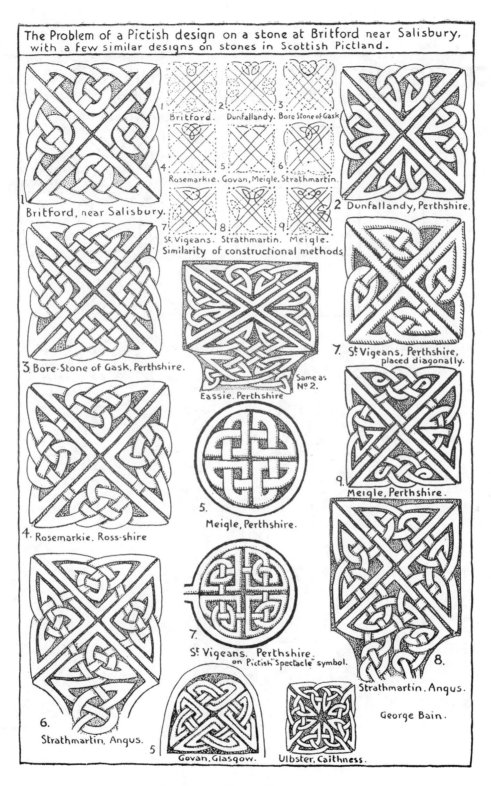

The Problem of a Pictish design on a stone at Britford near Salisbury, with a few similar designs on stones in Scottish Pictland.

1. Britford.
2. Dunfallandy.
3. Bore-Stone of Gask.
4. Rosemarkie.
5. Govan, Meigle.
6. Strathmartin.
7. St. Vigeans.
8. Strathmartin.
9. Meigle.

Similarity of constructional methods.

1. Britford, near Salisbury.

2 Dunfallandy, Perthshire.

3. Bore-Stone of Gask, Perthshire.

Eassie, Perthshire. Same as No. 2.

7. St. Vigeans, Perthshire, placed diagonally.

5. Meigle, Perthshire.

9. Meigle, Perthshire.

4. Rosemarkie, Ross-shire

7. St. Vigeans, Perthshire. on Pictish "Spectacle" symbol.

6. Strathmartin, Angus.

5 Govan, Glasgow.

Ulbster, Caithness.

8. Strathmartin, Angus.

George Bain.

Plate F

41

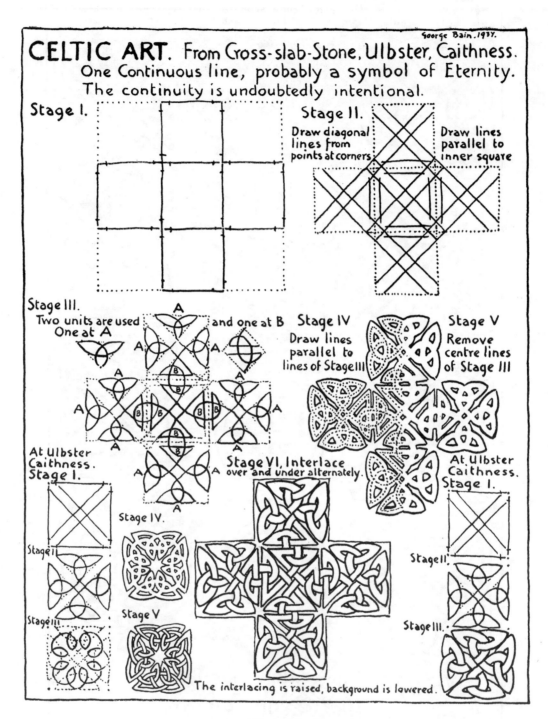

CELTIC ART. From Cross-slab-Stone, Ulbster, Caithness.
One Continuous line, probably a symbol of Eternity.
The continuity is undoubtedly intentional.

George Bain. 1937.

Stage I.

Stage II.
Draw diagonal lines from points at corners.
Draw lines parallel to inner square

Stage III.
Two units are used One at A and one at B

Stage IV
Draw lines parallel to lines of Stage III

Stage V
Remove centre lines of Stage III

At Ulbster Caithness. Stage I.

Stage II

Stage III

Stage IV.

Stage V

Stage VI, Interlace over and under alternately.

At Ulbster Caithness. Stage I.

Stage II

Stage III.

The interlacing is raised, background is lowered.

Plate G

42

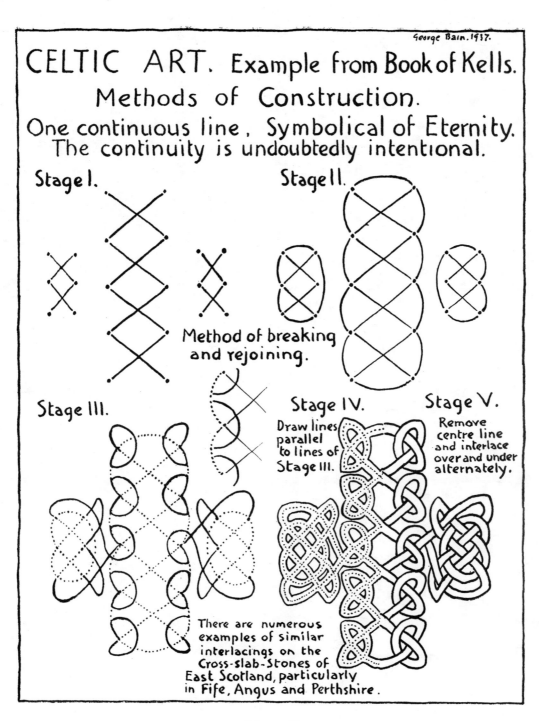

CELTIC ART. Example from Book of Kells.
Methods of Construction.
One continuous line, Symbolical of Eternity.
The continuity is undoubtedly intentional.

Stage I.

Stage II.

Method of breaking and rejoining.

Stage III.

Stage IV.
Draw lines parallel to lines of Stage III.

Stage V.
Remove centre line and interlace over and under alternately.

There are numerous examples of similar interlacings on the Cross-slab-Stones of East Scotland, particularly in Fife, Angus and Perthshire.

George Bain. 1937.

Plate H

43

The Methods of Construction for Simple Celtic Knotwork Panels.(Pictish School.)

In Pictish Panels, the proportion of the lay-out is not rectangular, it is lozenge ◇ or ◇ 1 by $\frac{3}{4}$.

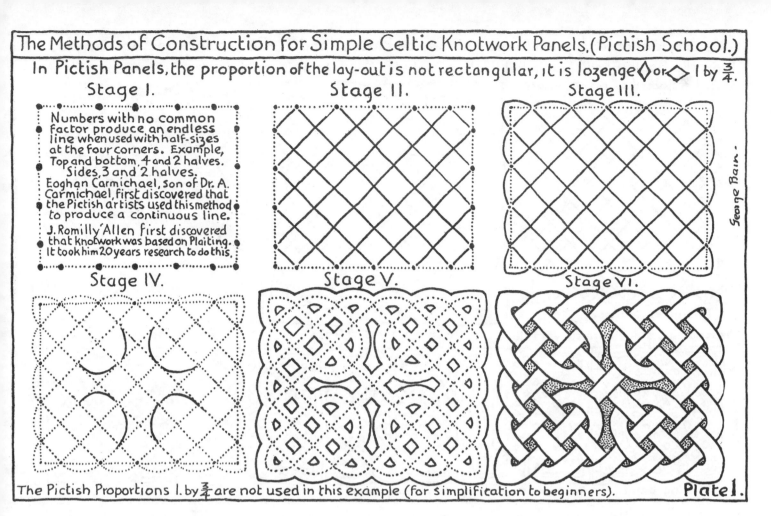

Stage I.

Numbers with no common factor produce an endless line when used with half-sizes at the four corners. Example, Top and bottom, 4 and 2 halves. Sides, 3 and 2 halves. Eoghan Carmichael, son of Dr. A. Carmichael, first discovered that the Pictish artists used this method to produce a continuous line.

J. Romilly Allen first discovered that knotwork was based on Plaiting. It took him 20 years research to do this.

Stage II.

Stage III.

Stage IV.

Stage V.

Stage VI.

George Bain.

The Pictish Proportions 1. by $\frac{3}{4}$ are not used in this example (for simplification to beginners).

Plate 1.

The Methods of Construction for Simple Celtic Knotwork Panels (Pictish School).

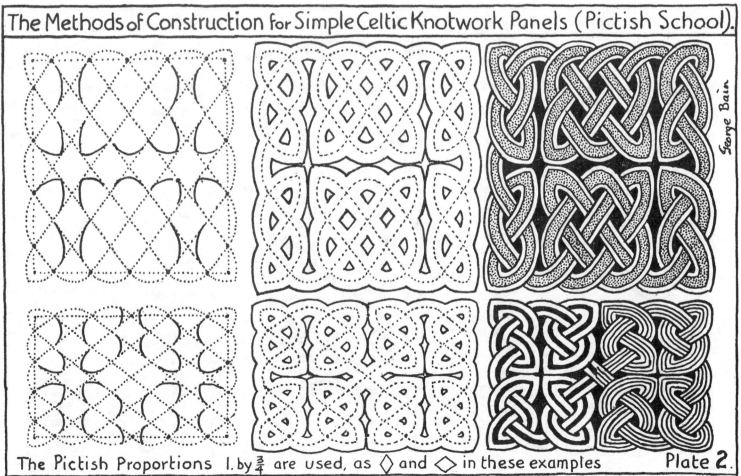

George Bain

The Pictish Proportions 1. by $\frac{3}{4}$ are used, as ◇ and ◇ in these examples

Plate 2.

An example of an exception to the methods of Plates 1 and 2, Celtic Interlacing Panels.

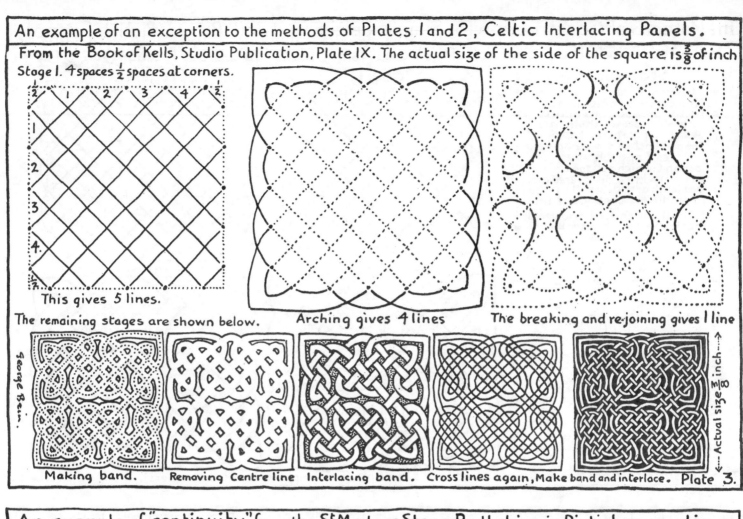

From the Book of Kells, Studio Publication, Plate IX. The actual size of the side of the square is $\frac{3}{8}$ of inch
Stage 1. 4 spaces $\frac{1}{2}$ spaces at corners.

This gives 5 lines.
The remaining stages are shown below.

Arching gives 4 lines

The breaking and re-joining gives 1 line

George Bain

Making band. Removing Centre line Interlacing band. Cross lines again, Make band and interlace. Plate 3.

Actual size $\frac{3}{8}$ inch

An example of "continuity" from the St Madoes Stone, Perthshire, in Pictish proportions.

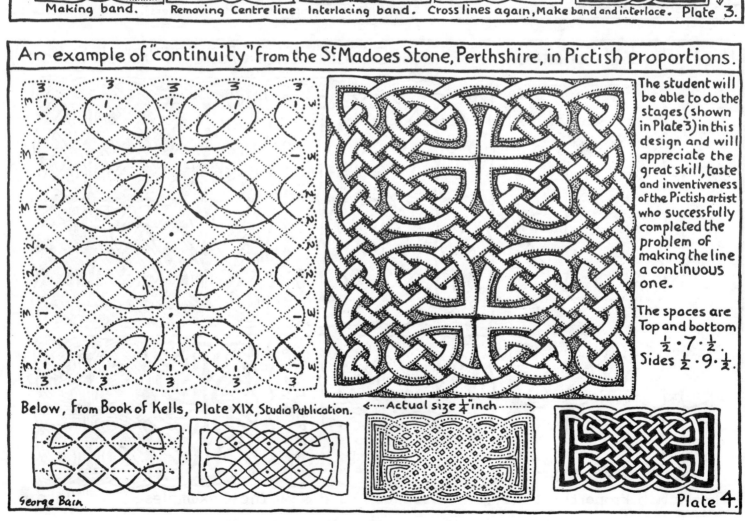

The student will be able to do the stages (shown in Plate 3) in this design and will appreciate the great skill, taste and inventiveness of the Pictish artist who successfully completed the problem of making the line a continuous one.

The spaces are
Top and bottom
$\frac{1}{2} \cdot 7 \cdot \frac{1}{2}$
Sides $\frac{1}{2} \cdot 9 \cdot \frac{1}{2}$

Below, from Book of Kells, Plate XIX, Studio Publication. ←---- Actual size $\frac{1}{4}$ inch ------→

George Bain

Plate 4.

46

A few of the numerous Methods used by Pictish Artists for Simple Knotwork Panels.

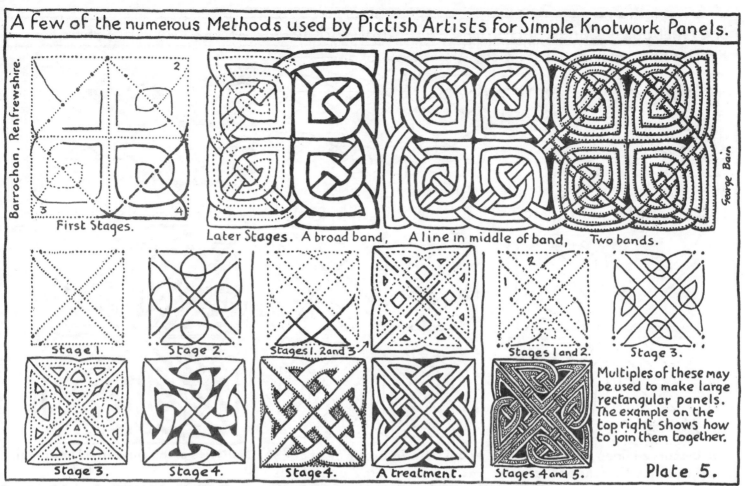

Barrochan. Renfrewshire.

First Stages.

Later Stages. A broad band, A line in middle of band, Two bands.

George Bain

Stage 1. Stage 2. Stages 1. 2 and 3. Stages 1 and 2. Stage 3.

Stage 3. Stage 4. Stage 4. A treatment. Stages 4 and 5.

Multiples of these may be used to make large rectangular panels. The example on the top right shows how to join them together.

Plate 5.

A example from "Ulbster Stone, Caithness, and one from "Strathmartin Stone", Angus.

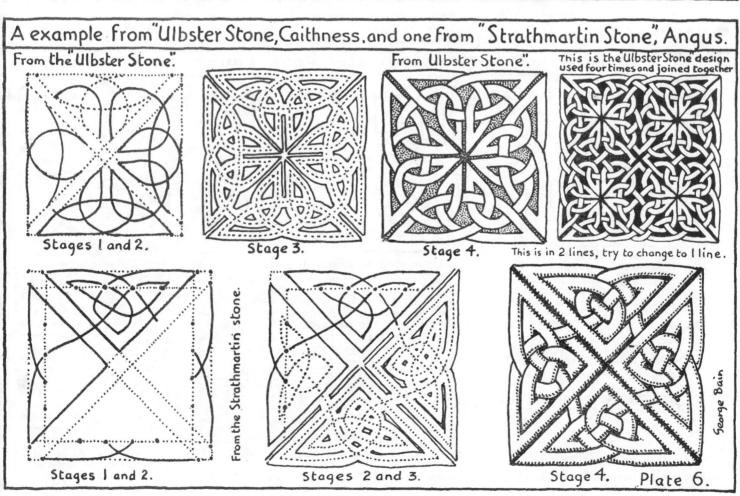

From the "Ulbster Stone".

From Ulbster Stone".

This is the Ulbster Stone design used four times and joined together

Stages 1 and 2. Stage 3. Stage 4. This is in 2 lines, try to change to 1 line.

From the Strathmartin stone.

Stages 1 and 2. Stages 2 and 3. Stage 4. Plate 6.

George Bain

47

Reptile knotwork panel from the "Shandwick Stone".

George Bain.

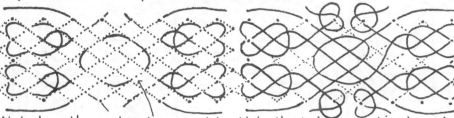

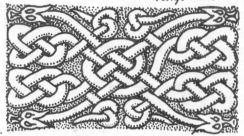

Note how the centre ring was joined into the design by making it a spiral.

Divide curved line into 11 spaces. Lindisfarne, St.Vigeans, Dunfallandy, Eassie, Gospels of M^cDurnan, etc.

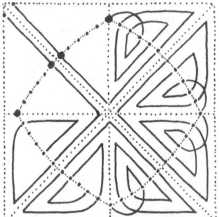

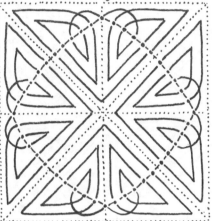

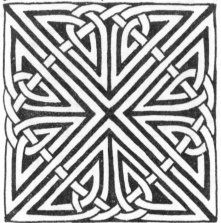

On the curved lines, first mark the large points, then the smaller ones.

continue in order of stages as shown in previous plates.

Multiples of this may be used for a panel.
Plate 7.

Book of Lindisfarne and Ulbster Stone, Caithness.

George Bain

Two units are used in the above design Multiples of them may be joined together as shown.

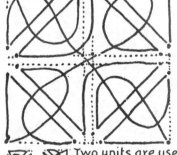

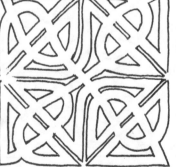

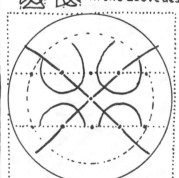

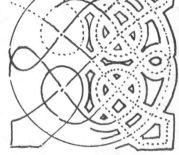

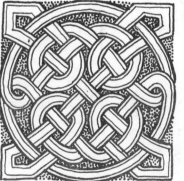

Used also as a border design.

This unit is used on the "Collieburn", Sutherland, and the "Glammis", Angus, stones. Multiples may be joined.

Plate 8.

The Methods of Construction of Pictish Knotwork Panels, Nigg Stone, Ross-shire

Nigg Stone, Portion of top left panel.

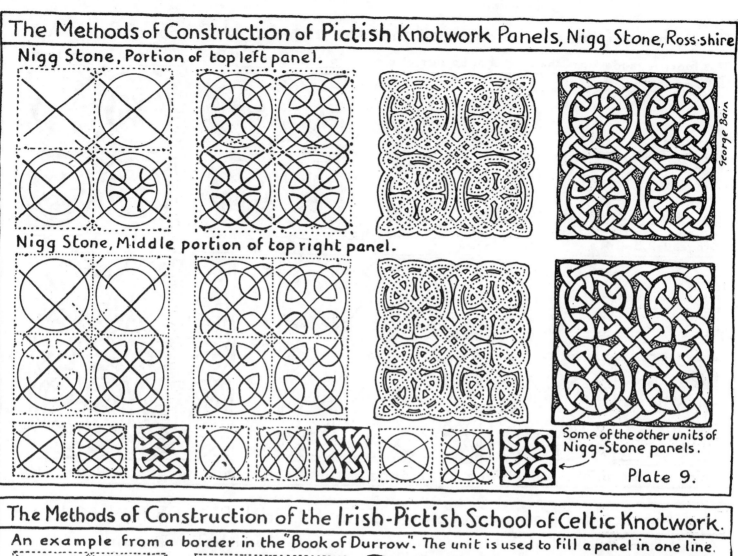

Nigg Stone, Middle portion of top right panel.

Some of the other units of Nigg-Stone panels.

George Bain

Plate 9.

The Methods of Construction of the Irish-Pictish School of Celtic Knotwork.

An example from a border in the "Book of Durrow". The unit is used to fill a panel in one line.

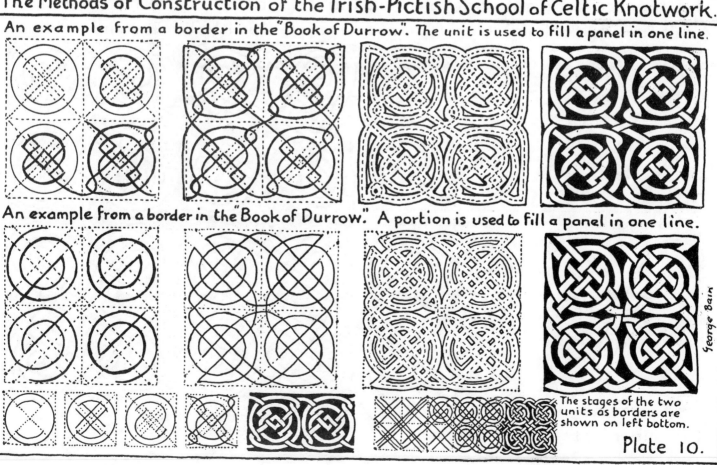

An example from a border in the "Book of Durrow." A portion is used to fill a panel in one line.

The stages of the two units as borders are shown on left bottom.

George Bain

Plate 10.

49

This Panel is made from the unit of a border of a page in the "Book of Durrow". It is in one line.

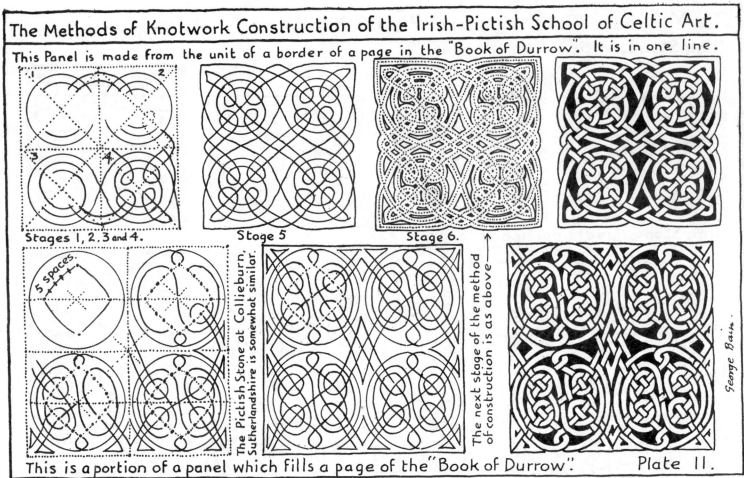

Stages 1, 2, 3 and 4.

Stage 5

Stage 6.

5 spaces.

The Pictish Stone at Collieburn, Sutherlandshire is somewhat similar.

The next stage of the method of construction is as above

George Bain

This is a portion of a panel which fills a page of the "Book of Durrow". Plate 11.

The Methods of Knotwork Construction of the Irish-Pictish School of Celtic Art.

A unit from the "Book of Durrow. It is a good example of an intentional continuous line.

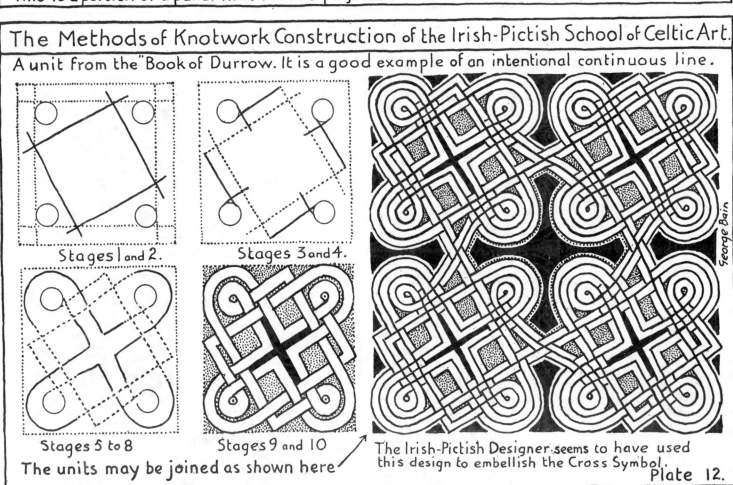

Stages 1 and 2.

Stages 3 and 4.

Stages 5 to 8

Stages 9 and 10

The units may be joined as shown here

George Bain

The Irish-Pictish Designer seems to have used this design to embellish the Cross Symbol.

Plate 12.

The Methods of Construction for Knotwork in Circular Panels, Pictish Art.

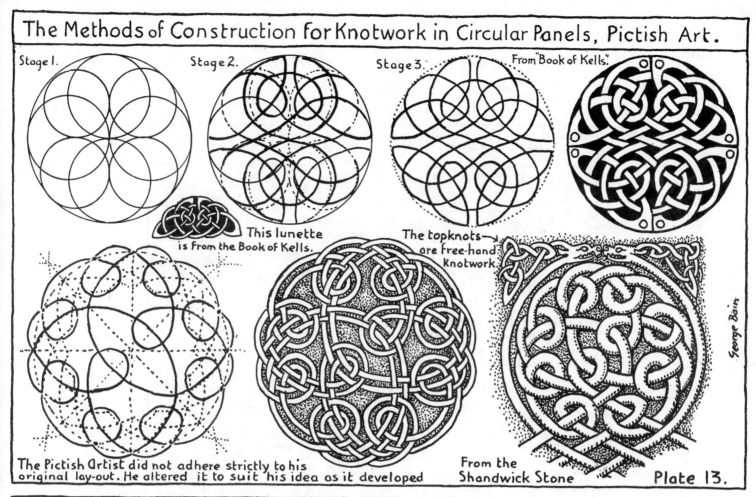

Stage I. Stage 2. Stage 3. From "Book of Kells."

This lunette is from the Book of Kells.

The topknots are free-hand Knotwork

The Pictish artist did not adhere strictly to his original lay-out. He altered it to suit his idea as it developed

From the Shandwick Stone

George Bain

Plate 13.

The Methods of Construction for Knotwork in Circular Panels, Pictish Art.

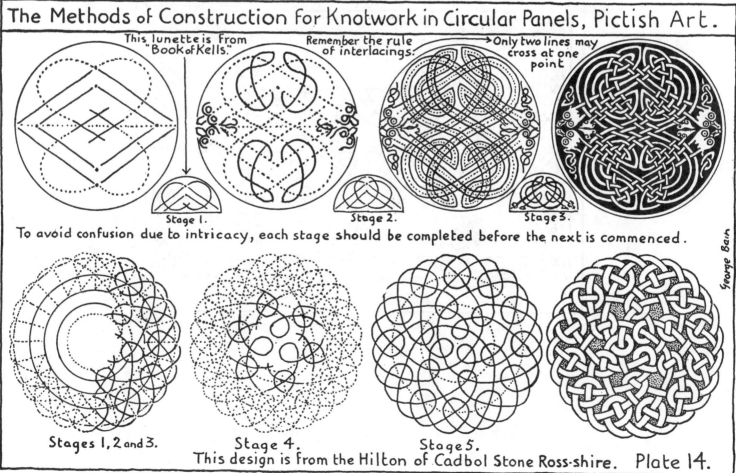

This lunette is from "Book of Kells." Remember the rule of interlacings: →Only two lines may cross at one point

Stage I. Stage 2. Stage 3.

To avoid confusion due to intricacy, each stage should be completed before the next is commenced.

Stages I, 2 and 3. Stage 4. Stage 5.
This design is from the Hilton of Cadbol Stone Ross·shire. Plate 14.

George Bain

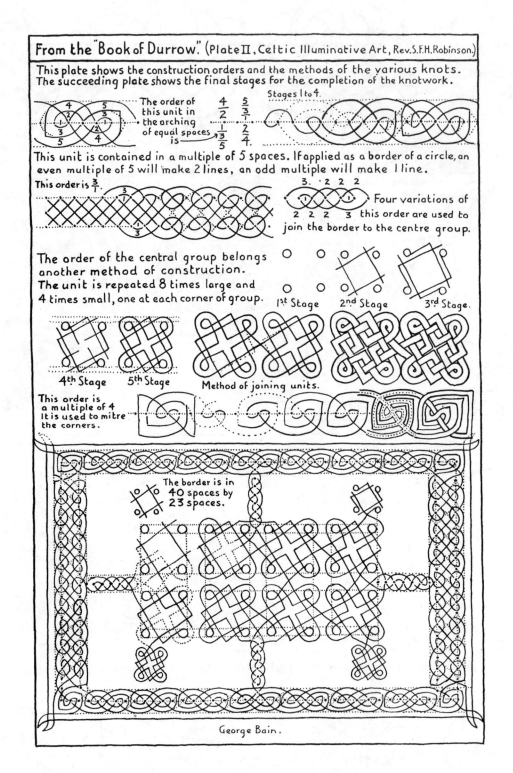

From the "Book of Durrow." (Plate II, Celtic Illuminative Art, Rev. S.F.H. Robinson.)

This plate shows the construction orders and the methods of the various knots. The succeeding plate shows the final stages for the completion of the knotwork.

Stages 1 to 4.

The order of this unit in the arching of equal spaces is $\frac{4}{2} \quad \frac{5}{3}$

$\frac{1}{3} \quad \frac{2}{4}$

$\frac{3}{5}$

This unit is contained in a multiple of 5 spaces. If applied as a border of a circle, an even multiple of 5 will make 2 lines, an odd multiple will make 1 line.

This order is $\frac{3}{1}$.

3. · 2 2 2

Four variations of this order are used to join the border to the centre group.

2 2 2 3

The order of the central group belongs another method of construction.
The unit is repeated 8 times large and 4 times small, one at each corner of group.

1st Stage 2nd Stage 3rd Stage.

4th Stage 5th Stage Method of joining units.

This order is a multiple of 4. It is used to mitre the corners.

The border is in 40 spaces by 23 spaces.

George Bain.

Plate 1

52

From the Book of Durrow. (Plate II. Celtic Illuminative Art, Rev. S.F.H. Robinson.)

The original is not a continuous line. it has three irregular parts, one large, two small. Probably an assistant scribe was responsible for this slight error. The excellence of the constructive methods shows the design to be the work of a Great Master. Two simple changes, as shown at Axx, make the whole of this knotwork into one line.

The preceding plate shows the construction orders of the various knots.

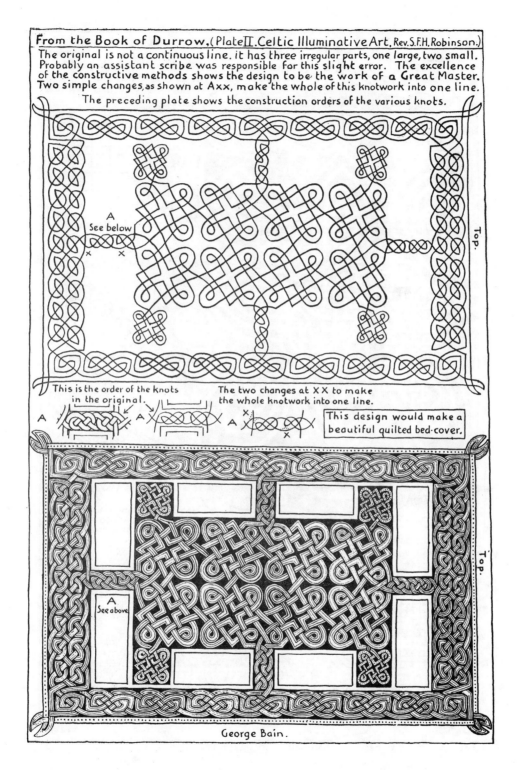

A
See below

Top.

This is the order of the knots in the original.

A

A

The two changes at X X to make the whole knotwork into one line.

A

This design would make a beautiful quilted bed-cover.

A
See above

Top.

George Bain.

Plate J

53

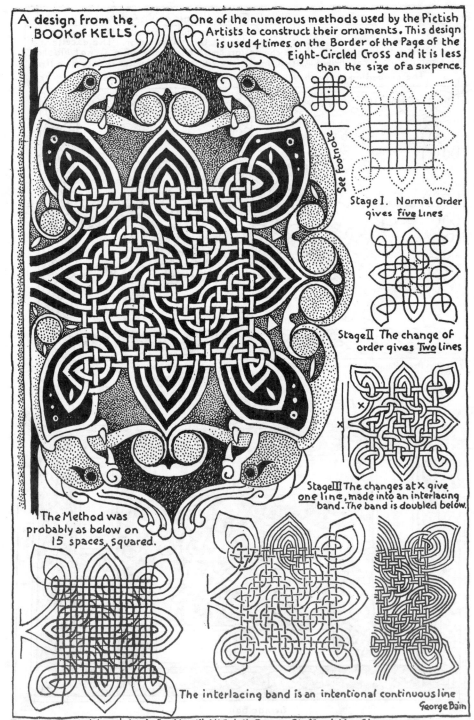

A design from the BOOK of KELLS

One of the numerous methods used by the Pictish Artists to construct their ornaments. This design is used 4 times on the Border of the Page of the Eight-Circled Cross and it is less than the size of a sixpence.

See footnote

Stage I. Normal Order gives _Five_ Lines

Stage II The change of order gives _Two_ lines

Stage III The changes at X give _one line_, made into an interlacing band. The band is doubled below.

The Method was probably as below on 15 spaces, squared.

The interlacing band is an intentional continuous line

George Bain

The small symbol, top right, is for Nov. 1st _All Saint's Day_ on Staffordshire Clogg.

Plate K

54

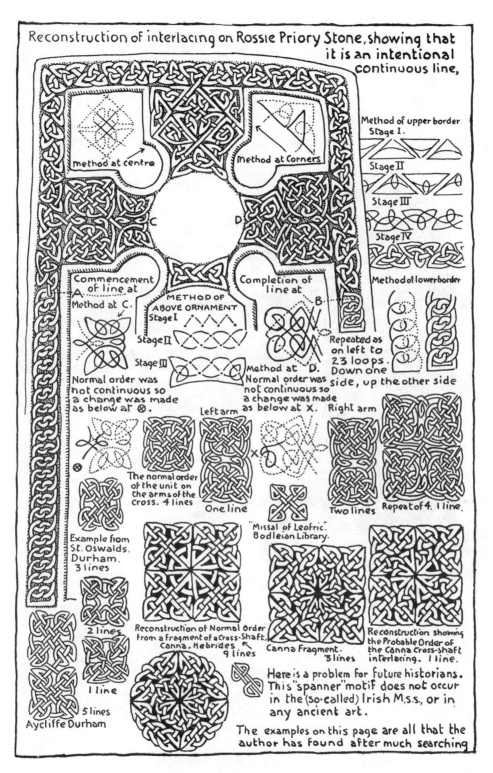

Reconstruction of interlacing on Rossie Priory Stone, showing that it is an intentional continuous line,

method at centre

Method at Corners

C D

Commencement of line at A. Method at C.

Completion of line at B.

METHOD OF ABOVE ORNAMENT
Stage I
Stage II
Stage III

Normal order was not continuous so a change was made as below at ⊗.

Method at D.
Normal order was not continuous so a change was made as below at X.

Method of upper border
Stage I.
Stage II
Stage III
Stage IV

Method of lower border

Repeated as on left to 23 loops. Down one side, up the other side

Left arm Right arm

The normal order of the unit on the arms of the cross. 4 lines

One line

Two lines Repeat of 4. 1 line.

⊗

Example from St. Oswalds. Durham. 3 lines

"Missal of Leofric". Bodleian Library.

Reconstruction of Normal Order from a fragment of a Cross-Shaft, Canna. Hebrides → 9 lines

Canna Fragment. 3 lines

Reconstruction showing the Probable Order of the Canna Cross-shaft interlacing. 1 line.

2 lines

1 line

5 lines
Aycliffe Durham

Here is a problem for future historians. This "spanner" motif does not occur in the (so-called) Irish M.s.s., or in any ancient art.

The examples on this page are all that the author has found after much searching

Plate L

The 23rd Psalm
O King Dauvit. Frae the Hebrew.

Spirals.

Spirals

THE Spiral as a symbol and as an ornament had a beginning at the dawn of man's intellect. It was the development of the inherited impulse that made man construct the first circular hut. With very few exceptions (if any) the constructions by insects, birds and animals are made by circular motions. The circle may be considered as man's first step in art. As a recapitulative impulse it is every child's beginning in drawing, and it is as much used by the educated doodler as it is by the uneducated female for pipe-clay decoration on the doorstep. The spiral is an application of its constructional methods that rapidly became magical. It could be performed to the right or to the left, sunwise or anti-sunwise.

The beauty of nature's spirals was probably observed by man's earliest ancestors, for the shell was also the container of his staple food.

From the terminating point to the opening in the shell to the food, the movement of the spiral is to the right or sunwise and the motion of extracting the food is to the left or anti-sunwise.

Most of nature's spirals are to the right with a notable exception in pairs of horns, which are symmetrical. The Scottish Highlander's sword-dance, being a war dance, is anti-sunwise, but finishes sunwise symbolical of victory.

An assessment of the dating of the commencement of the use of spirals as an ornamental and magical art may be conjectured from the fact, already stated, that highly developed key patterns, engraved on mammoth ivory were found in the Ukraine and in Yugo-Slavia, and are dated from 25,000 B.C. to 15,000 B.C. Key patterns are really spirals in straight lines, and man had to travel long in time before he "invented" the square. Although one-coil spirals are to be found in the arts of most peoples of Europe, Asia, Africa, Polynesia and the Americas, with the Greek Ionic as the acme, yet the finest developments of spiral ornament were made by the Celtic race, who at an early period found the methods of making two, three, four or more coils. There is a continuity of the evolution of the spiral three-dimensional art in Scotland, England, Wales and Ireland from pre-prehistoric times, commencing with two incised points continued as two incised coils that have between them a raised spiral line that revolves back upon itself. This double spiral is also found in the metal bronze-age work of the peoples of the Baltic countries. The Mycenaean artist-craftsman used the spiral motive in a manner that suggests one of the courses of the migration of Celtic peoples to Britain and Ireland. The Egyptians used spirals as all-over motifs from 3000 B.C. to 1500 B.C.

It was in Britain and Ireland, however, that spirals found full artistic growth, first, in the enamelled bronze ornaments for the horse, the chariot and man, then, in the age of the ornamented stone monuments and the late Pagan and early Christian Jewellers' Art.

The noble spirals of Aberlemno, Shandwick, Tarbet, Hilton of Cadboll, Nigg, the Tara brooch, and the Ardagh chalice led the way to the great art of the scribes, who produced the supreme masterpieces of the world's decoration of books, profusely embellished with spiral art.

The few survivors of a great artistic period, the books of Durrow, Kells, Lindisfarne, and St. Chad will shed a light for future generations upon the greatness of the art and the other cultures of the Pict and the Briton.

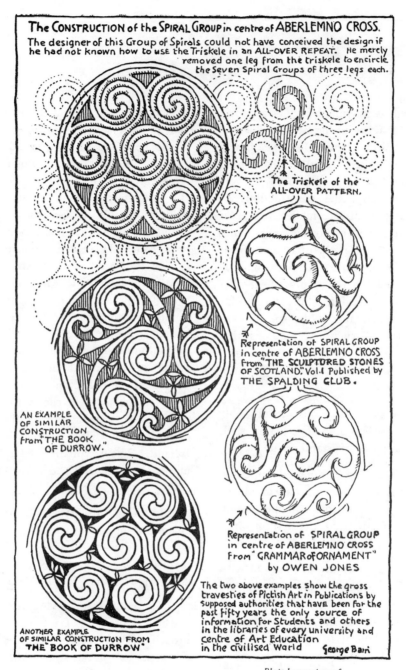

The CONSTRUCTION of the SPIRAL GROUP in centre of ABERLEMNO CROSS.

The designer of this Group of Spirals could not have conceived the design if he had not known how to use the Triskele in an ALL-OVER REPEAT. He merely removed one leg from the triskele to encircle the Seven Spiral Groups of three legs each.

The Triskele of the ALL-OVER PATTERN.

Representation of SPIRAL GROUP in centre of ABERLEMNO CROSS from "THE SCULPTURED STONES OF SCOTLAND," Vol. I Published by THE SPALDING CLUB.

AN EXAMPLE OF SIMILAR CONSTRUCTION from "THE BOOK OF DURROW."

Representation of SPIRAL GROUP in centre of ABERLEMNO CROSS from "GRAMMAR of ORNAMENT" by OWEN JONES

ANOTHER EXAMPLE OF SIMILAR CONSTRUCTION FROM THE "BOOK OF DURROW"

The two above examples show the gross travesties of Pictish Art in Publications by supposed authorities that have been for the past fifty years the only source of information for Students and others in the libraries of every university and centre of Art Education in the civilised World George Bain

*Plate by courtesy of
the Gaelic Society of Inverness*

Plate M

Some Methods for the Construction of Spirals of the Pictish School of Celtic Art.

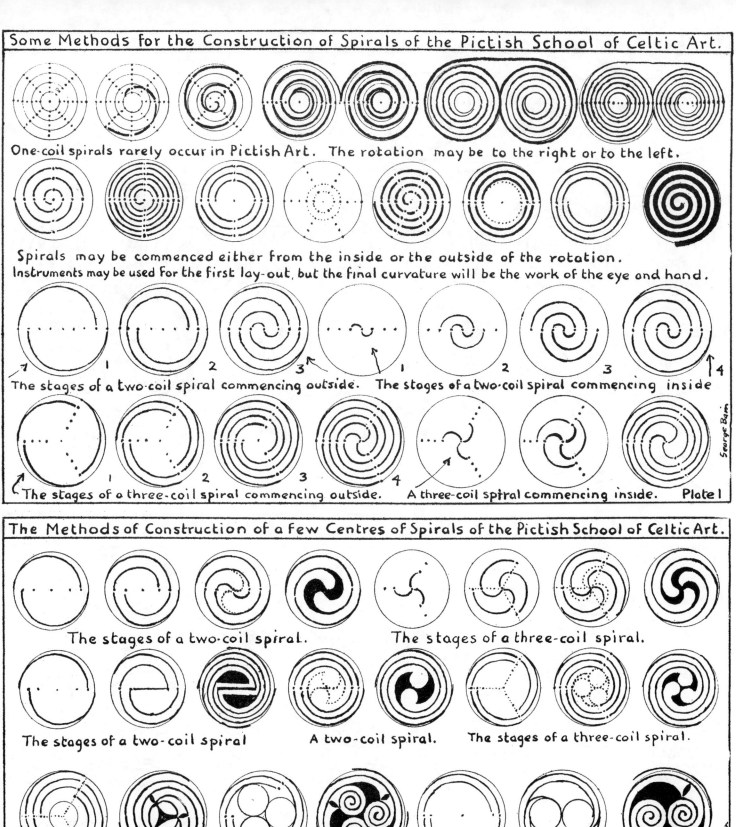

One-coil spirals rarely occur in Pictish Art. The rotation may be to the right or to the left.

Spirals may be commenced either from the inside or the outside of the rotation.
Instruments may be used for the first lay-out, but the final curvature will be the work of the eye and hand.

The stages of a two-coil spiral commencing outside. The stages of a two-coil spiral commencing inside

The stages of a three-coil spiral commencing outside. A three-coil spiral commencing inside. Plate 1

The Methods of Construction of a Few Centres of Spirals of the Pictish School of Celtic Art.

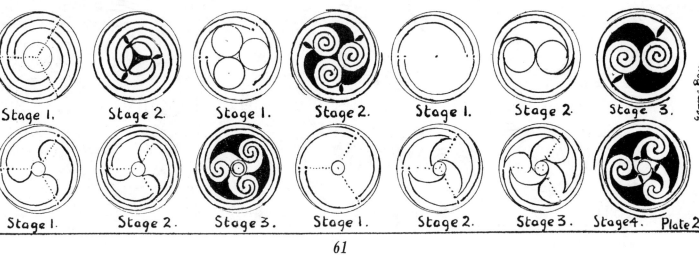

The stages of a two-coil spiral. The stages of a three-coil spiral.

The stages of a two-coil spiral A two-coil spiral. The stages of a three-coil spiral.

Stage 1. Stage 2. Stage 1. Stage 2. Stage 1. Stage 2. Stage 3.

Stage 1. Stage 2. Stage 3. Stage 1. Stage 2. Stage 3. Stage 4. Plate 2

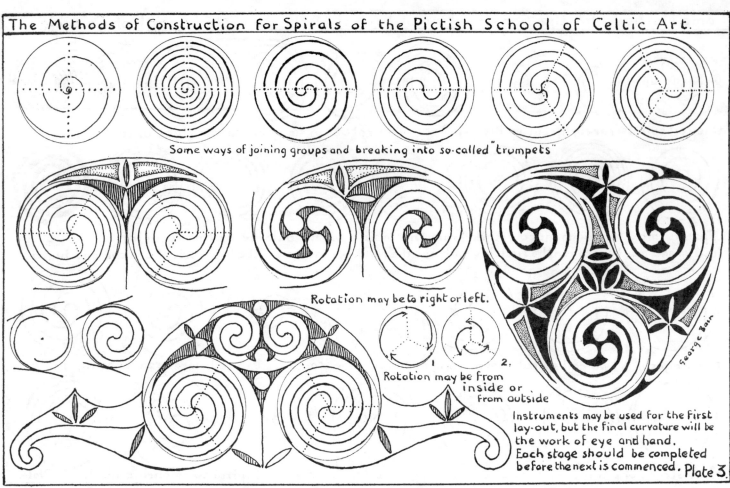

Some ways of joining groups and breaking into so-called "trumpets"

Rotation may be to right or left.

Rotation may be from inside or from outside

Instruments may be used for the first lay-out, but the final curvature will be the work of eye and hand.
Each stage should be completed before the next is commenced. Plate 3.

Methods of joining Spirals in "C"(top) and "S"(bottom) fashions. Top from "Book of Kells". Bottom from "Aberlemno Stone".

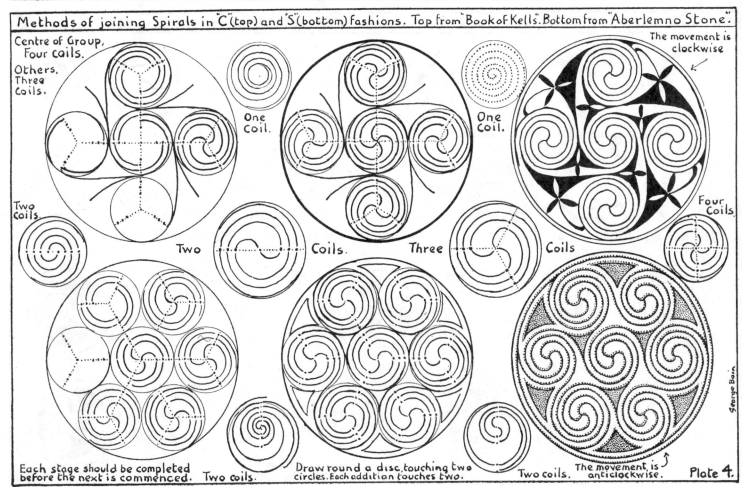

Centre of Group, Four coils.
Others. Three Coils.

One Coil.

One Coil.

The movement is clockwise

Two Coils.

Two Coils.

Two Coils.

Four Coils

Two Coils.

Three Coils.

Each stage should be completed before the next is commenced. Two coils.

Draw round a disc, touching two circles. Each addition touches two.

Two coils.

The movement is anticlockwise.

Plate 4.

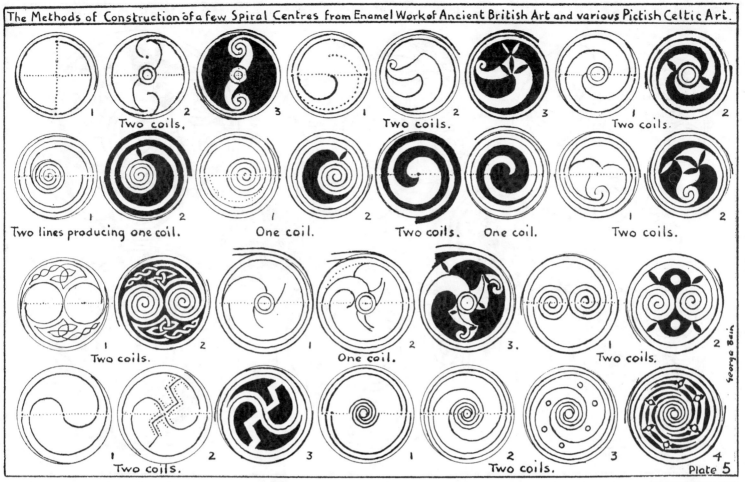

The Methods of Construction of a few Spiral Centres from Enamel Work of Ancient British Art and various Pictish Celtic Art.

Two coils.

Two coils.

Two coils.

Two lines producing one coil. One coil. Two coils. One coil. Two coils.

Two coils. One coil. Two coils.

Two coils. Two coils.

Plate 5

George Bain

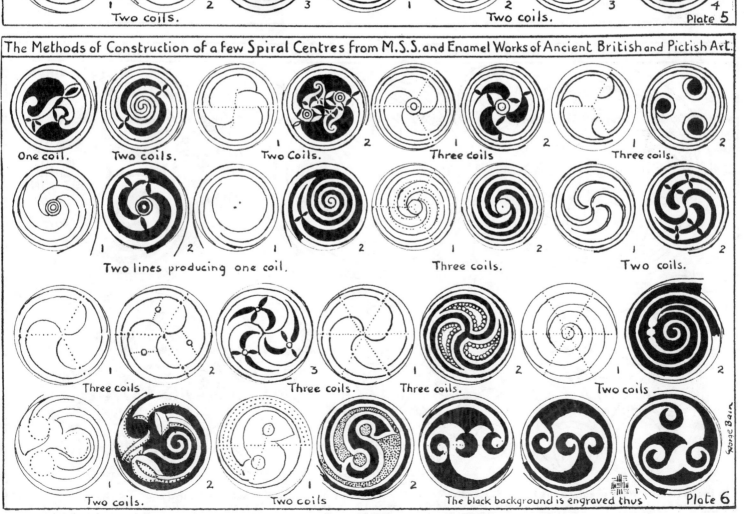

The Methods of Construction of a few Spiral Centres from M.S.S. and Enamel Works of Ancient British and Pictish Art.

One coil. Two coils. Two Coils. Three coils Three coils.

Two lines producing one coil. Three coils. Two coils.

Three coils Three coils. Three coils. Two coils

Two coils. Two coils The black background is engraved thus Plate 6

George Bain

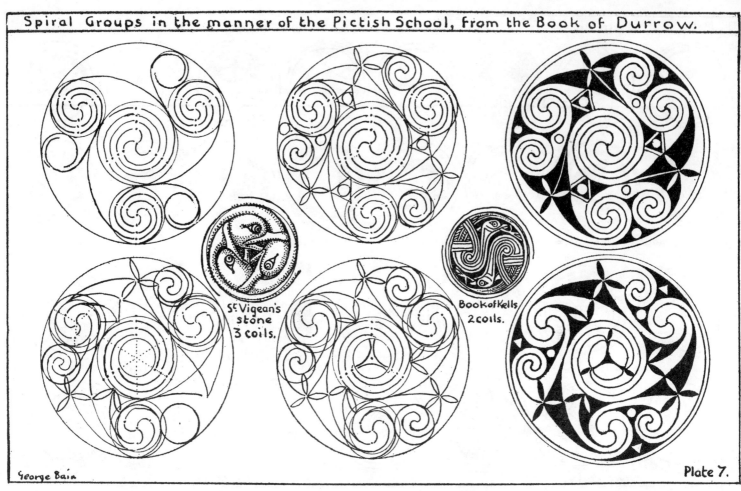

St.Vigean's
stone
3 coils.

Book of Kells
2 coils.

George Bain

Plate 7.

Lindisfarne.

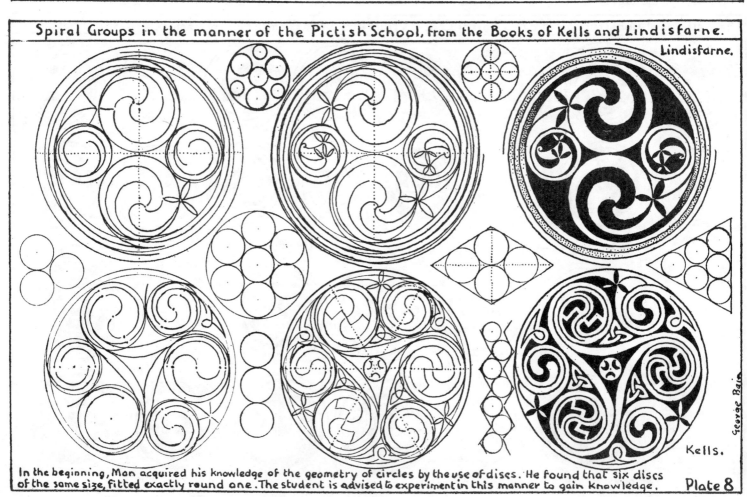

Kells.

George Bain

In the beginning, Man acquired his knowledge of the geometry of circles by the use of discs. He found that six discs of the same size, fitted exactly round one. The student is advised to experiment in this manner to gain knowledge.

Plate 8

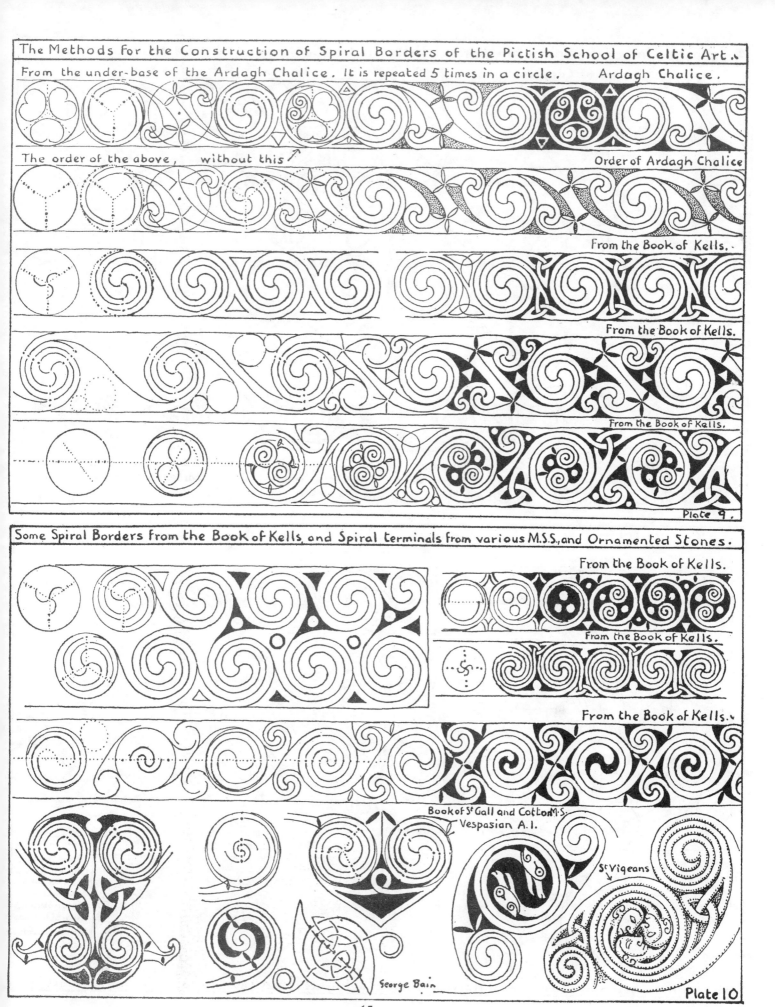

The Methods for the Construction of Spiral Borders of the Pictish School of Celtic Art.

From the under-base of the Ardagh Chalice. It is repeated 5 times in a circle. Ardagh Chalice.

The order of the above, without this↗ Order of Ardagh Chalice

From the Book of Kells.

From the Book of Kells.

From the Book of Kells.

Plate 9.

Some Spiral Borders from the Book of Kells, and Spiral terminals from various M.S.S., and Ornamented Stones.

From the Book of Kells.

From the Book of Kells.

From the Book of Kells.

Book of St Gall and Cotton M.S.
Vespasian A. I.

St Viqeans

George Bain

Plate 10

65

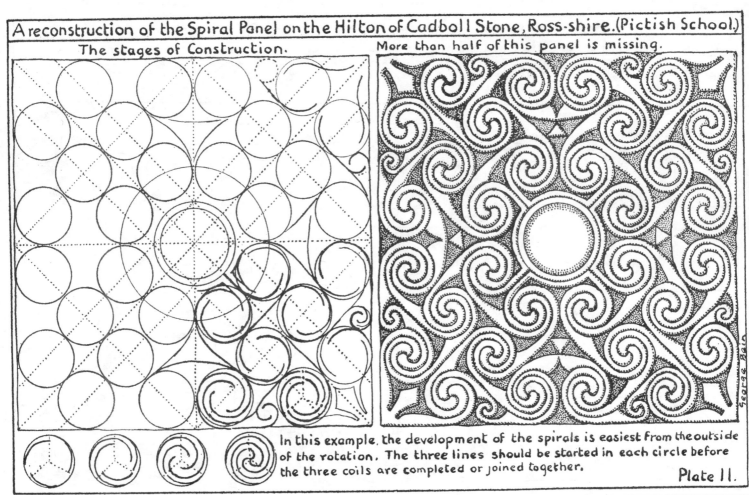

A reconstruction of the Spiral Panel on the Hilton of Cadboll Stone, Ross-shire. (Pictish School.)

The stages of Construction.

More than half of this panel is missing.

In this example, the development of the spirals is easiest from the outside of the rotation. The three lines should be started in each circle before the three coils are completed or joined together.

Plate 11.

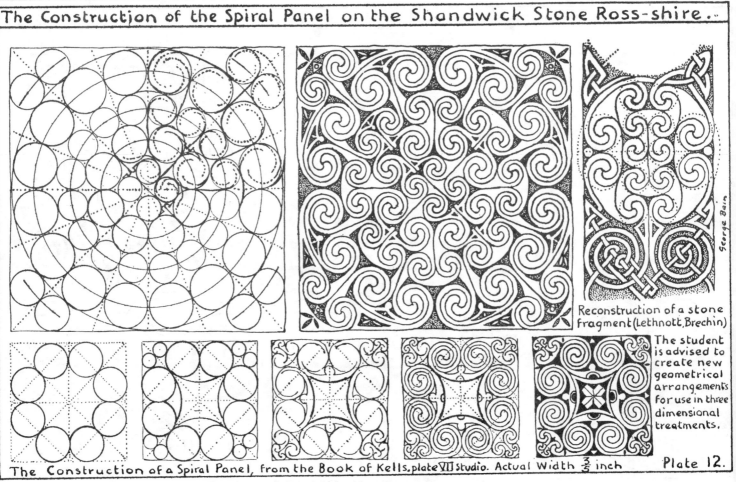

The Construction of the Spiral Panel on the Shandwick Stone Ross-shire.

Reconstruction of a stone fragment (Lethnott, Brechin)

The student is advised to create new geometrical arrangements for use in three dimensional treatments.

The Construction of a Spiral Panel, from the Book of Kells, plate VII studio. Actual Width ¾ inch.

Plate 12.

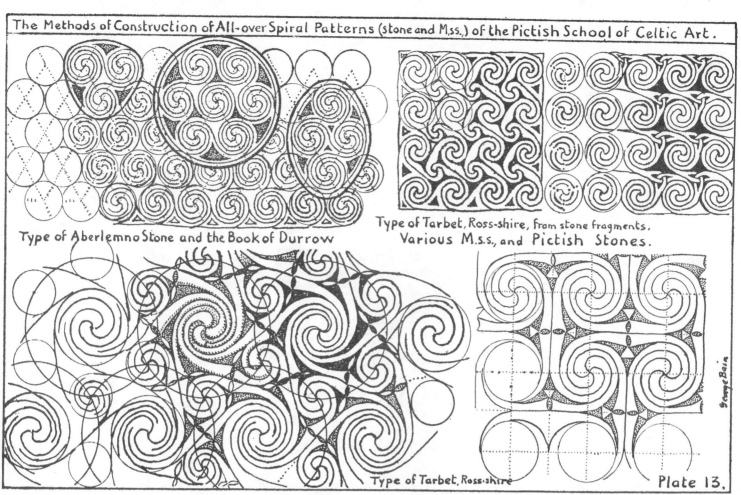

The Methods of Construction of All-over Spiral Patterns (stone and M.S.S.) of the Pictish School of Celtic Art.

Type of Aberlemno Stone and the Book of Durrow

Type of Tarbet, Ross-shire, from stone fragments.
Various M.S.S., and Pictish Stones.

Type of Tarbet, Ross-shire

Plate 13.

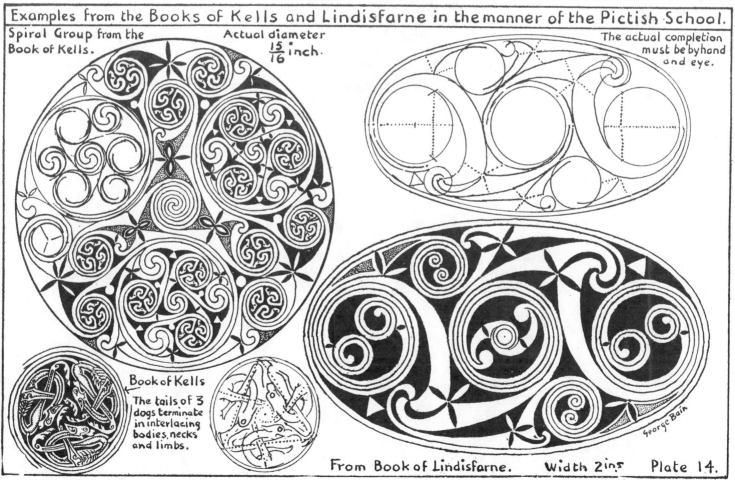

Examples from the Books of Kells and Lindisfarne in the manner of the Pictish School.

Spiral Group from the Book of Kells.

Actual diameter $\frac{15}{16}$ inch.

The actual completion must be by hand and eye.

Book of Kells
The tails of 3 dogs terminate in interlacing bodies, necks and limbs.

From Book of Lindisfarne. Width 2 ins Plate 14.

67

Key Patterns

THERE are numerous references to, and a few descriptions of, Celtic Key Patterns by writers who have been blinded by the "classical" education that still claims to be the basis of all European artistic achievements.

J. Romilly Allen was of the opinion that the essential difference between the classical Key patterns and those used by the Christian Celts of Britain and Ireland, consisted in the introduction of diagonal lines by the latter.

The square Key patterns of the "classical" Greek fret type were seldom used in the art of the Pagan or the Christian peoples of Britain and Ireland. They occur still less in the Pictish School of Celtic Art. The diagonal cross, which at a later period had the Saint Andrew story grafted on it, became the St. Andrew's Cross that emerged in a new dressing to be symbolical of the Scotland that succeeded the Pictland of Malcolm Canmore. This diagonal cross is the basic construction of many key pattern panels and interlacing knotwork panels of Pictish art.

According to J. Romilly Allen, these diagonal arrangements, and the necessary adjustments to fill the spaces in order to fit the pattern to a straight line, are supposed to be the cause of the distinctive Celtic character, but the result, nevertheless, was merely an imitation of the Greek fret. Westwood, who preceded him, had less art knowledge but a greater vision. He described Celtic key patterns as "a series of diagonal lines, forming various kinds of Chinese-like patterns. These ornaments are generally introduced into small compartments, a number of which are arranged so as to form the large initial letters and borders, or tesselated pages, with which the finest manuscripts are decorated."

Some Chinese key patterns belonging to periods prior to B.C. 1000 are very similar to the Pictish key patterns. What is probably a reference to key patterns is in the Old Testament, 1st Kings, chapter 7, verse 31, in the description of the building of Solomon's House. This is dated B.C. 1005. "And also upon the mouth of it were gravings with their borders, four-square, not round." This qualification "not round" suggests that the reference in 2nd Kings, chapter 25, verse 17 (Solomon's Temple of the Lord) is to spirals as a more customary form of ornament. "And like unto these had the second pillar with wreathen work."

In the British Museum there is a much damaged Egyptian carving in ivory of a priest whose robe shows a key pattern panel and inter-lacings on its borders. It is dated at B.C. 3500—B.C. 3000.

The most interesting of all discoveries are those of the square and diagonal key patterns engraved on mammoth ivories in the Ukraine and Yugo-Slavia and dated by authorities as the period B.C. 20,000 to B.C. 15,000. Many of these are panelled like the key panels of the Ornamented stones of East Pictland, from Durham to Caithness, and also like those of the Books of Durrow, Kells, Lindisfarne, and other Early Celtic MSS.

An example of this great art of distant pre-history is shown in this text-book on Plate 14. It is from a pair of bracelets made of mammoth ivory, and the pattern is engraved. The unit of the design is a swastika with anti-clockwise motion. The interlocking swastikas are part of an all-over pattern, and it will serve to draw attention to the mathematical and geometrical knowledge and the engraving skill that was necessary.

A very small percentage of the inhabitants of the present-day civilised Europe could copy it without the instructions given on the plate, and fewer still could make a new design comparable with it. On Plate 13 of the spiral text-book the triskele unit of the spiral group in the centre of the cross of the Aberlemno Stone is also anti-clockwise and a portion of an all-over pattern. In both cases the symbols are magical and are probably charms to avert evil.

The Isle of Man Triskele symbol has suffered at the hands of a waggish invader, who added a foot to each of what looked to him like three legs. Later these legs and feet became encased in armour. This is on a par with those places having the Celtic name Reston or Restan that are on the top of a hill (being probably on the

site of a hill fort). The wags turned the name into Rest and (be thankful).

There are many examples of human figures, animals and birds arranged in triskele and swastika designs on Pictish stones and in Celtic MSS. On Plate 13 of the Studio publication of a number of the finest pages of the Book of Kells in colours, there are six circles with diameters of less than half an inch and each containing three men with a forearm of each forming the triskele. Each man has a leg thrown over his forearm, and he is complete with hair, topknot, beard and clothing.

Four of the circles have clockwise and two anti-clockwise motion.

The Pre-Columbus Central American key patterns used by the priests of the Maya religion to decorate the interiors and exteriors of their temples of cruciform (Greek cross) plan, as at Mitla, are·not carved or incised. They are designed so that the projections of the prepared stones or bricks produced the patterns, and the keys are both square and diagonal, resembling those of the Perthshire Pictish type named by Romilly Allen the " Tree key pattern." This special use of prepared stones or bricks by the Maya priests to produce key patterns in the building of their temples is proof that key patterns were long antecedent. The key patterns of the Pre-Columbus Central American, Mexican, and South American pottery that also contained the highly stylised spiral, animal, bird and human decorations have much that is comparable to Pictish art.

The first Spanish invaders of Central America were astonished to find in the Maya temples highly ornamented carvings of stone crosses that were held in the greatest reverence. The proportions of this type of cross are very similar to those of the Pictish cross-slab stones. The Maya priests were manuscript artists of great skill, who decorated their books profusely with colours. The religious intolerance of the Spanish priests led to the almost total destruction of this form of Maya art. The " Dresden " Maya MS. is one of the very few survivors of the fury that grew out of and obscured the simple teachings of Christ.

The manuscripts, records and chronicles of the early British and Pictish Christian churches suffered a somewhat similar destruction at the hands of the Augustine Church over the differences of dogma and over the use of the " Barbaric " native language instead of polished Latin in the writing of the Gospels. The manuscripts that survived were again greatly reduced in numbers by the Viking raids and, later, in the throes of the Reformation.

The connections between Scythian, Mycenaean, Cretan, Maltese and the British and Irish Celtic art cultures are very apparent in key and spiral patterns.

The labyrinth or maze and the meander symbols have both influenced the key patterns of the Pictish school of Celtic art. The labyrinth is to be found in the Books of Durrow, Kells, Lindisfarne, and probably in other early Celtic MSS. It is repeated four times on the X of the Christ name-page of the Book of Kells, and there is an excellent example of an ornamented stone with a labyrinth design in the National Museum, Dublin. The " classicists " will find difficulty in attributing Maya key patterns and other art symbols to Greek sources, though the connection between Egyptian, Greek, Roman, Maya, Chinese and Pictish key patterns becomes clearer when considered in juxtaposition with the B.C. 20,000—B.C. 15,000 Ukrainian and old Serbian key patterns. Viewed in this way, it will become apparent that key patterns and also spirals and interlacings, as represented by the fret, the Ionic spiral and the guilloche, are exotics in Greek art. They are invaders due to contact with migrating peoples.

From the first appearance of the Greek nationality that emerged from the union of the various tribes there does not appear to have been any religious prohibitions of the copying of created forms of life. The religions of many Asiatic races prohibited the copying of living things, " in the heavens, on the earth, or in the waters under the earth." The Pictish people appear to have been strictly forbidden to copy plants or any form of vegetation until the Christian era, and then it was used rarely and only symbolically until after the seventh century, when it commenced a decadence that finally destroyed the art. Before this period the plant which was used, with very few exceptions, emerged from a pot. The whole of its growth was continuous and it threw off branches that terminated in a horn or cornucopia to throw off other branches. It was sometimes developed into interlacings or knotwork with men, animals, reptiles, birds and occasionally fish. The leaves and fruits or berries resemble mistletoe more

than the "classical" vine, and the potted plant symbol is probably the "tree of life." Taken with the other symbols mentioned, it is apparent that they are the total of living things. Man, animal, bird, reptile, fish, insect and plant are all on the X Christ name-page of the Book of Kells. This plant or tree symbol of life emerging from a pot is to be found on some of the Pictish ornamented cross-slab stones, for example at Nigg, and occurs in the Book of Kells where its minuteness has hitherto hidden most of it. It is connected with Persian and Chinese-Turkestan art. In a fragment of Maya MS., the "Borgian Codex," two priests each hold an inverted pot from which emerges a plant with one long stem with numerous willow-like leaves and terminating in fruits or berries. Beneath the archway

thus formed is a small man, or his soul, undergoing an examination of a sort. There is a somewhat similar representation in Egyptian art.

The evidences available show that the key patterns of Britain and Ireland arrived many centuries before the Romans, and that the peoples who brought them made contacts in their migrations with the tribes that later became the makers of the Greek Empire.

"The Classicists," however, have another explanation, *i.e.* from a Greek source to Roman, to Byzantine, and then as a by-product of Early Byzantine Christian Art to the British and Irish Art to be distorted into the Celtic version of the Greek key pattern. The evidences that are now available do not uphold this view.

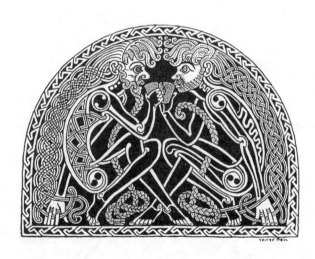

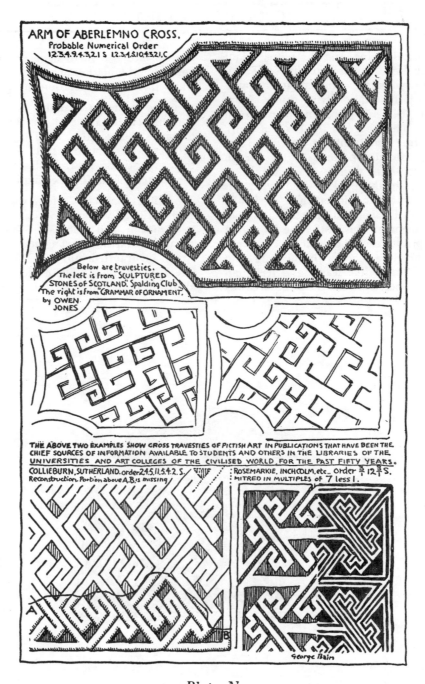

ARM OF ABERLEMNO CROSS.
Probable Numerical Order
1.2.3.4.9.4.3.2.1 S 1.2.3.4.5.10.4.3.2.1.C

Below are travesties.
The left is from "SCULPTURED
STONES of SCOTLAND". Spalding Club.
The right is from "GRAMMAR OF ORNAMENT".
by OWEN.
JONES

THE ABOVE TWO EXAMPLES SHOW CROSS TRAVESTIES OF PICTISH ART IN PUBLICATIONS THAT HAVE BEEN THE
CHIEF SOURCES OF INFORMATION AVAILABLE TO STUDENTS AND OTHERS IN THE LIBRARIES OF THE
UNIVERSITIES AND ART COLLEGES OF THE CIVILISED WORLD, FOR THE PAST FIFTY YEARS.

COLLIEBURN, SUTHERLAND. order 2.4.5.11.5.4.2. S.
Reconstruction. Portion above A.B. is missing

ROSEMARKIE, INCHCOLM, etc.. Order $\frac{3}{4}$ 12 $\frac{3}{4}$ S.
MITRED IN MULTIPLES of 7 less 1.

George Bain

Plate N

74

The Methods of Construction of Key Patterns of the Pictish School of Celtic Art.

The stages of the most elementary borders are shown below. Panels are made by variations of the unit.

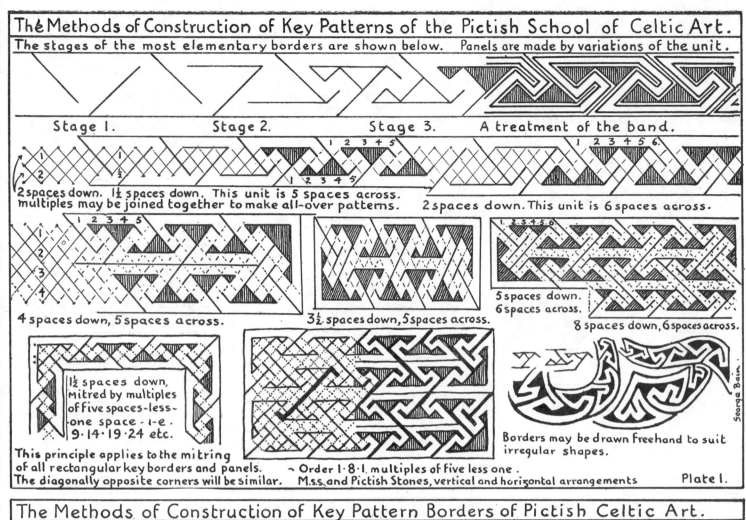

Stage 1. Stage 2. Stage 3. A treatment of the band.

2 spaces down. 1½ spaces down. This unit is 5 spaces across.
multiples may be joined together to make all-over patterns. 2 spaces down. This unit is 6 spaces across.

4 spaces down, 5 spaces across. 3½ spaces down, 5 spaces across. 5 spaces down. 6 spaces across.
8 spaces down, 6 spaces across.

1½ spaces down, mitred by multiples of five spaces-less-one space - i·e·9·14·19·24 etc.

This principle applies to the mitring of all rectangular key borders and panels. The diagonally opposite corners will be similar.

~ Order 1·8·1. multiples of five less one.
M.s.s. and Pictish Stones, vertical and horizontal arrangements

Borders may be drawn freehand to suit irregular shapes.

George Bain.

Plate 1.

The Methods of Construction of Key Pattern Borders of Pictish Celtic Art.

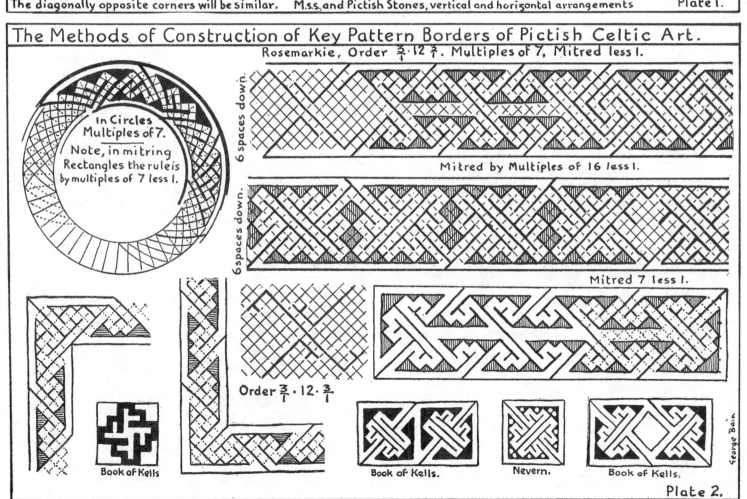

Rosemarkie, Order ⅗·12·⅞. Multiples of 7, Mitred less 1.

In Circles Multiples of 7.
Note, in mitring Rectangles the rule is by multiples of 7 less 1.

6 spaces down.

Mitred by Multiples of 16 less 1.

6 spaces down.

Mitred 7 less 1.

Order ⅗·12·⅗

Book of Kells

Book of Kells. Nevern. Book of Kells.

George Bain

Plate 2.

75

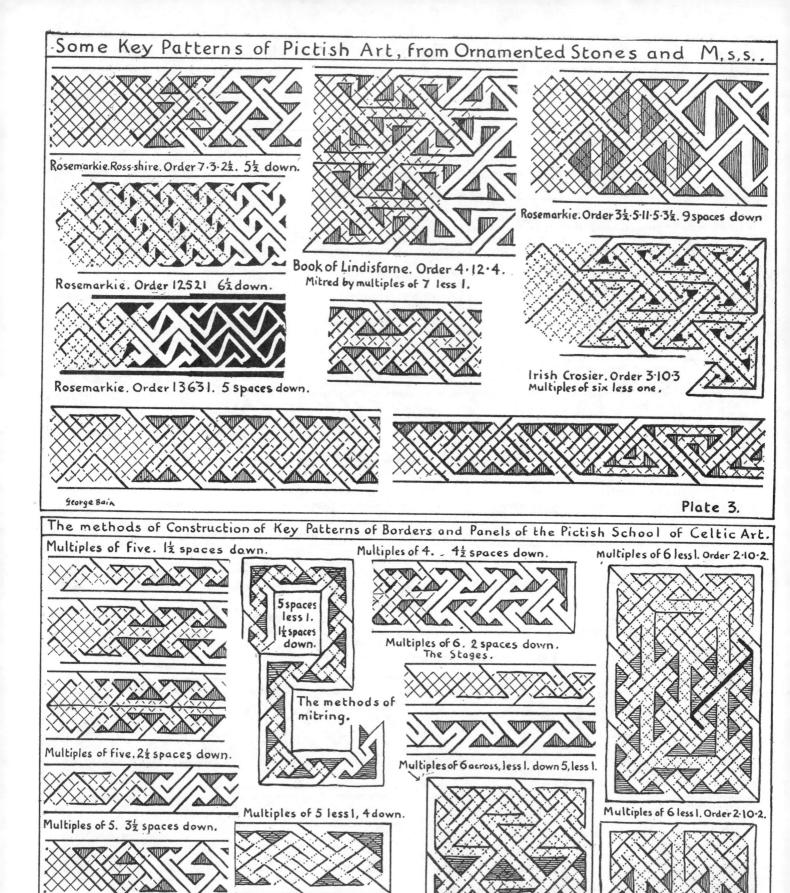

Some Key Patterns of Pictish Art, from Ornamented Stones and M.s.s..

Rosemarkie. Ross-shire. Order 7·3·2½. 5½ down.

Rosemarkie. Order 12521 6½ down.

Rosemarkie. Order 13631. 5 spaces down.

Book of Lindisfarne. Order 4·12·4.
Mitred by multiples of 7 less 1.

Rosemarkie. Order 3½·5·11·5·3½. 9 spaces down

Irish Crosier. Order 3·10·3
Multiples of six less one.

George Bain

Plate 3.

The methods of Construction of Key Patterns of Borders and Panels of the Pictish School of Celtic Art.

Multiples of Five. 1½ spaces down.

Multiples of five, 2½ spaces down.

Multiples of 5. 3½ spaces down.

Five. less 1. 4 down.

5 spaces less 1. 1½ spaces down.

The methods of mitring.

Multiples of 5 less 1, 4 down.

Multiples of 5. less 1. 4 down.

Multiples of 4. 4½ spaces down.

Multiples of 6. 2 spaces down.
The Stages.

Multiples of 6 across, less 1. down 5, less 1.

Multiples of 6 less 1. Order 2·10·2.

Multiples of 6 less 1. Order 2·10·2.

George Bain

Plate 4.

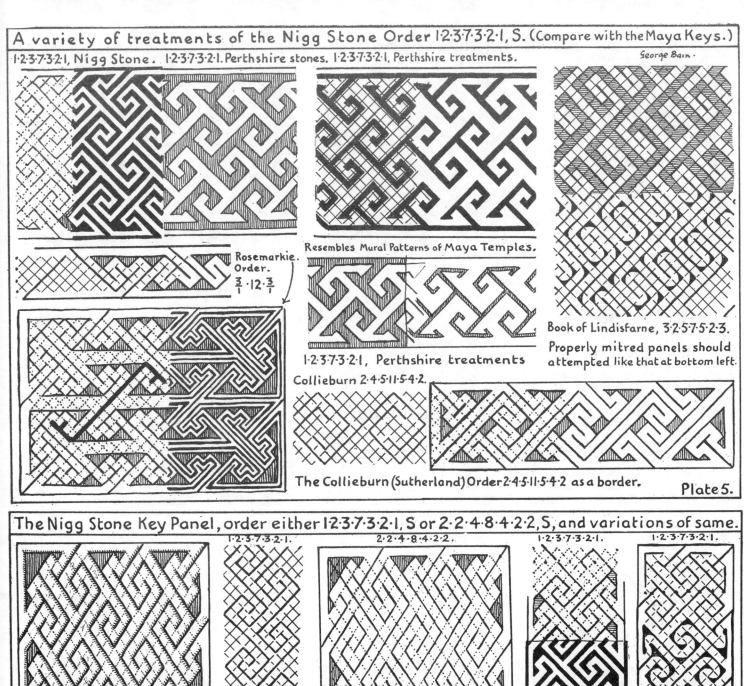

A variety of treatments of the Nigg Stone Order 1·2·3·7·3·2·1, S. (Compare with the Maya Keys.)

1·2·3·7·3·2·1, Nigg Stone. 1·2·3·7·3·2·1. Perthshire stones. 1·2·3·7·3·2·1, Perthshire treatments.

George Bain.

Rosemarkie. Order. 3/1 · 12 · 3/1

Resembles Mural Patterns of Maya Temples.

1·2·3·7·3·2·1, Perthshire treatments

Collieburn 2·4·5·11·5·4·2.

Book of Lindisfarne, 3·2·5·7·5·2·3.
Properly mitred panels should attempted like that at bottom left.

The Collieburn (Sutherland) Order 2·4·5·11·5·4·2 as a border.

Plate 5.

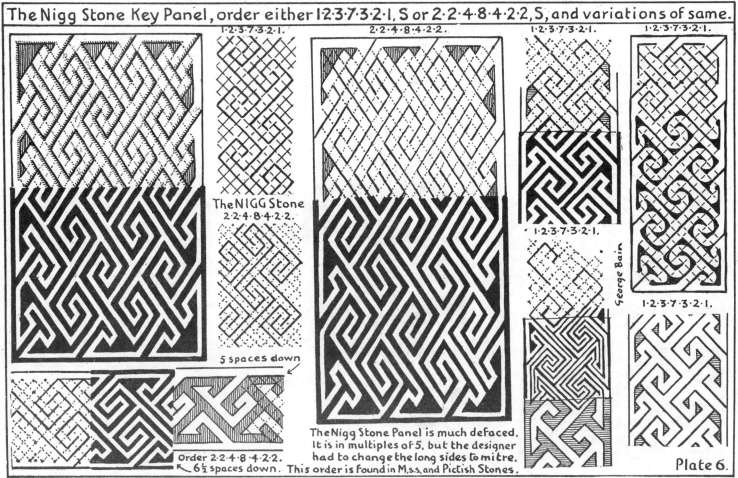

The Nigg Stone Key Panel, order either 1·2·3·7·3·2·1, S or 2·2·4·8·4·2·2, S, and variations of same.

1·2·3·7·3·2·1. 2·2·4·8·4·2·2. 1·2·3·7·3·2·1. 1·2·3·7·3·2·1.

The NIGG Stone
2·2·4·8·4·2·2.

5 spaces down

1·2·3·7·3·2·1.

George Bain

1·2·3·7·3·2·1.

Order 2·2·4·8·4·2·2.
6½ spaces down.

The Nigg Stone Panel is much defaced. It is in multiples of 5, but the designer had to change the long sides to mitre. This order is found in M.S.S. and Pictish Stones.

1·2·3·7·3·2·1.

Plate 6.

77

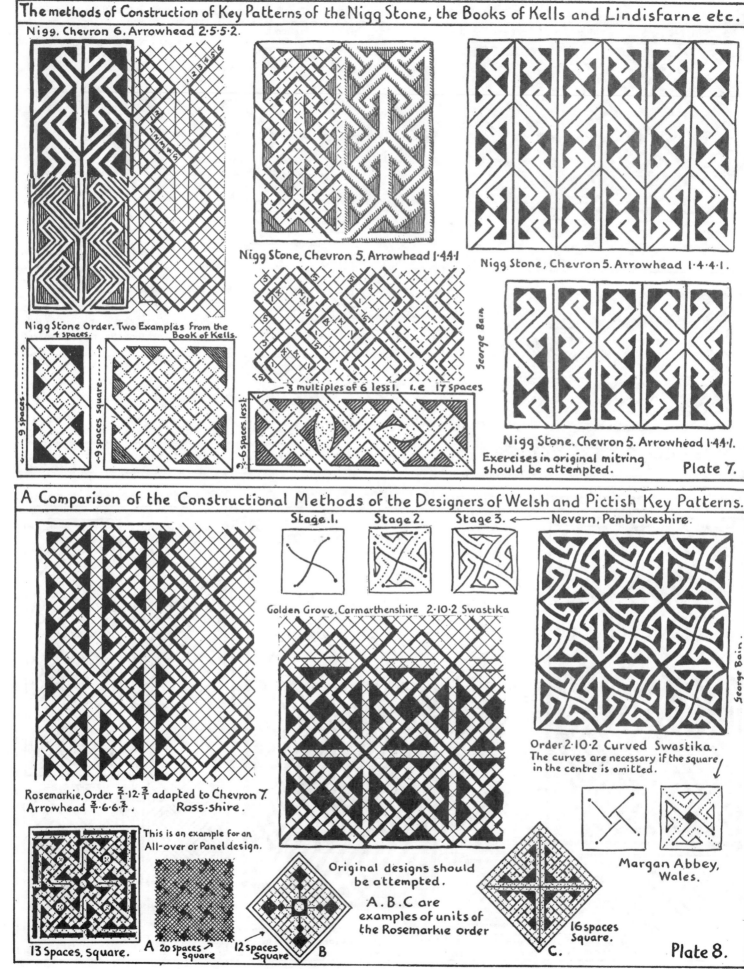

The methods of Construction of Key Patterns of the Nigg Stone, the Books of Kells and Lindisfarne etc.

Nigg. Chevron 6. Arrowhead 2·5·5·2.

Nigg Stone, Chevron 5. Arrowhead 1·4·4·1.

Nigg Stone, Chevron 5. Arrowhead 1·4·4·1.

Nigg Stone Order. Two Examples from the Book of Kells.
4 spaces.
9 spaces
9 spaces square
2·6 spaces less.

3 multiples of 6 less 1. i.e. 17 spaces

George Bain

Nigg Stone. Chevron 5. Arrowhead 1·4·4·1.
Exercises in original mitring should be attempted.

Plate 7.

A Comparison of the Constructional Methods of the Designers of Welsh and Pictish Key Patterns.

Stage 1. Stage 2. Stage 3. ⟵ Nevern, Pembrokeshire.

Golden Grove, Carmarthenshire 2·10·2 Swastika

George Bain

Rosemarkie. Order ⁷⁄₇·12·⁷⁄₇ adapted to Chevron 7.
Arrowhead ⁷⁄₇·6·6·⁷⁄₇. Ross·shire.

This is an example for an All-over or Panel design.

Order 2·10·2 Curved Swastika.
The curves are necessary if the square in the centre is omitted.

Margan Abbey, Wales.

Original designs should be attempted.

A. B. C are examples of units of the Rosemarkie order

13 Spaces, square. A 20 spaces square 12 spaces Square B

16 spaces square. C

Plate 8.

78

The Methods of Construction of Pictish Key Patterns.

Units of Top and Bottom, multiples of 7. Sides, multiples of 6. Notice the mitring.

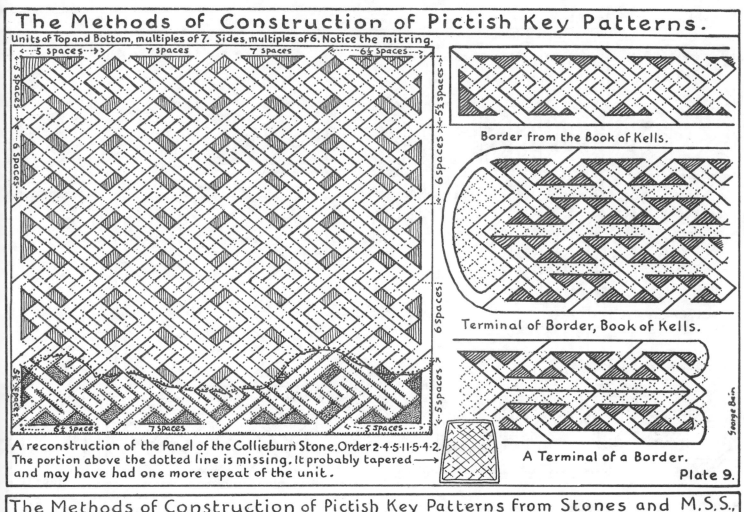

← 5 spaces → · · 7 spaces · · 7 spaces · · 6½ spaces

A reconstruction of the Panel of the Collieburn Stone. Order 2·4·5·11·5·4·2.
The portion above the dotted line is missing. It probably tapered
and may have had one more repeat of the unit.

Border from the Book of Kells.

Terminal of Border, Book of Kells.

A Terminal of a Border.

George Bain

Plate 9.

The Methods of Construction of Pictish Key Patterns from Stones and M.S.S.,

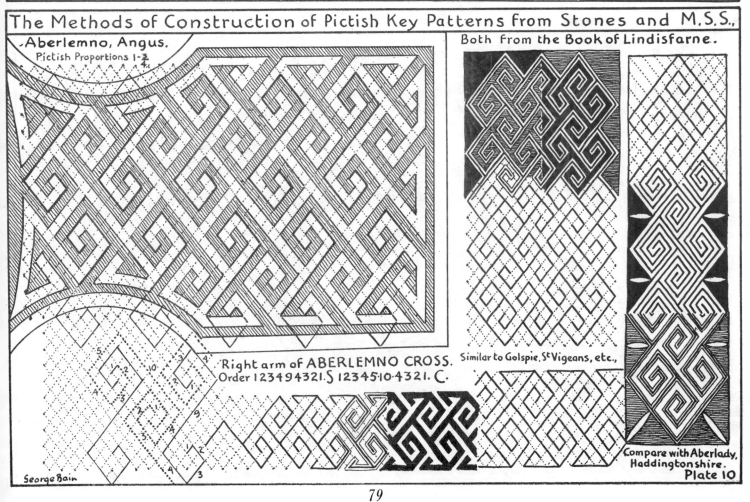

Aberlemno, Angus.
Pictish Proportions 1–3/4.

Right arm of ABERLEMNO CROSS.
Order 123494321. S 1234510·4321. C.

Both from the Book of Lindisfarne.

Similar to Golspie, St Vigeans, etc.,

Compare with Aberlady,
Haddingtonshire.

George Bain

Plate 10.

79

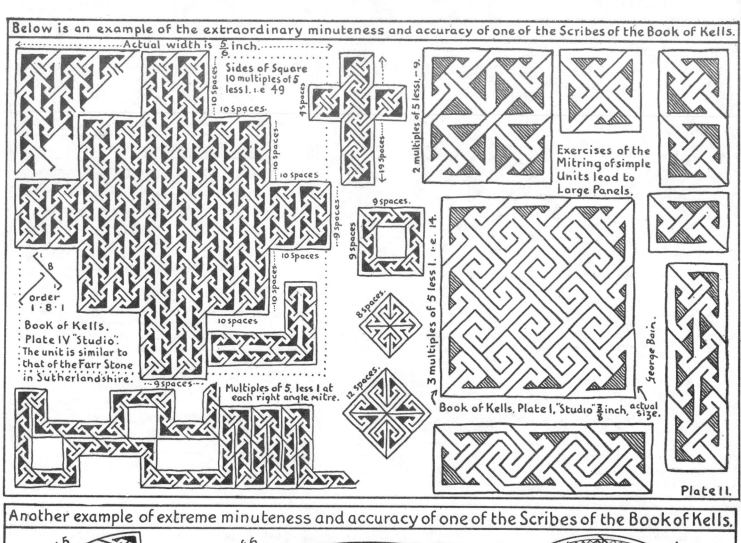

Below is an example of the extraordinary minuteness and accuracy of one of the Scribes of the Book of Kells.

Actual width is 5/6 inch.

Sides of Square 10 multiples of 5 less 1. i.e 49

10 spaces.
10 spaces
10 spaces
10 spaces
10 spaces
9 spaces
9 spaces
9 spaces
9 spaces
8 spaces.
8 spaces
12 spaces.
19 spaces.
2 multiples of 5 less 1. — 9.

order 1·8·1

Book of Kells. Plate IV "Studio". The unit is similar to that of the Farr Stone in Sutherlandshire.

Multiples of 5. less 1 at each right angle mitre.

Exercises of the Mitring of simple Units lead to Large Panels.

3 multiples of 5 less 1. i.e. 14.

George Bain.

Book of Kells, Plate I. "Studio" 3/8 inch, actual size.

Plate 11.

Another example of extreme minuteness and accuracy of one of the Scribes of the Book of Kells.

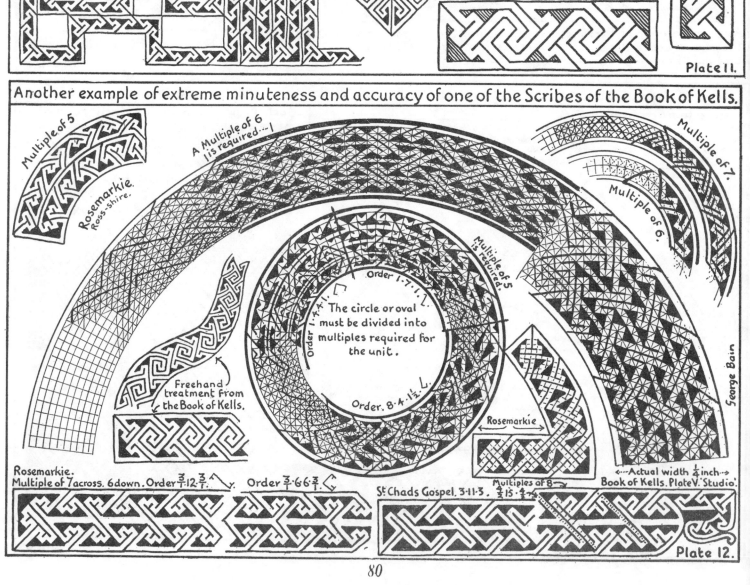

Multiple of 5
Rosemarkie. Ross-shire.

A Multiple of 6 1 is required

Multiple of 7.
Multiple of 6.

Multiple of 5 is required.

Order 1·7·1. ⌐

Order 1·4·4·1. ⌐

The circle or oval must be divided into multiples required for the unit.

Order. 8·4·1½. ⌐

Freehand treatment from the Book of Kells.

Rosemarkie

George Bain

Rosemarkie. Multiple of 7 across. 6 down. Order 3/1·12·3/1 ↱ y. Order 3/1·6·6·3/1 ⌐ St Chads Gospel. 3·11·3. 4/1·15·4·1/4

Multiples of 8

Actual width 1/4 inch. Book of Kells. Plate V. "Studio".

Plate 12.

80

The application of the Methods of Construction of Pictish Key Patterns to Panels.

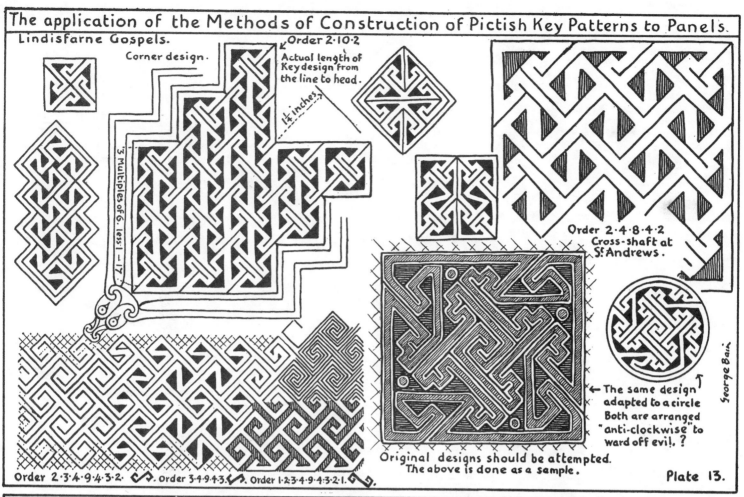

Lindisfarne Gospels.

Corner design.

Order 2·10·2
Actual length of Key design from the line to head.

1¼ inches.

"3 multiples of 6, less 1 = 17.

Order 2·4·8·4·2
Cross-shaft at St. Andrews.

← The same design adapted to a circle. Both are arranged "anti-clockwise" to ward off evil. ?

Original designs should be attempted. The above is done as a sample.

George Bain

Order 2·3·4·9·4·3·2. Order 3·4·9·4·3. Order 1·2·3·4·9·4·3·2·1.

Plate 13.

The methods of Construction of Pictish and other Key Patterns by George Bain.

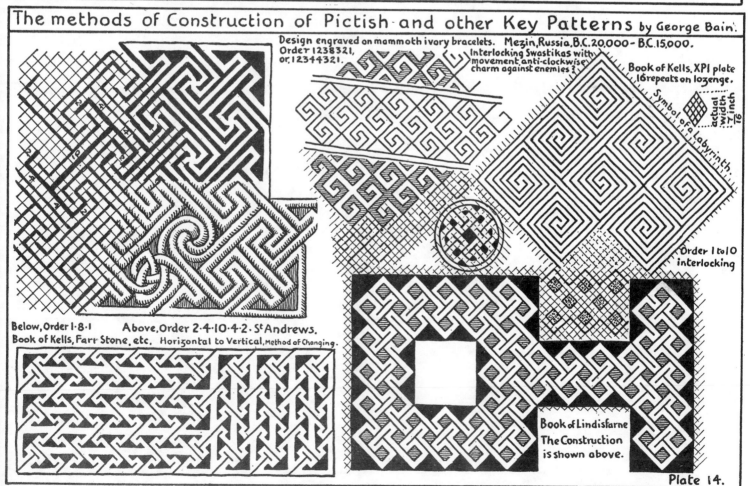

Design engraved on mammoth ivory bracelets. Mezin, Russia, B.C. 20,000 - B.C. 15,000.
Order 1238321, or, 12344321.

Interlocking Swastikas with movement anti-clockwise charm against enemies?

Book of Kells. XPI plate. 16 repeats on lozenge.

Symbol of a labyrinth.

actual width 7/16 inch.

Order 1 to 10 interlocking

Below, Order 1·8·1 Above, Order 2·4·10·4·2. St. Andrews.
Book of Kells, Farr Stone, etc. Horizontal to Vertical, Method of Changing.

Book of Lindisfarne The Construction is shown above.

Plate 14.

Adapted from Russian Peasant work by George Bain.

Lettering

THE work of an artist-observer, who has little or no knowledge of ancient languages, may be a very useful aid to research into the written words of Celtic ornamented manuscripts. By a diligent sorting out of the varieties of treatments and the uses of letters, freed from their embellishments, much may be arranged to simplify the work of the language expert. If the artist-observer has in his possession a few examples of the alphabets of the principal ancient languages of the Eastern Mediterranean that preceded the ancient Greek and Latin alphabets, it will not be difficult to find a system of tabulating the results of his works, and if it happens to be in a known language, a language expert will do the rest. A few examples are on Plate 14.

In every publication known to the author that deals with the page of the opening words of the Gospel of St. John in the Book of Kells the language experts have given " In principio erat verbum et verbum," which is a wrong reading. Because of their knowledge from other versions of these opening words they were contented with an unfinished sentence as the theme for the decoration of a whole page of the Book of Kells. The Rev. Stanford F. H. Robinson, M.A., gave it up after the first part " In principio erat verbum," The artist-observer, with some knowledge of letter shapes, but only the vaguest boyhood Latin, is able to show that the sentence is a complete one and that the letters are " In principio erat verbum verum." " In the beginning was the true word."

Another interesting example shown on the same plate is the unornamented inscription on the Newton Pillar Stone, Garioch, Aberdeenshire. It is in an unknown language, but most of its letters appear to be similar to Phoenician or Early Greek. It has also an inscription in Ogam letters, and by this it probably resembles the " Rosetta Stone." Unfortunately the Ogam letters are much defaced, and all photographs and drawings examined by the author show that it is extremely difficult to make a correct reading of the Ogam inscription. Shepherds appear to have noticed the inscriptions on it and to have called attention to them in 1803. There have been numerous attempts during the past century, and no two readings have any similarity.

The artist-observer who is unbiassed by a knowledge of ancient languages can sort out the letters to give an interesting and unexpected result connected with the entry of Christianity into North Britain. In the middle of the main inscription the Greek letters for " Christ," a variation of the monogram X.P.I. probably " Christis " or " Chrestus," an ancient mutilated spelling, are followed by the Greek letters for " Jesus " I.H.S.S., and then immediately by the Greek word " LOGOU," " of the word."

The circumstances of these letters appearing together supports this interpretation even in an unknown language, for such words would undergo little change on entering any language. Following these words, but with less certainty, is either " Sot-r " (Soter) Saviour or " Pat-r " (Father). Further support of the correctness of this reading is found in the Ogam inscription. Although it is much defaced, yet, if it is read from the right to the left in the Celtic Ogam manner, which in this case means commencing under the other inscription and reading downwards and bending upwards to the left to the height of the top of the other inscription, then the letters IEASOISE are followed by X on the stemline, which is unusual in Ogam. Assuming this to be the X Greek CHI, or merely the X symbol of Christ's name as in Xmas, the next letter is R or I. This circumstance added to those of the other inscription goes to strengthen the suggestion that the Ogam also refers to " Jesus Christ " whatever the language may be. I am of the opinion that when these inscriptions are fully deciphered they will be found to be dedicated to a " Servant of the word of Jesus Christ, the Son of God, the Saviour." The evidences shown may give some enlightenment regarding the Pre-Ninian Christianity of East Scotland, and particularly to " the Scots who believed in Christ." They had presbyters and ecclesiastics until Palladius was sent from Rome in 420 A.D. to be their first bishop (Bede).

The other inscription shown on Plate 14, that of the St. Vigeans Stone, Angus, is mostly in the Celtic letters used in the Book of Durrow, 4th to 6th century. The contraction of the letter A (derived from the Phoenician), as used in that book and those of Kells and Lindisfarne, appears in RA of the word VORAET. In this text-book on Celtic Letters numerous survivals of Phoenician and Early Greek letters are shown from the Books of Durrow, Kells and Lindisfarne. The appearance of Greek letters on this and on other Celtic inscribed and ornamented stones is not unusual. The first two lines are

purely Celtic letters of 4th to 6th century " DROSTEN: · IPE VORAET," and the author has given what he can decipher from it on Plate 14.

The reason of the mystical use of the fish to symbolise Christianity is that the first letters of the words " Jesus Christ, Son of God, Saviour " in the Greek language are the letters of the Greek word for a " Fish." The salmon (or the sturgeon) in the Celtic pagan periods is the symbol of all knowledge past and future. The " Bracket " symbol, also shown on Plate 14, was used by the Celtic scribe in the same way that a modern letter-writer, when cramped for space, adds a bracket in the available space above the line and completes the sentence there. The scribe appears to have roughly drafted out his page arrangement by making space allowances for the lengths of the sentences. He then designed and completed the initial letters on the left of the page, and when he failed to complete the sentence in the allotted line he placed the bracket symbol after the full stop of the sentence above, preceded it by the cross symbol placed over the full stop and added the remainder of the sentence, usually commencing at part of a word. This is to be seen on Plate III of the Studio publication of some of the best pages of the Book of Kells. In one of these examples an excellent decorative drawing of the fighting dog of the ancient Britons is placed between the cross symbol and the bracket symbol. The Irish authorities name this bracket the " Head under the wing " or " Turn under the path " symbol. It seems to have originated in the Altaic symbol " Pak," which signifies " Above," " the Firmament," " Supreme," etc. When placed over the symbol of a " King " it means " King of Kings " in Hittite cuneiform letters. It is also similar in outline to an old form of the Greek B.

Many of the Celtic letters are derived direct from the Phoenician and Early Greek alphabets and are to be found by the side of Roman letters in the Books of Durrow, Kells and Lindisfarne. The Phoenician or Egyptian M is used when it is the last letter in a line if the space is scanty. A good example of this is on the page of St. Luke's Gospel, Chapter I, Book of Durrow, with the large letters QUONIAM. The same use is made of the Phoenician N. The Greek D Delta and the Greek small d are the basic forms of the Celtic D. The Celtic capital A and its Celtic contraction are derived from the Phoenician A. The Greek O, small letter, omega, which resembles the W in script, is seen on the page of the opening words of the Gospel of St. Luke, QUONIAM, Plate XIV, Studio Book of Kells. The gradation from

the larger decorated capital letters on the left of the page to the small script on the right is rarely abrupt. The second letter, which is smaller, usually has some ornamentation. The third letter is still smaller and with less decoration, and then the ordinary script follows. In the Celtic languages of Britain and Ireland K and W are not used. The author has added them in forms to be in keeping with the others. K does not appear in Anglo-Saxon letter until about the 12th century. Selected letters from the works of the various scribes of the Book of Kells to form a complete alphabet are shown on Plate 1. They will justify to the Celtic scribes a prominent place in the front rank of lettering artists of any period or nation. It is with great misgivings that the author tampers with such beauty to attempt to give a suggested modification for modern uses on the same plate. This differs mainly in the G and Y.

No other treatment can compete with the Celtic G of the 4th to 6th century for its sheer beauty of form, and the suggested modernising of it only makes it more readable on first sight. With such an alphabet to be obtained from the Book of Kells, it is a wonder that the enthusiasts of Eire searched for the grotesque in their endeavour to revive this Celtic culture.

Evidences that the Phoenician and other Eastern cultures influenced British cultures many centuries before the invasions by the Romans are to be found in every form of Early British art, and it is not surprising to find similar evidences in the Celtic ornamented stones and the Celtic manuscripts of the Early Christian period. The author is indebted to his friend, Henry I. Cunningham, M.A., Exhibitioner of Christ Church, Oxford, for his part as ancient language expert to his artist-observer activities, and he leaves it to the readers to assess the results.

A book in Celtic script type, printed by Ebhlin Everingham in London 1711, came into the author's possession recently. In it are a few letters and contractions of letters hitherto unknown to him. Plate 15 shows its contents; capitals, smalls, contractions, numbers, etc. A reproduction of one of its pages, with some of its capitals, all of the smalls and most of the contractions, shows the beauty of such Celtic letters when put to their real uses on the printed page. Sentences show no gaps, and although the letters and the spaces between words are of varying widths, yet the pattern produced is a flat tone with an interesting effect even to the uninitiated. The first capital A, which is used specially to commence paragraphs, is similar to the German 16th century capital A. The second

capital A which is derived from the early Celtic MSS., is used to commence sentences. The capital M partly resembles the first capital A and may be derived from the German 16th century M which it partly resembles. Comparisons with the Phoenician A show its affinity to parts of the Celtic contractions for Air, ea and ao. The contraction for UI is probably the Greek capital upsilon u and i. The seven-like symbol used as a contraction for " agus " or " and " has a resemblance to the Greek Tau, middle T. The author does not know why it should be selected to act as an ampersand. There is probably some other simple explanation that he is unable to give.

Professor MacAlister in his " Secret Languages of Ireland " says " Thus it comes about that these letters are provided with vowel or dipthong values in the M.S. tradition and their true but unnecessary consonant values are forgotten ".

He also says, " after Caesar's time the Druids abandoned the Greek for the dominant Roman letters. All bilingual Ogham inscriptions are accompanied by Roman, never by Greek letters and no trace suggesting the continuance of Greek letters appears to have survived." There are examples on the various plates of Celtic letters in this book, from Celtic MSS. written in Latin and on the Newton Stone, in Greek and Ogham, plate 14, confuting Professor MacAlister's last statement.

Comparisons of Celtic letters, 4th to 6th Century will show that A, D, M, N, etc. are derived from Phoenician and Early Greek. One M form is from Egyptian. The Greek O, omega is used on the page of the opening word " Quoniam " St. Luke's Gospel, Book of Kells. The scribe has hidden it from vulgar prying eyes, " Quo " fills more than half of the page, and " NIAM " forms the decorative structure that shows the Samaritan woman offering Christ water from a goblet, as described on page 102.

The Hebrew letter VAU, which resembles the number SEVEN, is sometimes used in Hebrew for AND. This is probably the reason for its use in the later Irish Gaelic religious MSS.

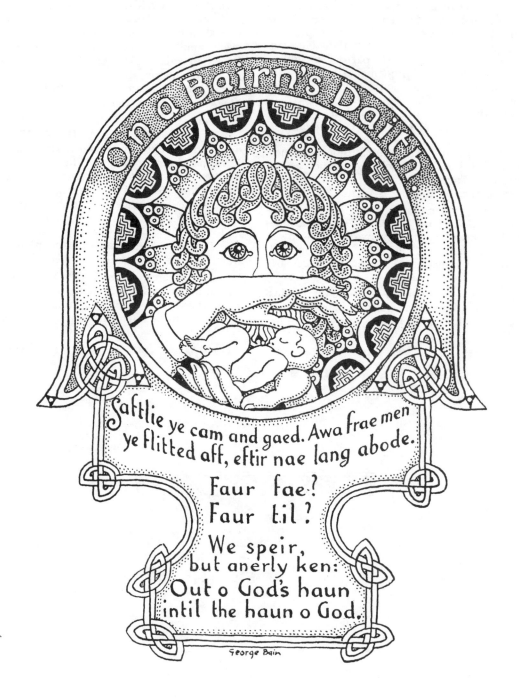

On a Bairn's Daith.

Saftlie ye cam and gaed. Awa frae men
ye flitted aff, eftir nae lang abode.

Faur fae?
Faur til?

We speir,
but anerly ken:
Out o God's haun
intil the haun o God.

George Bain

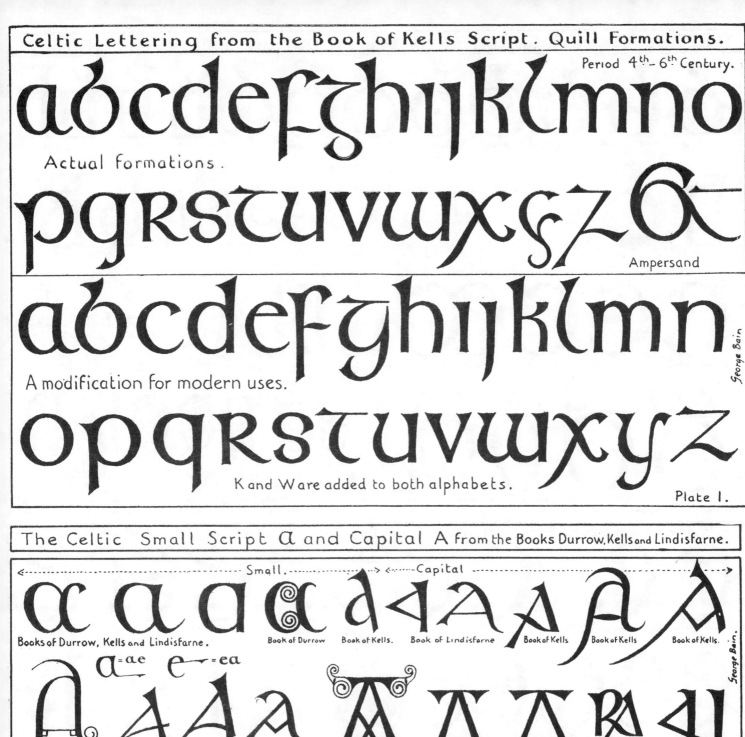

Celtic Lettering from the Book of Kells Script. Quill Formations.

Period 4th–6th Century.

abcdefghijklmno

Actual formations.

pqrstuvwxyz &

Ampersand

abcdefghijklmn

A modification for modern uses.

George Bain

opqrstuvwxyz

K and W are added to both alphabets.

Plate I.

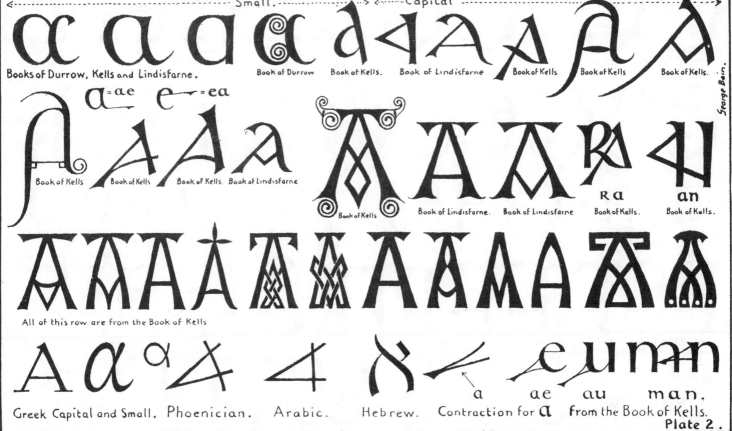

The Celtic Small Script α and Capital A from the Books Durrow, Kells and Lindisfarne.

← — — — Small. — — — → ← — Capital — — — — — — →

Books of Durrow, Kells and Lindisfarne. Book of Durrow Book of Kells. Book of Lindisfarne Book of Kells Book of Kells Book of Kells.

George Bain.

a = ae e = ea

Book of Kells Book of Kells Book of Kells. Book of Lindisfarne Book of Kells Book of Lindisfarne. Book of Lindisfarne. Book of Kells. Book of Kells.

Ra an

All of this row are from the Book of Kells

a ae au man.

Greek Capital and Small. Phoenician. Arabic. Hebrew. Contraction for a From the Book of Kells.

Plate 2.

89

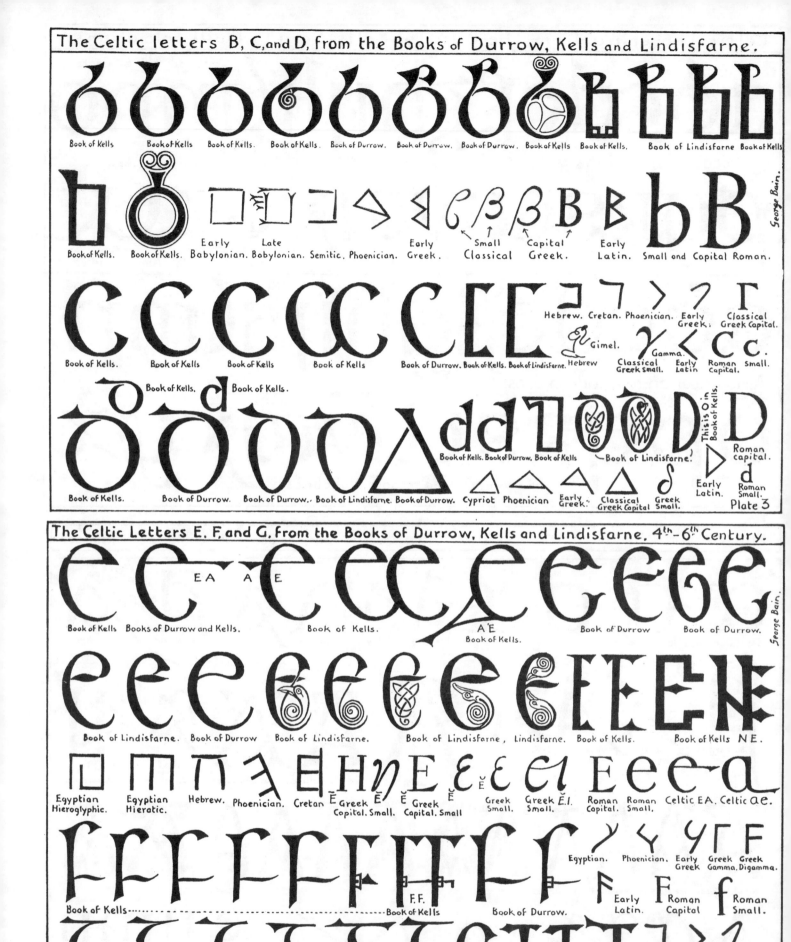

The Celtic letters B, C, and D, from the Books of Durrow, Kells and Lindisfarne.

George Bain

Book of Kells | Book of Kells | Book of Kells. | Book of Kells. | Book of Durrow. | Book of Durrow. | Book of Durrow. | Book of Kells. | Book of Kells. | Book of Lindisfarne | Book of Kells

Book of Kells. | Book of Kells. | Early Babylonian. | Late Babylonian. | Semitic. | Phoenician. | Early Greek. | Small Classical | Capital Greek. | Early Latin. | Small and Capital Roman.

Book of Kells. | Book of Kells. | Book of Kells. | Book of Kells | Book of Durrow. | Book of Kells. | Book of Lindisfarne. | Hebrew. | Cretan. | Phoenician. | Early Greek. | Classical Greek Capital.

Gimel. Hebrew | Gamma. Classical Greek small. | Early Latin | Roman Capital | Cc. Small.

Book of Kells. | Book of Kells.

Book of Kells. | Book of Durrow. | Book of Durrow. | Book of Lindisfarne. | Book of Durrow. | Cypriot | Phoenician | Early Greek. | Classical Greek Capital. | Greek Small. | Early Latin | Roman Small. | Roman capital.

Book of Kells. Book of Durrow. Book of Kells | Book of Lindisfarne. | This is O in Book of Kells.

Plate 3

The Celtic Letters E, F, and G, from the Books of Durrow, Kells and Lindisfarne, 4th–6th Century.

George Bain

Book of Kells | Books of Durrow and Kells. | EA | A | E | Book of Kells. | AE Book of Kells. | Book of Durrow | Book of Durrow.

Book of Lindisfarne. | Book of Durrow | Book of Lindisfarne. | Book of Lindisfarne. | Lindisfarne. | Book of Kells. | Book of Kells | N.E.

Egyptian Hieroglyphic. | Egyptian Hieratic. | Hebrew. | Phoenician. | Cretan | Ē Greek Capital. Small. | Ē Greek Capital. Small. | Greek Small. | Greek Small. | Ēl. Roman Capital. | Roman Small. | Celtic EA. | Celtic æ.

Book of Kells | F.F. Book of Kells | Book of Durrow. | Egyptian. | Phoenician. | Early Greek | Greek Gamma. | Greek Digamma. | Early Latin | Roman Capital | Roman Small.

Book of Kells. | Book of Kells. | Book of Durrow. | Book of Lindisfarne. | Book of Kells. | Kells. | Cretan. | Phoenician. | Early Greek. | Greek Capital. | Greek Small. | Similar to C.

Plate 4.

90

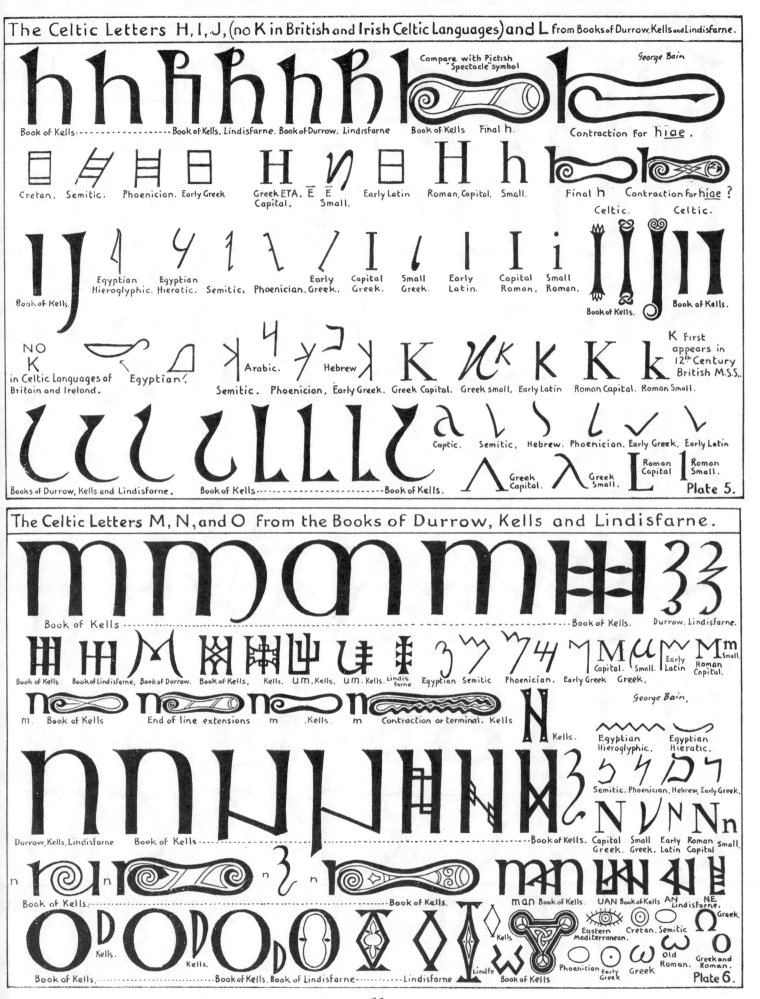

The Celtic Letters H, I, J, (no K in British and Irish Celtic Languages) and L from Books of Durrow, Kells and Lindisfarne.

George Bain

Book of Kells ---------- Book of Kells. Lindisfarne. Book of Durrow. Lindisfarne. Book of Kells. Final h. Compare with Pictish "Spectacle" symbol. Contraction for hiae.

Cretan. Semitic. Phoenician. Early Greek. Greek ETA. Ē Ē Capital. Small. Early Latin. Roman, Capital. Small. Final h. Contraction for hiae?

Book of Kells. Egyptian Hieroglyphic. Egyptian Hieratic. Semitic. Phoenician. Early Greek. Capital Greek. Small Greek. Early Latin. Capital Roman. Small Roman. Book of Kells. Celtic. Celtic. Book of Kells.

NO K in Celtic Languages of Britain and Ireland. Egyptian? Semitic. Phoenician. Early Greek. Greek Capital. Greek small. Early Latin. Roman Capital. Roman Small. K First appears in 12th Century British M.S.S.

Arabic. Hebrew.

Books of Durrow, Kells and Lindisfarne. Book of Kells ---------- Book of Kells. Coptic. Semitic. Hebrew. Phoenician. Early Greek. Early Latin. Greek Capital. Greek Small. L Roman Capital. l Roman Small.

Plate 5.

The Celtic Letters M, N, and O from the Books of Durrow, Kells and Lindisfarne.

Book of Kells ---------- Book of Kells. Durrow. Lindisfarne.

Book of Kells. Book of Lindisfarne, Book of Durrow. Book of Kells. Kells. UM. Kells. UM. Kells. Lindisfarne. Egyptian. Semitic. Phoenician. Early Greek. Greek. Capital. Small. Early Latin. Mm Small. Roman Capital.

m. Book of Kells. End of line extensions. m .Kells. m Contraction or terminal. Kells. Kells. George Bain.

Egyptian Hieroglyphic. Egyptian Hieratic.

Semitic. Phoenician. Hebrew. Early Greek.

Durrow, Kells, Lindisfarne. Book of Kells ---------- Book of Kells. Capital Greek. Small Greek. Early Latin. Roman Capital. N n small.

Book of Kells ---------- Book of Kells. man Book of Kells. UAN Book of Kells. AN Lindisfarne. NE Lindisfarne.

Kells. Eastern Mediterranean. Cretan. Semitic. Greek.

Book of Kells. Book of Kells. Book of Lindisfarne. Lindisfarne. Lindfe. Book of Kells. Phoenician. Early Greek. Greek. Old Roman. Greek and Roman.

Plate 6.

91

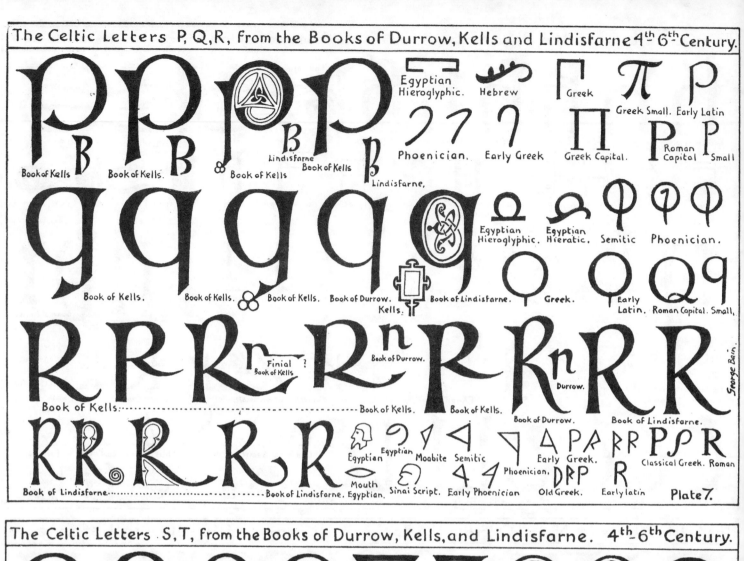

Plate 7.

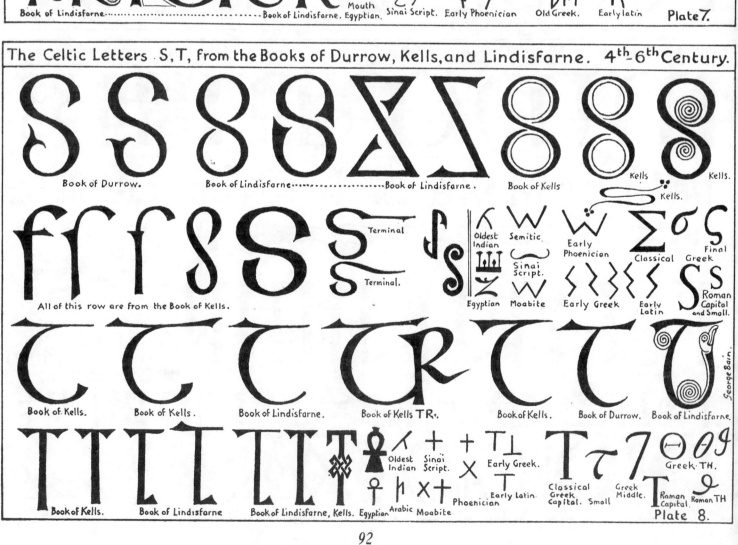

Plate 8.

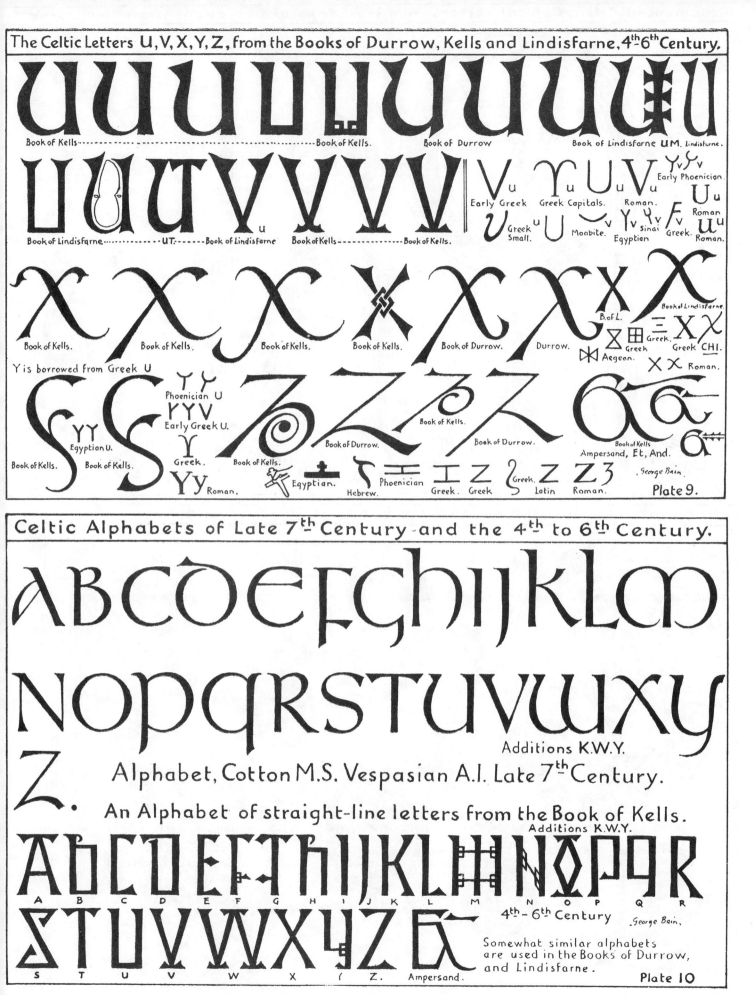

Book of Kells Book of Kells. Book of Durrow Book of Lindisfarne UM. Lindisfarne.

Book of Lindisfarne UT. Book of Lindisfarne Book of Kells Book of Kells.

Vu Early Greek Yu Greek Capitals. Uu Roman. YvV Early Phoenician Uu Roman
Uv Greek Small. uU Moabite. YvYv Sinai Egyptian FV Greek. uu Roman.

Book of Kells. Book of Kells. Book of Kells. Book of Kells. Book of Durrow. Durrow. B. of L. Book of Lindisfarne

Greek Greek CHI. Greek Aegean XX Roman.

Y is borrowed from Greek U

Phoenician U
Early Greek U.
Egyptian U. Greek.
Book of Kells. Book of Kells. Book of Kells. Yy Roman.

Book of Durrow. Book of Kells. Book of Durrow. Book of Kells Ampersand, Et, And.

Egyptian. Hebrew. Phoenician Greek. Greek Greek. Latin Roman.

George Bain

Plate 9.

ABCDEFGHIJKLM
NOPQRSTUVWXY
Z.

Additions K.W.Y.

Alphabet, Cotton M.S. Vespasian A.I. Late 7th Century.

An Alphabet of straight-line letters from the Book of Kells.
Additions K.W.Y.

ABCDEFGHIJKLMNOPQR
A B C D E F G H I J K L M N O P Q R

STUVWXYZE
S T U V W X Y Z. Ampersand.

4th-6th Century

George Bain.

Somewhat similar alphabets
are used in the Books of Durrow,
and Lindisfarne.

Plate 10

93

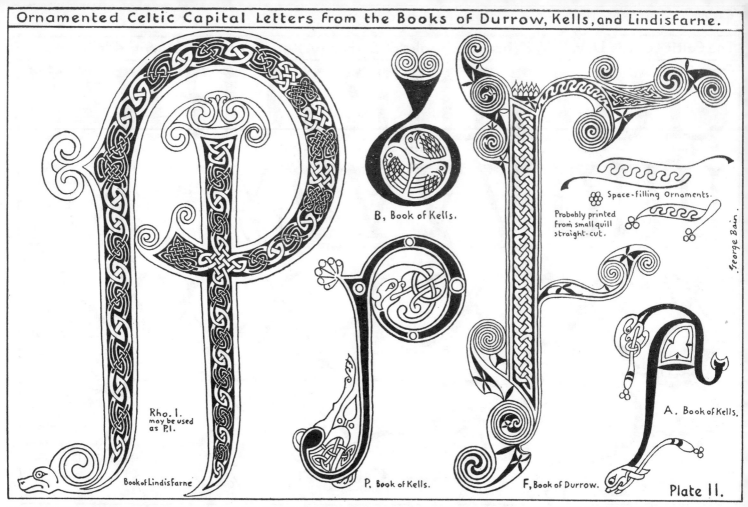

Rho. 1.
may be used
as P.1.

Book of Lindisfarne

B, Book of Kells.

Space-filling Ornaments.

Probably printed
from small quill
straight-cut.

George Bain

P, Book of Kells.

F, Book of Durrow.

A, Book of Kells.

Plate 11.

Ornamented Celtic Capitals from the Books of Durrow and Kells.

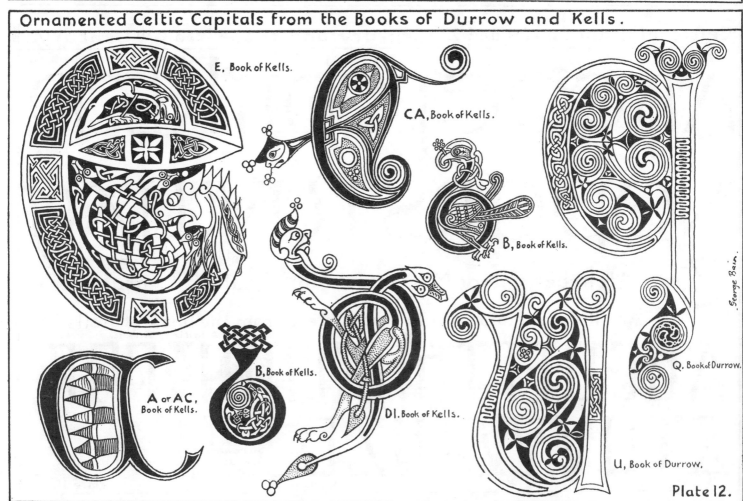

E, Book of Kells.

CA, Book of Kells.

B, Book of Kells.

A or AC,
Book of Kells.

B, Book of Kells.

DI, Book of Kells.

Q, Book of Durrow.

U, Book of Durrow.

George Bain

Plate 12.

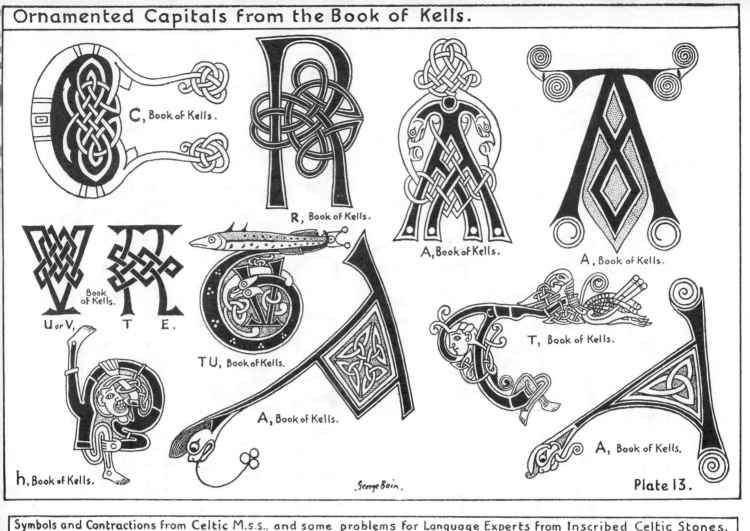

C, Book of Kells.

R, Book of Kells.

A, Book of Kells.

A, Book of Kells.

U or V, Book of Kells.

T E.

TU, Book of Kells.

A, Book of Kells.

T, Book of Kells.

A, Book of Kells.

h, Book of Kells.

.George Bain.

Plate 13.

Symbols and Contractions from Celtic M.S.S., and some problems for Language Experts from Inscribed Celtic Stones.

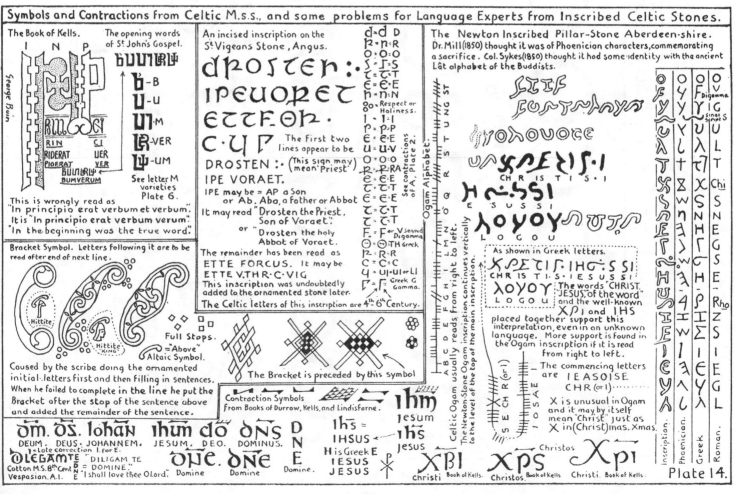

The Book of Kells.

George Bain

This is wrongly read as "In principio erat verbum et verbum." It is "In principio erat verbum verum." "In the beginning was the true word".

RIN — CI
RIDERAT — UER
PIOERAT — VER
BUMVERU
BUMVERUM

The opening words of St John's Gospel.

ʰ - B
ʰ - U
ᶆ - M
ᵐᵃ - VER
ᶆ - UM

See letter M varieties Plate 6.

Bracket Symbol. Letters following it are to be read after end of next line.

Hittite
Hittite King

Full Stops.
="Above". Altaic Symbol.

Caused by the scribe doing the ornamented initial letters first and then filling in sentences. When he failed to complete it in the line he put the Bracket after the stop of the sentence above and added the remainder of the sentence.

The Bracket is preceded by this symbol

Contraction Symbols from Books of Durrow, Kells, and Lindisfarne.

An incised inscription on the St Vigeans Stone, Angus.

DROSTEN :.
IPEUORET
ETTFOR.
CUP

The first two lines appear to be

DROSTEN :· (This sign may mean "Priest")
IPE VORAET.

IPE may be = AP a Son or Ab, Aba, a father or Abbot

It may read "Drosten the Priest, Son of Voraet." or "Drosten the holy Abbot of Voraet."

The remainder has been read as
ETTE FORCUS. It may be
ETTE V.THR.C.VIG
This inscription was undoubtedly added to the ornamented stone later.
The Celtic letters of this inscription are 4ᵗʰ-6ᵗʰ Century.

ᵈ=ᵈ D
ʀ=ⁿ·R
ᵒ=ᵒ:O
ꟲ=ꟲ·S
ꞇ=ꞇ·T·S
ꞓ=ꞓ·E
ʰ=ⁿ·N
∞=Respect or Holiness
I=I·I
ᵖ=ᵖ:P
ᵉ=ᵉ:E
ᵘ=ᵘ·U·V
ᵒ=ᵒ:O
ᵣ=ᵣ:P·RA
ꞓ=ꞓ·E
ꞇ=ꞇ·T
ꞓ=ꞓ·E
ꞇ=ꞇ·T
F.=F or V sound Digamma
Θ=Θ:TH Greek
ʀ=R·R
ᴄ=ᴄ·C
ꟷ=UI·UI or LI
Ꞇ=Ꞇ Greek G Gamma.

See contractions of A, Plate 2.

The Newton Inscribed Pillar-Stone Aberdeen-shire.
Dr. Mill (1850) thought it was of Phoenician characters, commemorating a sacrifice. Col. Sykes (1850) thought it had some identity with the ancient Lāt alphabet of the Buddists.

CHRISTIS·I
E·SUSSI
LOGOU

As shown in Greek letters.

ΧΡΕΤΙΣ·ΙΗΣ·ΣΣΙ
CHRISTIS·IESUSSI
ΛΟΓΟΥ
LOGOU

The words "CHRIST JESUS, of the word" and the well-known ΧΡΙ and IHS placed together support this interpretation, even in an unknown language. More support is found in the Ogam inscription if it is read from right to left.

The commencing letters are IEASOISE CHR (or I)

X is unusual in Ogam and it may by itself mean "Christ" just as X in (Christ)mas. Xmas.

Ogam Alphabet.

B L F S N H D T C Q
M G NG ST R
A O U E I

Celtic Ogam usually reads from right to left.

The Newton-Stone Ogam inscription continues vertically to the level of the top of the main inscription.

SE CH R (or I)
IOSAE

	Inscription.	Phoenician.	Greek	Roman.
			Digamma	
			sinat script	
			Chi	
			Rho	

ᵒᵐ. ᴅᴢ. Iohaⁿ
DEUM. DEUS. JOHANNEM.
I. for E.
ᵒlEGᴀᵐᵗᵉ DILIGAM TE
Cotton M.S. 8ᵗʰ Cent. D=DOMINE."
Vespasian. A.I. E "I shall love thee O Lord."

ihūm dᵒ ōⁿꞅ
JESUM. DEO. DOMINUS.
ōⁿᴇ. ōⁿᴇ
Domine. Domine.

ᴅⁿᴇ
ᴅⁿᴇ
Domine.

ihⁿ
Jesum
ihꞅ
IHSUS
zhⁿ
Jesus
H is Greek E
IESUS
JESUS

ᴍᴋ
Christi
ΧΒΙ
Christos. Book of Kells.
ΧΡꞅ
Christos. Book of Kells.
Christos
ΧρΙ
Christi. Book of Kells.

Plate 14.

𝔄 𝔞, 𝔞 𝔟 𝔠 𝔡 𝔢 𝔣 𝔰 𝔤 𝔥 𝔩 𝔷 𝔩

To begin sentences. Capitals.
paragraphs.

N o p p r s t u 10. 11. 12. 13. 14.
15. 16. 17. 18. 19.

Smalls.

a b c d e f g h i l m m n o p r s t u

Contractions— achd. air. eac. ea. ea. nn. bh. ch. dh. fh. gh.
mh. ph. rh. th. ui. ao. agus.

aguy maη ηin cιoñuy ḟéaḋpam a cḣuη a
ȝcéιll.

Iy ḟιóη yo, an méιḋ aȝa bḟηl a ȝcηοιḃτe
ḟιóηȝlanτa lé cηeιḋeṁh a Ṁóηa Cηιoyḋ, aȝuy
a nḋeȝóηḋúȝa ċum úṁlúȝaḋ ḋaιτenτa ḋé, ȝo
bḟéaḋηḋ aη uaιηe leτ áṁaηċ beȝ ḋḟáȝaιl ḋo
ȝlóιη an τyaoȝaιl oιle, ηemblay beȝ, no ηóητ
ḟaιynéιye aη na yubaιlcιḋ neṁḋa úḋ, le bḟιoηηⁿ
ḋιy τuȝιm ḋo τabȧτ ɟ a náḋúη, aȝuy aιη a
noιηḃeηcuy: Ú̃η ιy neιτe ιaḋ naċ bḟloḋuñ aon
nḋηηe a bḟιoy ḋo beιτ aιȝe (ȝo hιomlán) aη̃
an τé moċ̃ȝιoy ιáḋ: aȝuy nι mó τá aη a
ȝcumuy a naιτηιy, ná a ḋτuaηaycáιl ḋo τa-
bȧτ ḋo ḋáoιne oιle; maη ḋo beιη nⁿóṁ Pⱸḋaη
ḋa aιηe, maη a ηaιȝιon, aȝ τηαy ɟ Chηιoyḋ
leιy na ḋaoιne cηeιḋιoy ιoñ; an τι ḋa ḋτuȝa-
baιη ȝηáḋ, bιóḋ naċ bḟacabaιη é, añ a bḟηl
yιb a noιy aȝ cηeιḋeṁ, ȝe naċ leιη ḋιb é (η
αy) a nḋeánτáoι ȝaιηḋeċay lé luaτȝáιηe ḋó-
faιynéιy ȝlóηṁaη, I Pe. I 8. Tá luaτȝáιηe
aιnṁeyaηȝa, aȝuy ηoȝlóηṁaη oηηa τηē na
ȝcηeιḋeṁ a ȝcηιoyḋ, aȝuy beȝnaċ ḋaonáḋη̃η
léιτe yιoḋ a bḟlaιτ̃ey ḋé, aη yon ȝo bḟηl a
ȝceιm ιy ιyle; aη̃ nι fēιḋιη ι yo fóy ḋaιτηιy
le beáηηáḋ: Ȝιḋ ȝaη fⱸy ḋáιḃ fēιn lé ηιóη-
ȝnáy ȝo bḟηl yē ιoñτa fēιn, nι fēaḋηḋ a foιll-
yιuḋḋ aιη ṁoḋ ȝo bḟⱸḋηaḋ ḋuιne oιle a τ̃ηȝⁿ
yιn maη an ȝcéaḋna oιη nι fēaḋañ ⱱⁿoñⱸċ an
nι moċ̃ȝⱸy ḋ̃ηne oιle ḋo moċuȝaḋ, aη̃ an τé
moċ̃ȝιoy é, ȝιḋh ȝo nḋⱸnaḋ ye ṁηιn ḋáιḃ;
aȝuy nι ya lúȝ ȝo móη na ηⁿóιḋh eáⱱηaṁ-
la úḋ a τá óy cιoñ ȝaċ ηⁿle béalηaιḋh aιη
bιτh.

ḣ 3 Aȝuy

A page of Gaelic(Irish)type, printed in London 1711.

97

Zöömorphics.

Plate XIX Studio Publication
Actual height ¾ inch.

Plate O
In many publications this is erroneously
described as " a man playing a harp."
It is " a man, a beast, a bird and perhaps
a reptile."

Zoomorphics

ZOOMORPHIC ornaments are those based upon the forms of animals, birds and reptiles. Anthropomorphic ornaments are those based upon the forms of the human body. They make an early appearance in the Art of Bronze-age Britain and Ireland, and in the Bronze-age Gaulish, La Tene, and other European forms of Celtic Art. They are usually in conjunction with spiral ornaments, and the leg-joints and rib-forms of the animals in ornamental rendering have spiral terminal treatments. This peculiar manner of expressing the forms and movements of animals may be seen in the metal work of the 5000 B.C. to 3000 B.C. period of culture of the City of Ur. What are probably the representations of the sacred animals of the various families or tribes of North Britain are carved on the otherwise unornamented stones of Prehistoric Scotland. These depict in a manner that is intensely realistic, and of great artistry, a result that cannot be obtained by the imitation of Nature.

In this way the Burghead Bulls express the great strength and character of these animals and surpass in the expression of truth what realism of the purely imitative kind could achieve. The Boar, the Wolf, the Stag, the Hind, the Horse, the Goose, the Eagle, the fish and the reptile stones are all " picked " out with great skill in the manner of the incised stone carvings of Egypt and Assyria. Examples of the semi-realistic treatment of animals and mythical animals of Celtic Britain and Ireland, including the winged Lion and the winged Bull from the Book of Kells, containing much of the character of Assyrian Art, are shown on Plate 10. Every form and manner of treatment of the Scribes' works in the Book of Kells show that the origins are to be found in the arts of the carver, the metal worker, and the embroiderer. No matter how small and loaded with details the Scribe made his work, even if a magnifying glass is required to see it, then the smallest details of forms and surfaces will be found to have been thoroughly worked out as if to meet the demands of the carver or worker in three dimensions.

Artistic abandon that is not interested in the designing of every shape of the background with the same importance as the forms of the motif will not be found in the Book of Kells.

Lacertine or reptile ornaments, as shown on Plates 6 and 7, are numerous in the Books of Durrow, Kells, Lindisfarne, and St. Chad's.

Their beginnings are certainly in Pagan serpent worship. In the prehistoric Giant's Tower at Gozo, Malta, the only representation of any living thing is a bas-relief of a serpent in the vicinity of the altar, which is also decorated with spirals and geometric figures in the manner of Pictish Art, neatly and sharply cut in the stone. Numerous stones each bearing an incised serpent and sometimes other symbols are among the remains of Prehistoric Scotland.

The suggestion arises that these are the serpents that St. Patrick banished from Ireland, but, as he was educated in his religious and other cultures by the priests of the Southern Pictish Christian Church in Strath Clyde before he returned early in the 5th century to the land of his birth and early childhood, he did not banish them from the Manuscript Art, where they persisted for a few centuries after his time.

Abstract representations of human male figures with interlacing limbs, bodies, hair, top knots and beards are used to decorate the sacred pages of the Gospels of the Book of Kells. In the same book there are pairs of birds, animals, and groups of pairs of reptiles, comparable in some respects with those of Assyrian, Persian, Chinese, and Chinese-Turkestan Arts. Pairs of birds with interlaced or entwined necks are found in modern native art in Ceylon.

Groups of beard-pullers occur on Celtic Stones and in the Book of Kells. There are two pairs of beard-pullers with checked trousers or painted checks on their legs in a small panel on the right of the Christ monogram page of that book, see Plate 14. On another page the robed priests calmly survey the pairs of beard-pullers beneath them. As they descend in the panel the lowest pairs are topsy-turvy and are coloured in violet and dark green, a suggestion of the under-world more than mere taste in colour decoration. Perhaps beard-pullers are used as the symbol of the marketing or bartering of the Early British business men, the equivalent of those that Christ cleared out of the Temple. The problem of the purpose of such figures in the pages of the Gospels is awaiting serious investigators. It is more than a forerunner of the leg-puller. There are numerous examples of humour in Gospels of the Book of Kells, including a little fellow in tartan " cocking a snoot."

The author has reserved for an advanced book numerous examples of hitherto unnoticed or wrongly interpreted groups. One of the first

mentioned is built around the letters NIAM (see page 120). In it are depicted two figures with halos, ascending to heaven, twelve robed figures, the Apostles, two figures undergoing mental tortures for wickedness (all tortures are mental ones, that is, the head of the wicked sufferer is in the jaws of the beast). A woman (Samaritan) offering a goblet of water to a seated figure (Christ), who holds in His own hand a cup or beaker with the water of everlasting life. A figure (faith) reclines at Christ's feet and holds Christ's left leg. Nearby a young man lies dead. This excellently designed group has never been commented upon by any expert. An example of wrongful interpretation by experts of Celtic Art of the past century is to be found in many works on the subject. It has persisted for nearly a century, and it is even repeated in the "Studio" publication of some of the finest pages of the Book of Kells edited by Sir Edward Sullivan. Referring to the opening words of St. John's Gospel, the letters CI of principio are said to (see page 115) represent a "man playing a harp." This is an example of careless or casual looking and of the encouragement of the imagination. The Book of Kells is generally classed as Irish in origin; so is the harp. Thus by a casual glance "a man playing a harp" is born. Careful looking and the absence of imagination reveal a man, a beast, a bird, and perhaps a reptile—and nothing more. The probable meaning of this group is the "created forms of life on land." The preceding letters RIN are used to display the Celtic Tree of Life (see page 125), which emerges from a pot or beaker and has leaves and fruits that resemble mistletoe more than any other plant form. It branches from the main stem to form cornucopiae from which other branches with leaves and fruits emerge. Two birds pick the fruit. The letters RIN are formed into zoomorphic dog-like animals with top-knots, tails, tongues, forelegs, hindlegs, and toes with claws. This Celtic rendering of the Tree of Life, which always emerges from a pot or beaker, is the only plant form to be found in the Book of Kells, and not more than ten times. Two of these are beautiful examples, with tropical birds that have hitherto been unnoticed by experts. There are a number of examples of the Celtic Tree of Life on the Scottish Pictish Stones, including the Nigg and Hilton of Cadboll Stones.

There are also on the same page two interesting panels of beard-pullers with embroidered garments in the manner of Eastern Europe or Asia Minor. These and other interesting discoveries are reserved for an advanced work. On the centre of the Greek letter X of the Christ monogram page a multiple of the CI symbol may be seen. There are four hairy males with ribbon-like bodies, arms, legs, feet, and top-knots, four reptiles, four beasts, and twelve birds all with top-knots, etc. See Plate 12. Also on the Christ monogram page a complete list of life on land, in air, and in water is to be found—man, beast, bird, reptile, fish, insect and plant. All Celtic zoomorphic and anthropomorphic designs are logically completed and conform to the laws of Nature, no matter how the artist may have interlaced and contorted his motif. However crazy the result may appear by the rules of modern art, limbs and bodies, though elongated, and heads, legs, arms, tails, wings, and top-knots will be in relation to their positions in Nature.

The golden rule in the study of the ornaments of the Book of Kells and other Celtic MSS. is "beware of what you think it looks like." A scrutiny in minute portions may enable the student to draw each portion large, with no consideration of what they may portray. When these are put together they may make sense. Unless reason and imagination are divorced from observation, the results may be of the wrong kind already shown. There are a few examples of zoomorphic and other ornaments carved very minutely on the bones of sheep and deer. These were found in a crannog in Ireland and are illustrated in the preface by Dr. Stuart in the "Sculptured Stones of Scotland."

These are probably the models made by a jeweller for making moulds for casting metal ornamented panels for rivetting. A "squeeze" in a moist suitable clay would make such a mould and could be repeated as often as required.

A common device of which there are many examples in the Book of Kells and a few on the Scottish Pictish Cross slab-stones is a man and a bird or a man with a bird in each hand. On the page of the eight circled Cross of the Book of Kells there is a panel composed of four men and eight birds.

The Scottish ornamented Cross slab-stone of Rossie Priory has two small panels, one on each side of the space formed by the Cross and the Halo. In one there is a man with a goose in each hand. The other contains a winged and armless figure with a skirt-like garment covering the knees. In the British Museum there is a Minoan ivory plaque showing the Boeotian Goddess Artemis with a water-bird resembling a goose in each hand. She is winged and wears a skirt-like garment.

The following references show that in the Gaelic period of Scotland the zoomorphic art was in use. In Dr. Alexander Carmichael's collected Barra version in Gaelic of the Pre-

Christian "Tale of Deirdire" Fillan Fionn is described thus, " and the young hero, fresh-noble, fresh-manly, fresh-glorious with his lovely brown locks, went out girded in his war weapons of hard battle, that were polished, gleaming, glittering, brilliant, flushing, on which were the many figures of beasts, birds and creeping things (reptiles)." The use of "the" signifies that it was a customary form of ornamentation. A description of the arming of John, the last Lord of the Isles, in the 15th century mentions " an encircling belt with good clasps made of bronze with figures of 'flying birds' on the borders. An artist exercised his best skill in making that excellent girdle." There are numerous references to the skilled work of the Celtic artist craftsmen in jewellery, hammered metal work, repousee, casting, engraving and enamelling, in sculpture of ivory, bone, wood and stone, and to embroideries in Gaelic Pagan and Early Christian literature. The absence of any references to the spiral, key and interlacing ornaments peculiar to Celtic Art suggests that many of the Celtic motifs of Scotland and Ireland are pre-Gaelic. Neither are there any references to these in the writings of Bede, Adamnan, and other adherents of the Roman Church of Augustine.

The rare appearance of female figures on the Scottish East Coast ornamented stones, and their complete absence in the Anthropomorphic Art of the Celtic MSS. is worth remarking on, and the reason may yet be found.

Representations of the Virgin Mary begin with the entry of the Roman Church of Augustine to England and to Ireland, and they are not found in the Pictish areas of Scotland. A great mass of valuable manuscripts was destroyed by the Augustine Church by the orders of Pope Gregory the Great. The great and matured skill shown in every form of the art contained in the few surviving manuscripts would be impossible without many earlier books that gradually developed the prototype of Celtic Sacred Books. The prototype of the forms of the ornamentations and the peculiar methods of construction required to produce them is that of the ornamented Cross slab-stones of Pictish East Scotland. This great art was a religious one. Throughout the whole of the zoomorphic and anthropomorphic and the semi-realism of Celtic Art of the MSS. and of the Pictish Stones of Scotland there are no obscene carvings of any kind. This is not so in Roman and other Classical Arts. The study of the methods of construction of Celtic ornaments will shed a new light that will correct many wrongful ideas regarding the Celtic Race in Britain and Ireland. Words are often liars, and the older they are the more powerful and the more difficult to disprove. The evidence obtained by this new method of research cannot lie.

With such evidence already gained, the order of the periods of the so-called Irish manuscripts are:

The Book of Durrow—Early 5th to Early 6th Century.

The Book of Kells—Middle 6th to Early 7th Century.

The Book of Lindisfarne—Late 7th Century.

The Book of St. Chads—Late 7th to 8th Century.

The Book of MacRegol—Not later than 8th Century.

In same manner as Durrow and Kells, but by inferior artists.

The Book of MacDurnan—9th to 10th Century.

By this method of research the author hopes to include in an advanced work a classification of the Great Masters, Masters, assistants, and pupils who built up the world's greatest Celtic Art treasure—the Book of Kells.

The Celtic Version of "The Wolf shall also dwell with the Lamb, etc."
Isaiah, Chap.11, 6-9. Chap. 65.25.
high Cross of Muredach, Monasterboice,
Ireland.

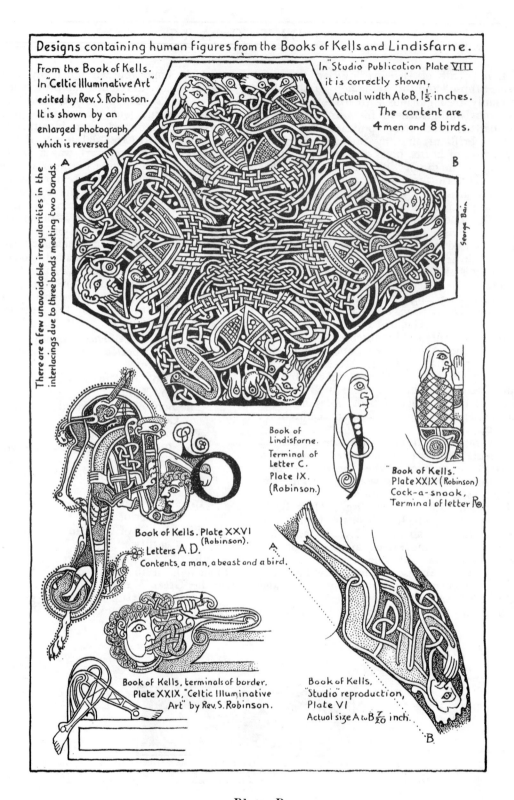

Designs containing human figures from the Books of Kells and Lindisfarne.

From the Book of Kells. In "Celtic Illuminative Art" edited by Rev. S. Robinson. It is shown by an enlarged photograph which is reversed.

There are a few unavoidable irregularities in the interlacings due to three bands meeting two bands.

A

B

In "Studio" Publication Plate VIII it is correctly shown. Actual width A to B, $1\frac{1}{5}$ inches. The content are 4 men and 8 birds.

George Bain.

Book of Lindisfarne. Terminal of Letter C. Plate IX. (Robinson.)

"Book of Kells." Plate XXIX (Robinson) Cock-a-snook, Terminal of letter R.

Book of Kells. Plate XXVI (Robinson). Letters A.D. Contents, a man, a beast and a bird.

A

Book of Kells, terminals of border. Plate XXIX, "Celtic Illuminative Art" by Rev. S. Robinson.

Book of Kells, "Studio" reproduction, Plate VI Actual size A to B $\frac{7}{20}$ inch.

B

Plate P

104

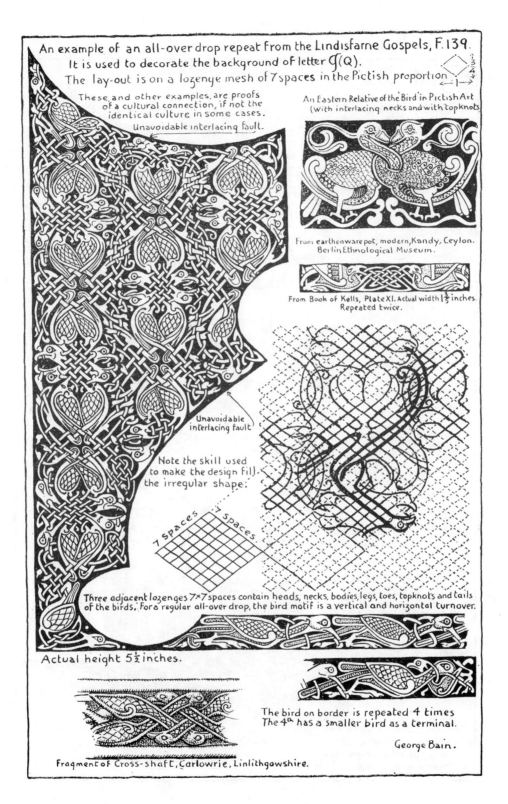

An example of an all-over drop repeat from the Lindisfarne Gospels, F.139.
It is used to decorate the background of letter 𝒬(Q).
The lay-out is on a lozenge mesh of 7 spaces in the Pictish proportion $\frac{3}{4}$: 1

These, and other examples, are proofs of a cultural connection, if not the identical culture in some cases.

Unavoidable interlacing fault.

An Eastern Relative of the Bird in Pictish Art (with interlacing necks and with topknots)

From earthenware pot, modern, Kandy, Ceylon. Berlin Ethnological Museum.

From Book of Kells, Plate XI. Actual width $1\frac{1}{2}$ inches. Repeated twice.

Unavoidable interlacing fault.

Note the skill used to make the design fill the irregular shape:

7 spaces 7 spaces.

Three adjacent lozenges 7×7 spaces contain heads, necks, bodies, legs, toes, topknots and tails of the birds. For a regular all-over drop, the bird motif is a vertical and horizontal turnover.

Actual height $5\frac{1}{2}$ inches.

The bird on border is repeated 4 times. The 4th has a smaller bird as a terminal.

George Bain.

Fragment of Cross-shaft, Carlowrie, Linlithgowshire.

Plate Q

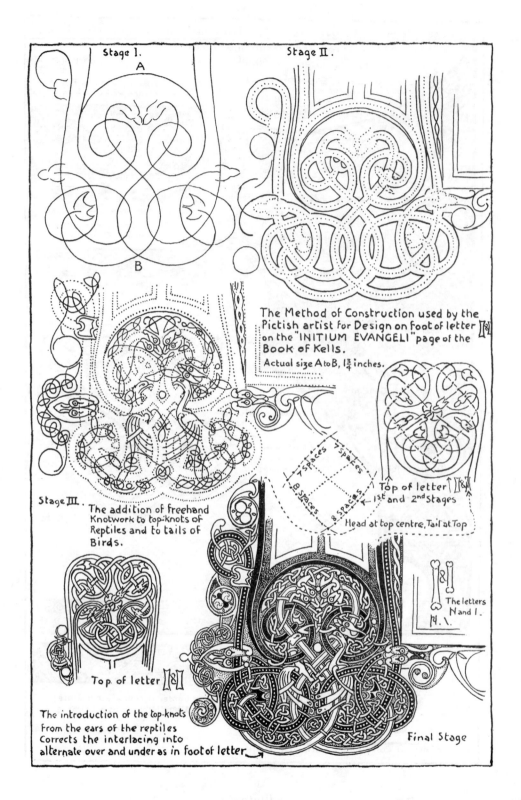

Stage I.

A

B

Stage II.

The Method of Construction used by the Pictish artist for Design on foot of letter R on the "INITIUM EVANGELI" page of the Book of Kells.

Actual size A to B, 1¾ inches.

Stage III. The addition of freehand Knotwork to top-knots of Reptiles and to tails of Birds.

7 spaces 7 spaces
8 spaces 8 spaces

Top of letter 1st and 2nd Stages

Head at top centre, Tail at Top

The letters N and I.

Top. of letter

The introduction of the top-knots from the ears of the reptiles Corrects the interlacing into alternate over and under as in foot of letter

Final Stage

Plate R

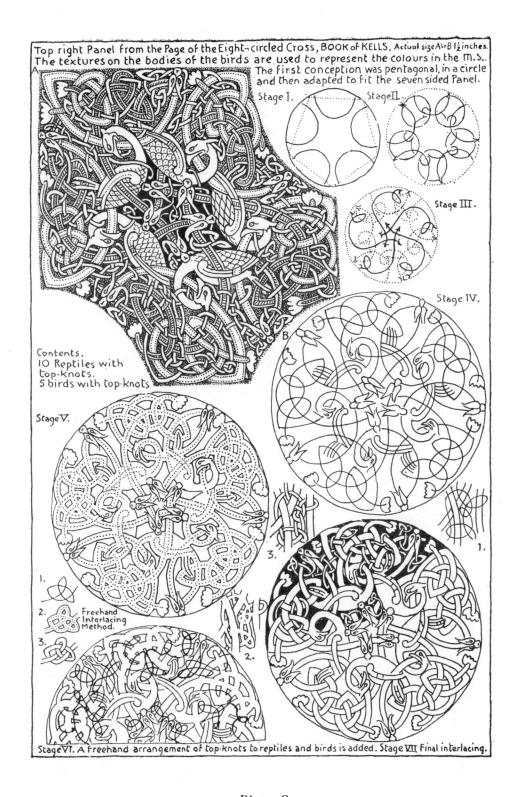

Top right Panel from the Page of the Eight-circled Cross, BOOK of KELLS. Actual size A to B 1½ inches. The textures on the bodies of the birds are used to represent the colours in the M.S.. The first conception was pentagonal, in a circle and then adapted to fit the seven sided Panel.

Stage I. Stage II.

Stage III.

Stage IV.

Contents,
10 Reptiles with top-knots.
5 birds with top-knots

Stage V.

1.
2. Freehand Interlacing Method.
3.

1.
2.
3.

Stage VI. A freehand arrangement of top-knots to reptiles and birds is added. Stage VII Final interlacing.

Plate S

107

The Use of Bird Motifs in Interlacing Ornaments from the Book of Lindisfarne. George Bain.

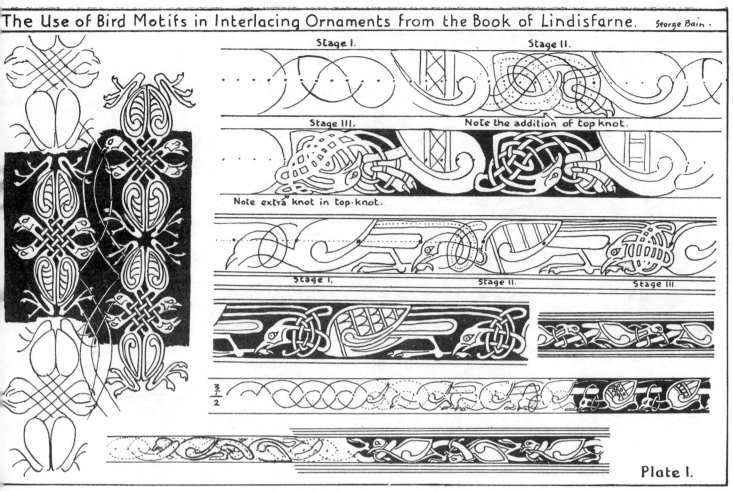

Stage I. Stage II.

Stage III. Note the addition of top knot.

Note extra knot in top-knot.

Stage I. Stage II. Stage III.

$\frac{3\frac{1}{2}}{2}$

Plate 1.

Birds, heads, top-knots, necks, bodies, wings, tails, legs and toes. From the Book of Kells.

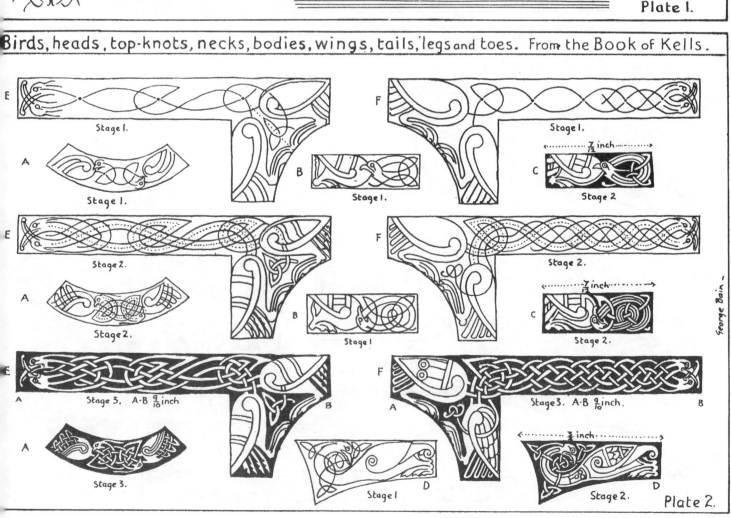

E Stage I. F Stage I.

A Stage I. B Stage I. C $\frac{7}{12}$ inch Stage 2.

E Stage 2. F Stage 2.

A Stage 2. B Stage I. C $\frac{7}{12}$ inch Stage 2.

E A Stage 3. A·B $\frac{9}{10}$ inch B F A Stage 3. A·B $\frac{9}{10}$ inch. B

A Stage 3. Stage I. D $\frac{7}{12}$ inch Stage 2. D

George Bain.

Plate 2.

109

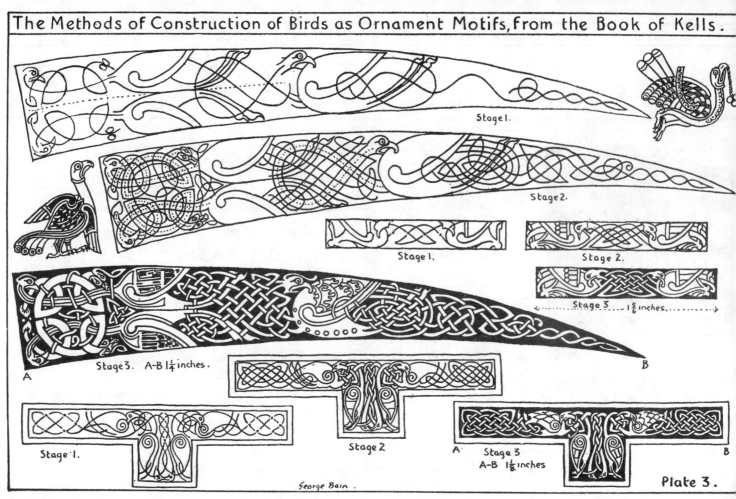

Stage 1.

Stage 2.

Stage 1.

Stage 2.

Stage 3. — 1⅝ inches.

Stage 3. A–B 1¼ inches.

A B

Stage 1.

Stage 2.

Stage 3. A–B 1⅝ inches

A B

George Bain.

Plate 3.

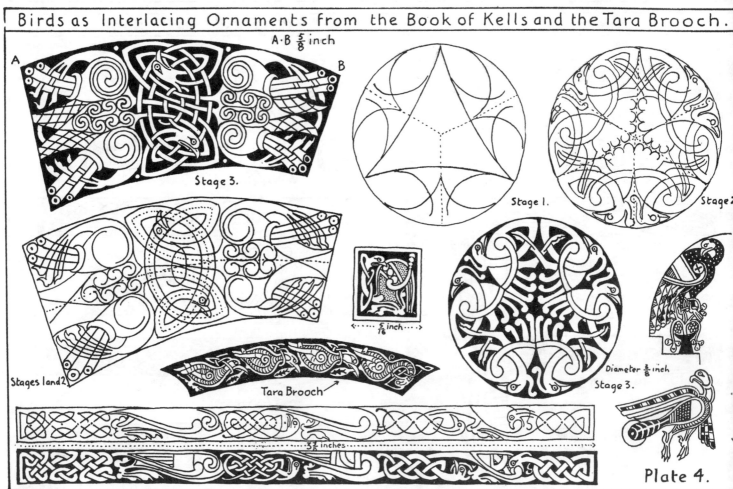

A·B ⅝ inch

A B

Stage 3.

Stage 1.

Stage 2.

⁵⁄₁₆ inch

Diameter ⅝ inch

Stage 3.

Stages 1 and 2.

Tara Brooch

3¼ inches

Plate 4.

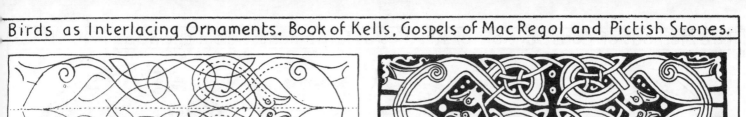

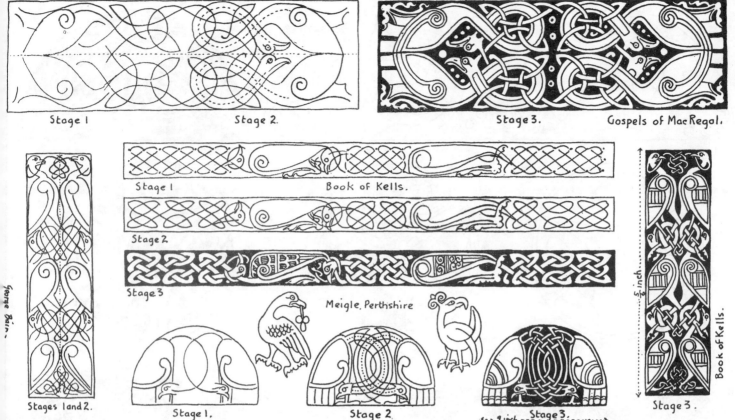

Stage 1 Stage 2. Stage 3. Gospels of Mac Regol.

George Bain

Stage 1 Book of Kells.

Stage 2

Stage 3

Meigle. Perthshire

Stages 1 and 2. Stage 1. Stage 2. Stage 3. Stage 3.
 Book of Kells. Book of Kells.

Plate 5.

Reptiles as Interlacing Ornaments, each complete with Head, Top-knots, Body and Tail. George Bain

From the Book of Kells.

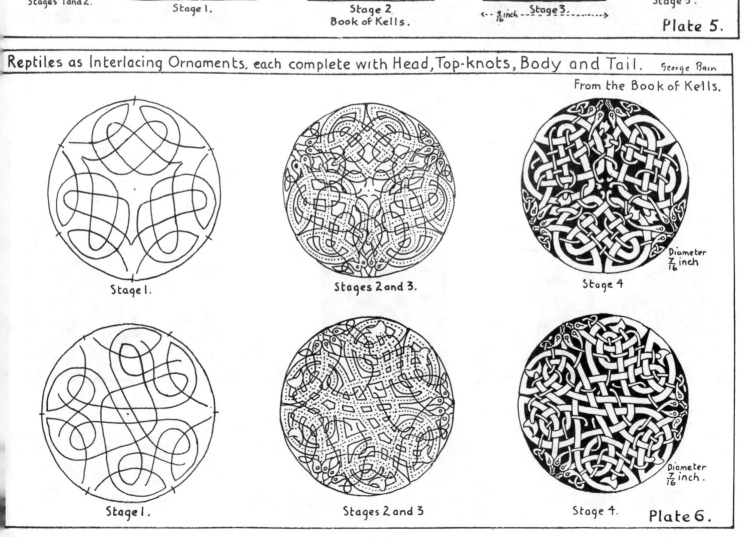

Stage 1. Stages 2 and 3. Stage 4.
 Diameter
 7/16 inch

Stage 1. Stages 2 and 3 Stage 4. Plate 6.
 Diameter
 7/16 inch.

111

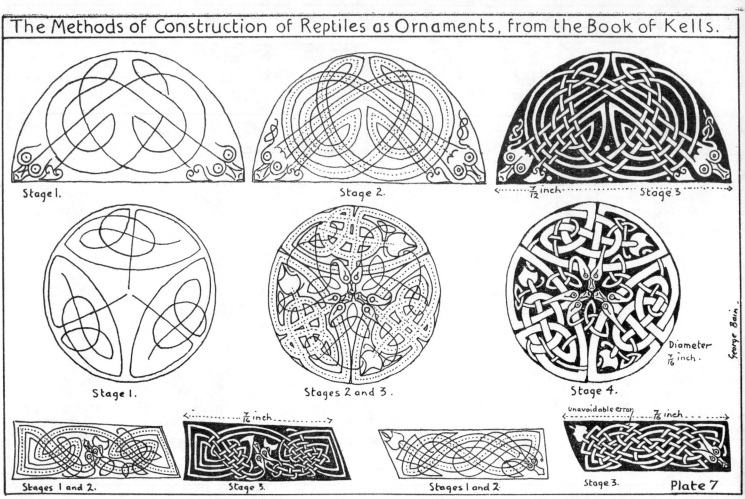

Stage 1.

Stage 2.

$\frac{7}{12}$ inch · · · Stage 3.

Stage 1.

Stages 2 and 3.

Stage 4.

Diameter $\frac{7}{16}$ inch.

George Bain.

$\frac{7}{16}$ inch

Stages 1 and 2.

Stage 3.

Stages 1 and 2.

Unavoidable error. $\frac{7}{8}$ inch

Stage 3.

Plate 7

Dog-like Animals. Head, Top-knot, Tail, Hind-leg, Fore-leg and Body, from the Book of Kells.

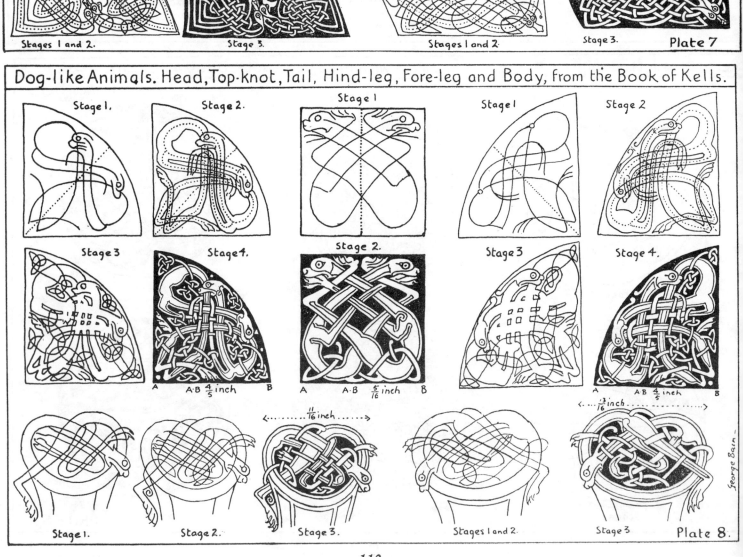

Stage 1.

Stage 2.

Stage 1

Stage 1

Stage 2

Stage 3

Stage 4.

A.B $\frac{4}{5}$ inch B

Stage 2.

A A·B $\frac{5}{16}$ inch B

Stage 3

Stage 4.

A A.B $\frac{4}{5}$ inch B

Stage 1.

Stage 2.

Stage 3.

$\frac{11}{16}$ inch

Stages 1 and 2.

Stage 3

$\frac{13}{16}$ inch

George Bain.

Plate 8.

The Use of Animals as Interlacing Ornaments. From the Book of Kells.

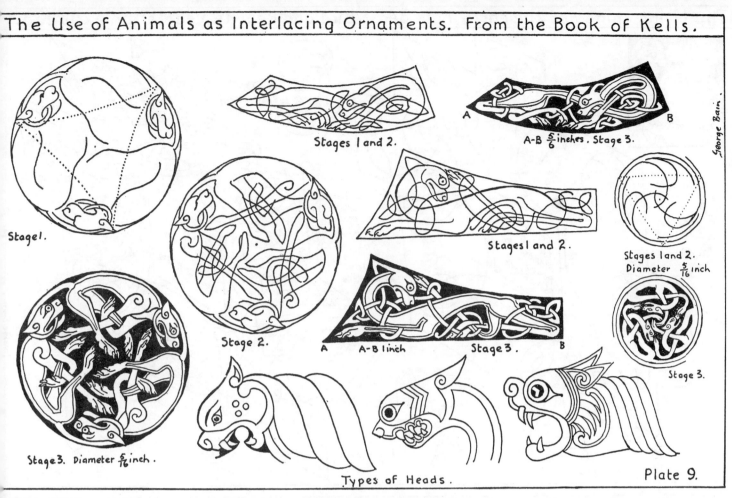

Stage 1.

Stages 1 and 2.

A-B $\frac{5}{6}$ inches. Stage 3.

George Bain.

Stages 1 and 2.

Stage 2.

Stages 1 and 2. Diameter $\frac{5}{16}$ inch.

A A-B 1 inch Stage 3. B

Stage 3.

Stage 3. Diameter $\frac{5}{16}$ inch.

Types of Heads.

Plate 9.

Semi-realistical and mythical Animals from Scottish Stones and the Book of Kells.

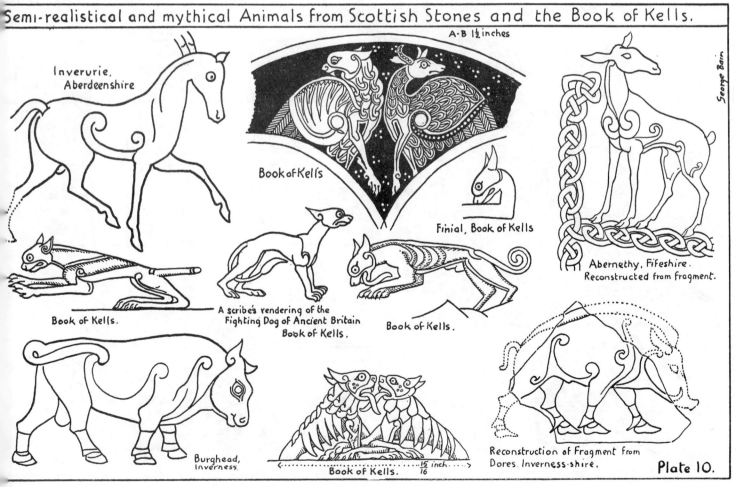

Inverurie, Aberdeenshire.

A-B 1½ inches

Book of Kells.

Finial, Book of Kells.

George Bain.

Abernethy, Fifeshire. Reconstructed from fragment.

Book of Kells.

A scribe's rendering of the Fighting Dog of Ancient Britain Book of Kells.

Book of Kells.

Burghead, Inverness.

Book of Kells. $\frac{15}{16}$ inch.

Reconstruction of Fragment from Dores, Inverness-shire.

Plate 10.

113

The Living Things of the Earth, Man, Beast, Bird and Reptile, Vegetation excluded.

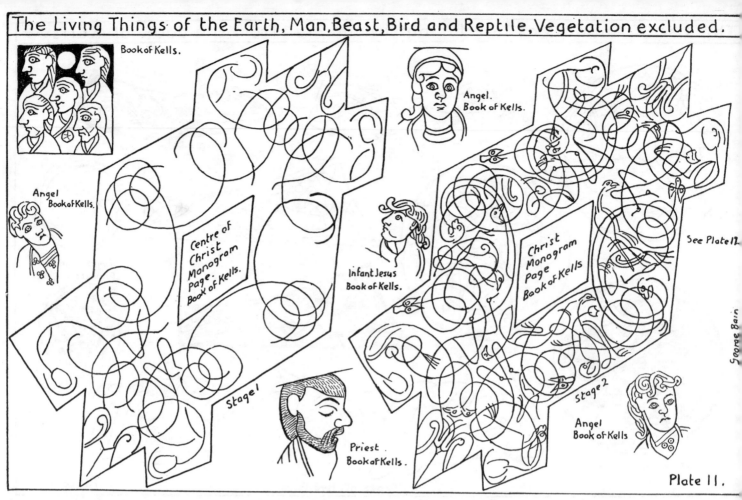

Book of Kells.

Angel. Book of Kells.

Angel Book of Kells.

Centre of Christ Monogram Page. Book of Kells.

Stage 1

Infant Jesus Book of Kells.

Priest. Book of Kells.

Christ Monogram Page Book of Kells

See Plate 12.

Stage 2

Angel Book of Kells

George Bain

Plate 11.

Interlacing Human Figures from the Book of Kells and the Clonmacnoise Stone.

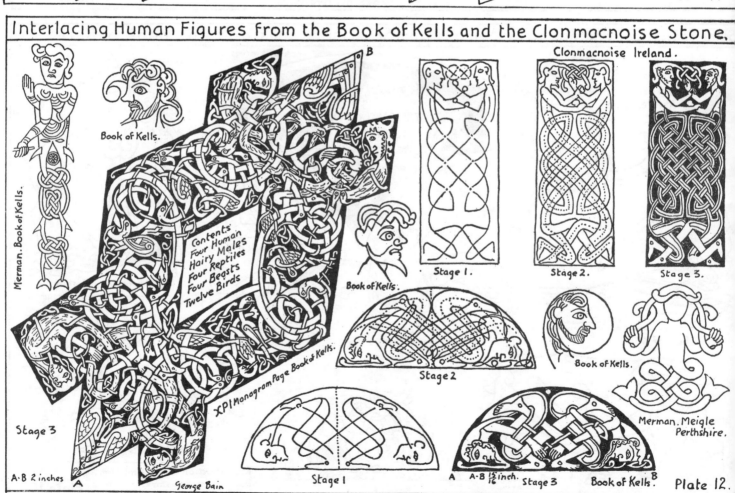

Book of Kells.

Merman. Book of Kells.

B

Contents: Four Human Hairy Males Four Reptiles Four Beasts Twelve Birds

Clonmacnoise Ireland.

Stage 1. Stage 2. Stage 3.

Book of Kells.

Stage 3

XPI Monogram Page Book of Kells.

Book of Kells.

Stage 2

Merman. Meigle Perthshire.

A·B 2 inches A

George Bain

Stage 1 A A·B 1¼/₁₆ inch. Stage 3 Book of Kells. B Plate 12.

114

Human Male Figures in Ornament from Stone at Clonmacnoise, and Book of Kells

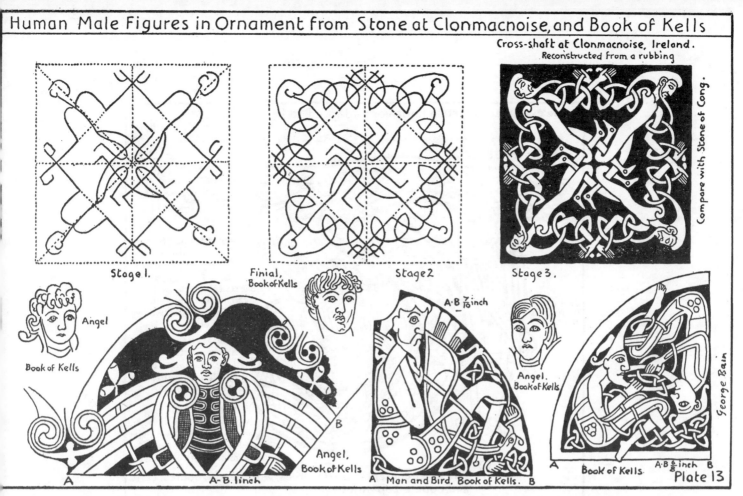

Cross-shaft at Clonmacnoise, Ireland.
Reconstructed from a rubbing

Compare with Stone of Cong.

Stage 1. Stage 2. Stage 3.

Finial, Book of Kells

Angel
Book of Kells

Angel, Book of Kells

A—B. 1 inch.

A·B $\frac{7}{10}$ inch

Man and Bird. Book of Kells. B

Angel.
Book of Kells

Book of Kells. A·B $\frac{6}{8}$ inch B

George Bain

Plate 13

Beard-pullers and other interlaced Human Male Figures in Ornament, from the Book of Kells.

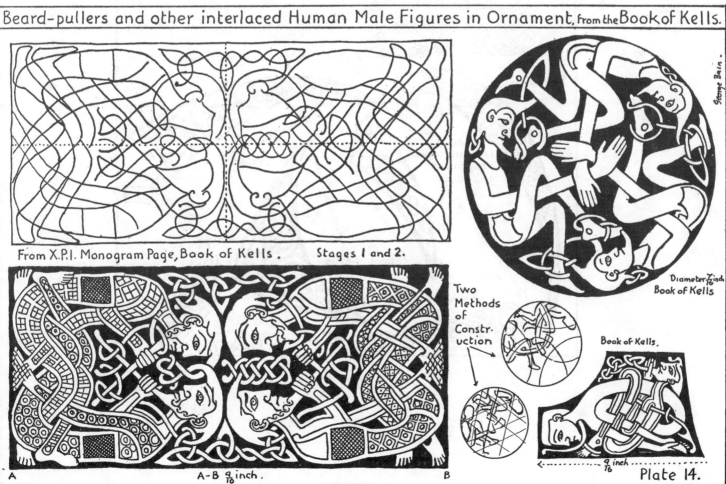

From X.P.I. Monogram Page, Book of Kells. Stages 1 and 2.

George Bain.

Diameter $\frac{7}{16}$ inch
Book of Kells

Two Methods of Construction

Book of Kells.

A A—B $\frac{9}{10}$ inch. B

$\frac{9}{16}$ inch

Plate 14.

115

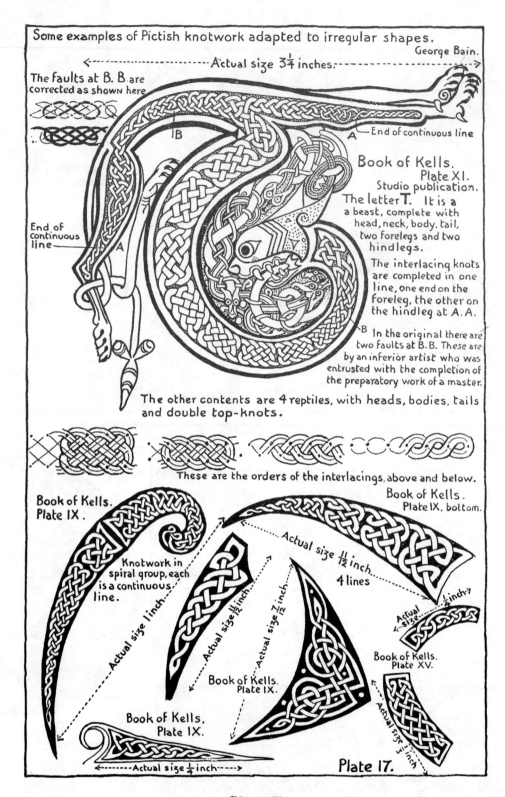

Some examples of Pictish knotwork adapted to irregular shapes.

George Bain.

Actual size 3¼ inches.

The faults at B. B. are corrected as shown here

End of continuous line

B

A

End of continuous line

Book of Kells.
Plate XI.
Studio publication.
The letter T. It is a a beast, complete with head, neck, body, tail, two forelegs and two hindlegs.

The interlacing knots are completed in one line, one end on the foreleg, the other on the hindleg at A.A.

In the original there are two faults at B.B. These are by an inferior artist who was entrusted with the completion of the preparatory work of a master.

End of continuous line

A

B

The other contents are 4 reptiles, with heads, bodies, tails and double top-knots.

These are the orders of the interlacings, above and below.

Book of Kells.
Plate IX.

Book of Kells.
Plate IX. bottom.

Knotwork in spiral group, each is a continuous line.

Actual size 1 inch.

Actual size ⁴⁄₁₂ inch.

Actual size ⁷⁄₁₂ inch.

Actual size ¹¹⁄₁₂ inch.
4 lines

Actual size ¼ inch

Book of Kells.
Plate IX.

Book of Kells.
Plate IX.

Book of Kells.
Plate XV.

Actual size 3⅓ inch

Actual size ¼ inch

Plate 17.

Plate T

116

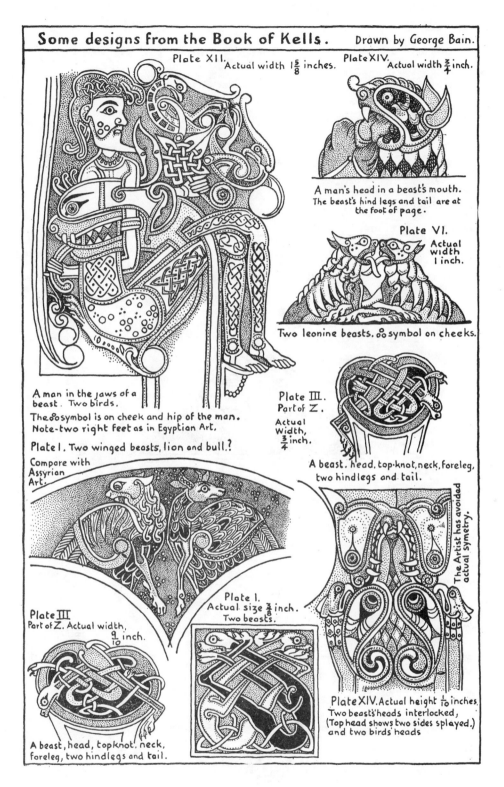

Some designs from the Book of Kells. Drawn by George Bain.

Plate XII. Actual width $1\frac{5}{8}$ inches.

Plate XIV. Actual width $\frac{3}{4}$ inch.

A man's head in a beast's mouth. The beast's hind legs and tail are at the foot of page.

Plate VI. Actual width 1 inch.

Two leonine beasts. $\overset{o}{\underset{o}{o}}$ symbol on cheeks.

A man in the jaws of a beast. Two birds.

The $\overset{o}{\underset{o}{o}}$ symbol is on cheek and hip of the man. Note—two right feet as in Egyptian Art.

Plate I. Two winged beasts, lion and bull.? Compare with Assyrian Art.

Plate III. Part of Z. Actual Width, $\frac{3}{4}$ inch.

A beast. head, top-knot, neck, foreleg, two hindlegs and tail.

The Artist has avoided actual symetry.

Plate III Part of Z. Actual width, $\frac{9}{10}$ inch.

A beast, head, topknot. neck, foreleg, two hindlegs and tail.

Plate I. Actual size $\frac{3}{8}$ inch. Two beasts.

Plate XIV. Actual height $\frac{7}{10}$ inches. Two beasts' heads interlocked, (Top head shows two sides splayed.) and two birds' heads

Plate U

117

Plant and
Human Forms

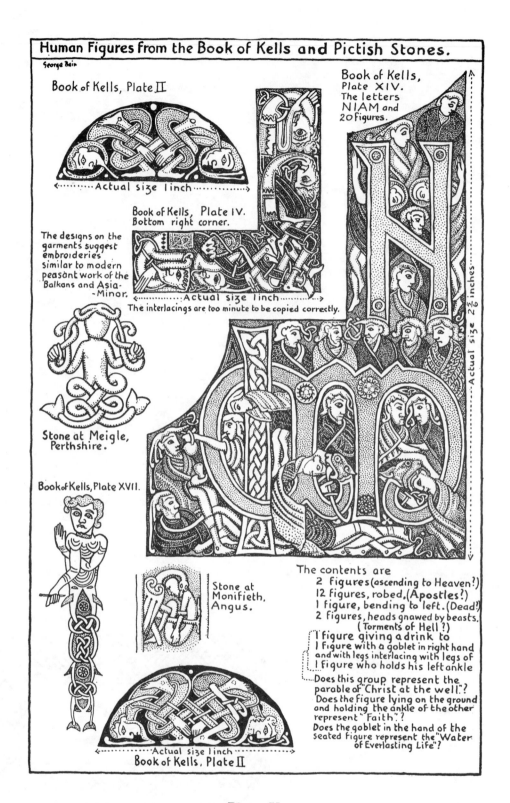

Human Figures from the Book of Kells and Pictish Stones.

George Bain

Book of Kells, Plate II

Actual size 1 inch

Book of Kells, Plate IV.
Bottom right corner.

The designs on the garments suggest embroideries similar to modern peasant work of the Balkans and Asia-Minor.

Actual size 1 inch

The interlacings are too minute to be copied correctly.

Stone at Meigle, Perthshire.

Book of Kells, Plate XVII.

Book of Kells, Plate XIV.
The letters NIAM and 20 figures.

Actual size 2⅙ inches

Stone at Monifieth, Angus.

Actual size 1 inch
Book of Kells, Plate II

The contents are
 2 figures (ascending to Heaven?)
 12 figures, robed, (Apostles?)
 1 figure, bending to left. (Dead?)
 2 figures, heads gnawed by beasts.
 (Torments of Hell ?)
 1 figure giving a drink to
 1 figure with a goblet in right hand
 and with legs interlacing with legs of
 1 figure who holds his left ankle

Does this group represent the parable of "Christ at the well"?
Does the figure lying on the ground and holding the ankle of the other represent "Faith"?
Does the goblet in the hand of the seated figure represent the "Water of Everlasting Life"?

Plate V

120

The Celtic "Tree of Life"

THE references to the plant forms which rarely occur in the Book of Kells and not at all in the Books of Durrow and Lindisfarne, have been used to prove that the two latter books belong to an earlier period. It is the author's opinion, based upon many evidences, that the Book of Lindisfarne is later than the Book of Kells. Foliated ornaments entered Southern Britain with the Roman invasions, and forms of Gothic foliage came with the invaders after the fall of Rome, but they differ from those of the Pictish Stones of East Scotland and those of the Book of Kells. In the portions of that Book which have been available to the author for research, namely the "Studio" publication in colours, of some of its most important pages, and "Celtic Illuminative Art" in black and white, by Rev. Stanford F. H. Robinson, M.A., the examples, with one exception, emerge from pots or beakers, and are shown on Plates A.1 to A.5. The extreme minuteness of these examples make it probable that the pots have not been noticed and no known mention of them has hitherto been made. Without any possible doubt, this is a pagan and, later, a Christian symbol and its use was a religious one and not merely decorative.

The Celtic "Tree of Life" is used by the author to name this symbol. It completes the total of created life, the seven created beings of the Celtic world, Plant, Insect, Fish, Reptile, Bird, Animal and Man. As such it occupies a place on the "Christ Monogram" page of the "Book of Kells," see Plate A.5. The British and Pictish Christian Churches of Pelagius believed that God gave seven faculties to man, Sight, Smell, Taste, Hearing, Feeling, Good and Evil. The belief in the last two faculties was the chief cause of the Pelagian heresies.

Prototypes of the Celtic "Tree of Life" growing from pots in the manner of those of the Pictish stones of East Scotland and of the Book of Kells were very difficult to find from all available works on Asiatic and European ornaments. The few examples found by the author over a number of years of searching are now shown in the plates. They are from Pre-historic Greece, Cnossus (Crete), Maya (Central America) and Buddhist (India).

The most remarkable similitude of the "Tree of Life" symbol on a Buddhist vessel of elephant ivory, to an example from the Book of Kells, Plate A.2, should be of value to future historians in writing about the migrations and cultures of the peoples of Britain and Ireland prior to the Roman invasions. A well-known authority of pre-historic archaeology named some of the pot types that hold the "Tree of Life" from the author's drawings which are now shown on these plates. The search for similar forms of earthenware, glass and metal pots, shows that Pre-Dynastic Egyptian and pre-historic British, Irish and European food vessels and cinerary urns are very similar.

In two panels on Plate A.4, the singing types of birds are also fruits of the plant which grows out of the pot. It will be observed that in every example, the tree or plant has a logical growth. It branches from the main stem to form cornucopiae from which other branches with leaves and fruits emerge. These have more resemblance to mistletoe than to any other plant.

After the victory of the "Synod of Whitby" 664 A.D., the British and Pictish Christian Churches suffered extirpation as heretics. Following the victorious Church of Augustine, the Romanesque vine and other plant forms replaced the Celtic "Tree of Life" and rapidly produced decadent forms of Celtic Art. These eventually became submerged in the ever-changing artistic fashions of the medieval manuscripts that ended in meaningless scrolls and vegetation realism of the crudest types.

That the Celtic spirit lived on in pockets of culture, is shown by the works of the artists of the Winchester Bible, already referred to where some of the charms of the plant forms of the artists of the Book of Kells are retained, though the pot and the significance of the "Tree of Life" have disappeared into the vast world of decoration.

For Willie Soutar

October 1943.

Twenty year beddit, and nou
 the mort-claith.
This suld gar ilk ane grue,
 sic a daith...................

Was his life warth livan? Ay,
 siccar it was.
He was eident, he was blye
 in Scotland's cause.........

Liggan quate, his hairns were thrang
 for Libertie,
his pen wove thegither sang
 and musardrie.

In the time of tyrants he
 testified truth,
and sae our yirth bydes aye free,
 saut wi fresh youth.

Sic smeddum, kindliness, and wit,
 hope and faith,
 nou that his corp is by wi it,
 outlive daith.

George Bain

Designed by the Author. Poem by Douglas Young

Celtic Art. On Pictish Stones and in the Book of Kells the "Tree of Life" emerges from a Pot.

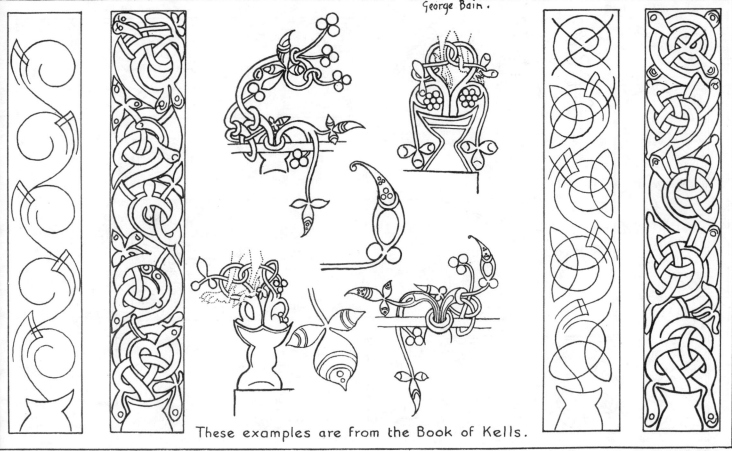

George Bain.

These examples are from the Book of Kells.

Celtic Art. The "Tree of Life" Symbol, from the Book of Kells, Pictish Stones and Asiatic Sources.

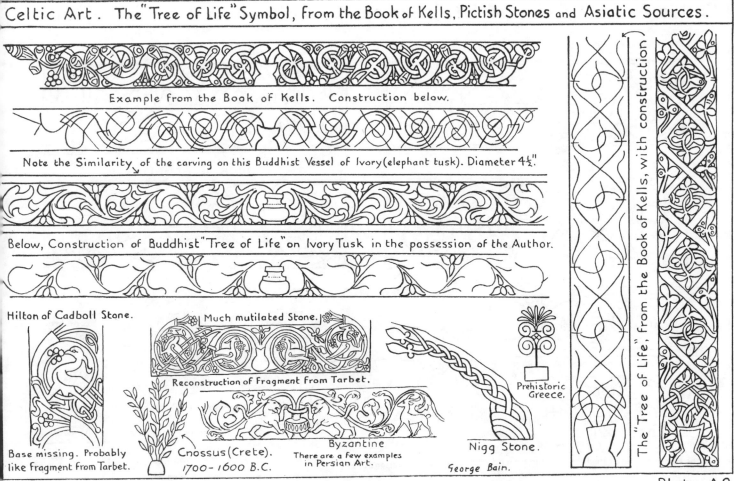

Example from the Book of Kells. Construction below.

Note the Similarity of the carving on this Buddhist Vessel of Ivory (elephant tusk). Diameter 4½".

Below, Construction of Buddhist "Tree of Life" on Ivory Tusk in the possession of the Author.

Hilton of Cadboll Stone.

Much mutilated Stone.

Reconstruction of Fragment from Tarbet.

Base missing. Probably like fragment from Tarbet.

Cnossus (Crete). 1700-1600 B.C.

Byzantine
There are a few examples in Persian Art.

Prehistoric Greece.

Nigg Stone.

George Bain.

The "Tree of Life", from the Book of Kells, with construction.

Tail of Letter Q

Book of Kells.

Priest here

Priest here

MAYA ART. From the Borgian Codex. Two Priests hold the Pots over a man on platform.

Farnell Stone (Garden) (of Eden)

Eassie Stone.

Book of Kells. Size in Studio Publication 1 inch.

Book of Kells.

In hand of Angel, Virgin and Child page.

Benvie Stone Angus. Romilly Allen makes it a cherubim.

Book of Kells. The Letters (Z)ACHA(RIAE)

Size in Studio Publication 3⅛ inches

Letter O, Cottonian M.S.

Book of Kells ---- Size in Studio publication 1 inch.

Late 7th or early 8th Cent., Cottonian M.S..

Foliage is not used in Books of Durrow, St. Chad and Lindisfarne. The examples shown are almost the total to be found in the Book of Kells.

George Bain

Plate, A,3.

Book of Kells.

Book of Kells.

Book of Kells.

Book of Kells.

Stone fragment. Hexham, Northumberland. 700-800 A.D.

Vegetation from Pots,?

Stone fragment, Spital, Hexham, Northumberland.

Bewcastle, Cumberland. 700 A.D.?

Stone fragment, Narham, Durham.

Stone Fragment, Jarrow, Durham 700-800 A.D.

Stone Fragment, Rothbury, Northumberland.

Vegetation and Beasts from a Pot.?

George Bain

Plate. A.4

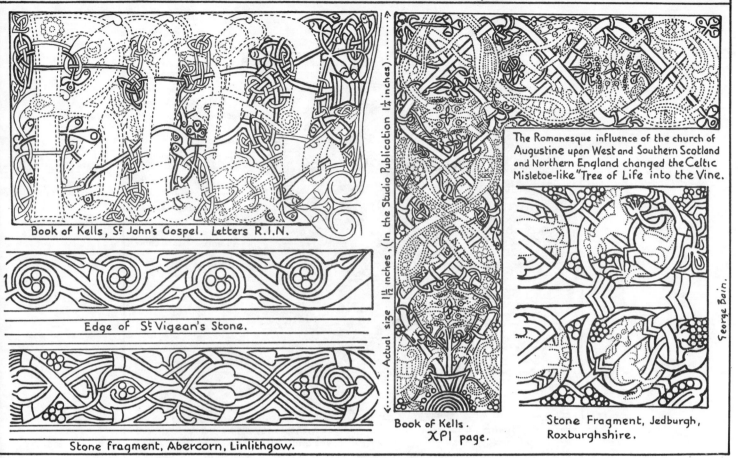

Book of Kells, St John's Gospel. Letters R.I.N.

Edge of St Vigean's Stone.

Stone fragment, Abercorn, Linlithgow.

Actual size 1½ inches, (In the Studio Publication, (7 inches).)

The Romanesque influence of the church of Augustine upon West and Southern Scotland and Northern England changed the Celtic Misletoe-like "Tree of Life" into the Vine.

George Bain.

Book of Kells.
XPI page.

Stone Fragment, Jedburgh, Roxburghshire.

Plate, A,5.

Plants emerging from Pots. Examples from the Book of Kells.

George Bain.

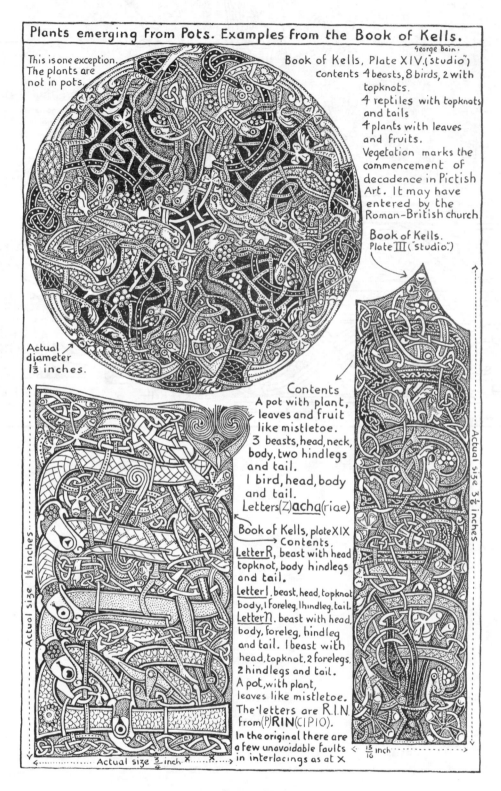

This is one exception. The plants are not in pots.

Book of Kells, Plate XIV. ('studio")
Contents 4 beasts, 8 birds, 2 with topknots.
4 reptiles with topknots and tails
4 plants with leaves and fruits.
Vegetation marks the commencement of decadence in Pictish Art. It may have entered by the Roman-British church

Book of Kells. Plate III ('studio".)

Actual diameter 1⅓ inches.

Contents
A pot with plant, leaves and fruit like mistletoe.
3 beasts, head, neck, body, two hindlegs and tail.
1 bird, head, body and tail.
Letters (Z) acha (riae)

Book of Kells, plate XIX
Contents.
Letter R, beast with head topknot, body hindlegs and tail.
Letter I. beast, head, topknot, body, 1 foreleg, 1 hindleg, tail.
Letter N. beast with head, body, foreleg, hindleg and tail. 1 beast with head, topknot, 2 forelegs, 2 hindlegs and tail.
A pot, with plant, leaves like mistletoe.
The letters are R.I.N. from (P) RIN (CIPIO).
In the original there are a few unavoidable faults in interlacings as at X

Actual size 3⅝ inches

Actual size 1½ inches

Actual size ¾ inch. X

13/16 inch

Plate W

126

Semi=realistic Human Figures
and Probable Portraits
from the Books of Kells and Lindisfarne

THE representations of human figures by Celtic Artists were influenced by the Pagan Laws that forbade the copying of the works of the Almighty Creator. In Celtic Zoomorphic ornaments the physical appearance of man was not copied. His legs, arms, body, topknot, hair and beard interlaced with each other. Portraiture of a living person, in his created form was a heinous crime. The portrayal of the Saints of the sacred Gospels in the Books of Kells and Lindisfarne was that of persons who had long departed from earthly habitation and of the angels who were migrants of the Heavenly Host.

In a similar way persons were dead before they were depicted on the Pictish stones of East Scotland and could no longer be injured by the copies that were made of them. Such beliefs have survived from prehistoric times in many countries and in the Highlands and Islands of Scotland even to the present day. Numerous instances of this may be found.

A sculptor on holiday in Western Scotland was inspired by the figure of an old Highland lady who sat in a chair outside her cottage. He asked permission to make a study of her and was refused. Thinking that the refusal was due to shyness, he made a study mainly by observation and memory. He eventually completed the work in his London studio and sent a plaster copy to her as a present. When she opened the case containing it, she at once got a hammer and smashed the image to pieces. Finding the armature of iron, inside the plaster, she showed it to her friends as further proof of its evil.

Most of the hitherto accepted authorities of Celtic Art thought it necessary to apply the measuring rod of Greek Classical Art to this human figure form of Celtic Art and not to its other forms. Because the British and Irish Celtic artists were ignorant of, or indifferent to the rules of the Greek idealistic and realistic human figures in drawing, painting and sculpture, their abstract statements of human physique and physiogmony were ridiculed and condemned, while all other aspects of their art were given the highest praise.

These critics, who condemned the Celtic Artists for their inability to copy from living people, with the skill of Leonardo da Vinci, and for their ignorance of the manners and rules of the great Greek sculptors and painters, and who could go into raptures over the other forms of Celtic Art, cannot be reliable authorities. They may have had some knowledge of the art of the Greeks but their knowledge of all other forms of Celtic Art was mere ability to distinguish its differences from the arts of other peoples as one may compare a cow with a motor car and yet know nothing of the anatomy or structure of either.

These other forms of Celtic Art may be described as a combination of magic, invention and imagination, with logic, mathematics and geometry which had an original function of teaching as well as adorning. This dual-purpose-art retained its philological or communicative purpose throughout its whole development which reached its apex in the Book of Kells. One such authority, after spending hours with a magnifying glass examining the pages of the Book of Armagh, without finding a single mistake in interlacing looked upon that as its miraculous quality!!

Volumes of praise containing few words of understanding and none of its methods of construction, have been written and are still being written on Celtic Art, although it is over fifty years since Romilly Allen opened a way to research by finding that some knotwork panels were based upon pleating. Even he thought that Celtic Artists were mere copyists who unwittingly imparted their Celticisms to the things they had copied from Classical Art. The intense personalities of the imaginary portraits of Matthew, Mark, Luke and John from the Book of Kells and the manners of representing the features, hair, hands, feet and dress, etc., show conclusively that the Celtic Artists had gained the required knowledge of such forms

from the three dimensional arts of the carver and the metal worker. The heads of the saints are designed and constructed without under-cutting, as models should be carved, for metal casting from sand, where every shape must be designed for that purpose.

The picturesque abandon of the artist in paint, who has no other controlling medium than his paint is not found in the Book of Kells. All evidences point to craft traditions that had beginnings at the same source as the Asiatic Arts, the Assyrian, the Persian, the Indian and the Chinese. The stylised Egyptian profile figures with two right or two left feet or hands have counterparts in Celtic Art, and the great interest in the beauty and movements of animals, particularly the horse on the Pictish stones of East Scotland, undoubtedly show a connection with the art of the Assyrians. Most of the human figures of the Pictish stones whether on foot or on horse are in profile.—See Plate B.4.

The Celtic Artists of the MSS. period were more interested in front or three quarter front face than in profile. Comparisons of the types of features, tonsures and colours of hair and eyes with such descriptions as are to be found in the Celtic pagan and Early Celtic Christian literature show that they are similar. Of the examples from the Book of Kells shown on Plate B.1 and B.2, 15 persons have grey or blue-grey eyes, 4 have yellow-grey eyes, 5 have brown eyes, 15 have yellow hair, 5 have red-gold hair, 4 have brown hair, 5 have brown beards, 2 have black beards.

R. A. S. Macalister, Litt., D.F.S.A., remarks in " Ireland in pre-Celtic Times " " *All persons of importance* native to Ireland are described as having *Golden Hair*. Most persons in *subordinate positions* and those who are *spoken of with scorn* are Dark-Haired."

In all probability the same conditions existed in North Britain.

" As a rule yellow hair is described as *long and flowing*. Dark hair as *close-cropped*.

Ruling classes are marked by *long flowing locks*. Enslaved classes with *close-cropped black or brown heads*." In this connection it is interesting to note the 4 panels on Plate B.2.

King Cormac MacAirt is thus described in the Book of Ballymote. " Hair-braids slightly curled, all golden upon him, like blue-bells his eyes, like the sheen of a dark-blue blade his eyebrows." Yellow hair, bluish eyes with black eyelashes and eyebrows are plentiful with the youth of North and West Scotland. The Book of Kells shows many of this type.

The great variety of hair-dressing styles including those of the angels, who, if they are females are the only ones depicted, except the Virgin Mother, and the Samaritan woman holding a goblet of water for Christ to drink in the letter A of QUONIAM, on the page of the opening word of St. Luke's Gospel shows that the artists of the Book of Kells appreciated the skilful work of the tonsure-artists of the period. The symbol of *Sanctity*, three circles forming an equilateral triangle, adorns the garments, sacred books and haloes of the saints and angels. A comparison of the St. John of the Book of Kells and the St. John of the Book of Lindisfarne, shows that the latter has the Romanesque influence of the Church of Augustine. This portrait which occupies a full page and the portraits of the other apostles on full pages are probably later additions and are painted by artists who were not conversant with all the methods of construction of the native Celtic Artists.

That the Celtic spirit was not extinguished is shown by the work of the Artists of the the Winchester Bible 1140-1160 A.D., who produced human figures which are the direct descendants of the schools that produced the human figures of the Book of Kells, but they lacked the knowledge of the mathematical formulae which made possible the other forms of Celtic Art.

Celtic Art. Semi-Realistic Human Portraits from the Book of Kells.

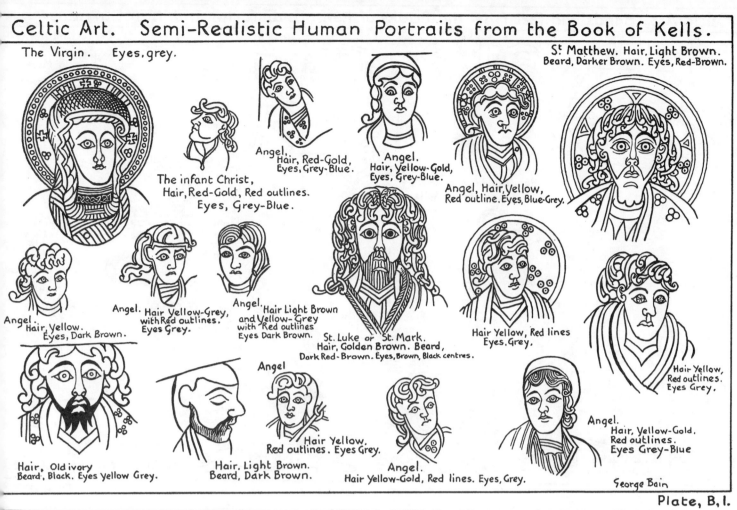

The Virgin. Eyes, grey.

St Matthew. Hair, Light Brown. Beard, Darker Brown. Eyes, Red-Brown.

Angel. Hair, Red-Gold. Eyes, Grey-Blue.

The infant Christ, Hair, Red-Gold, Red outlines. Eyes, Grey-Blue.

Angel. Hair, Yellow-Gold, Eyes, Grey-Blue.

Angel, Hair, Yellow, Red outline. Eyes, Blue-Grey.

Angel. Hair, Yellow. Eyes, Dark Brown.

Angel. Hair Yellow-Grey, with Red outlines. Eyes Grey.

Angel. Hair Light Brown and Yellow-Grey with Red outlines Eyes Dark Brown.

St. Luke or St. Mark. Hair, Golden Brown. Beard, Dark Red-Brown. Eyes, Brown, Black centres.

Hair Yellow, Red lines Eyes, Grey.

Hair Yellow, Red outlines. Eyes Grey.

Hair, Old ivory Beard, Black. Eyes yellow Grey.

Hair, Light Brown. Beard, Dark Brown.

Angel Hair Yellow. Red outlines. Eyes Grey.

Angel. Hair Yellow-Gold, Red lines. Eyes, Grey.

Angel. Hair, Yellow-Gold. Red outlines. Eyes Grey-Blue

George Bain

Plate, B, I.

Celtic Art. Semi-Realistic Human Portraits, Books of Kells, Lindisfarne and MacDurnan.

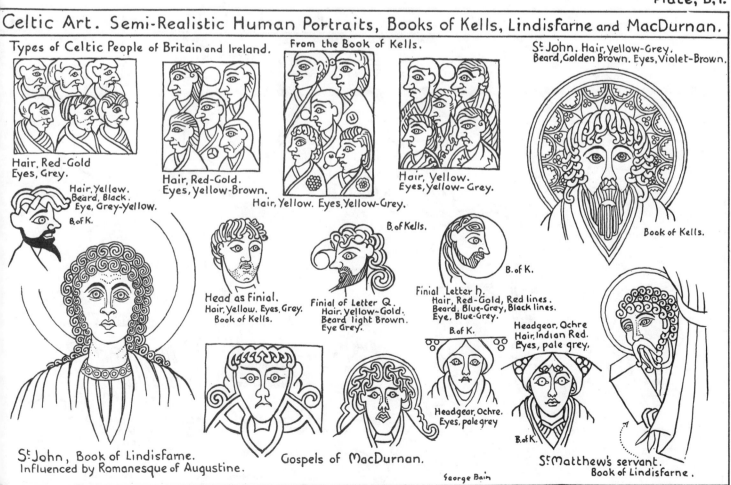

Types of Celtic People of Britain and Ireland.

From the Book of Kells.

St John. Hair, Yellow-Grey. Beard, Golden Brown. Eyes, Violet-Brown.

Hair, Red-Gold Eyes, Grey.

Hair, Yellow. Beard, Black. Eye, Grey-Yellow. B. of K.

Hair, Red-Gold. Eyes, Yellow-Brown.

Hair, Yellow. Eyes, Yellow-Grey.

Hair, Yellow. Eyes, Yellow-Grey.

Book of Kells.

B. of Kells.

Head as Finial. Hair, Yellow. Eyes, Grey. Book of Kells.

Finial of Letter Q. Hair. Yellow-Gold. Beard light Brown. Eye Grey.

B. of K.

Finial Letter h. Hair, Red-Gold, Red lines. Beard. Blue-Grey, Black lines. Eye, Blue-Grey.

B. of K.

Headgear, Ochre Hair, Indian Red. Eyes, pale grey.

Headgear, Ochre. Eyes, pale grey

B. of K.

St John, Book of Lindisfarne. Influenced by Romanesque of Augustine.

Gospels of MacDurnan.

George Bain

St Matthew's servant. Book of Lindisfarne.

Plate, B, 2.

129

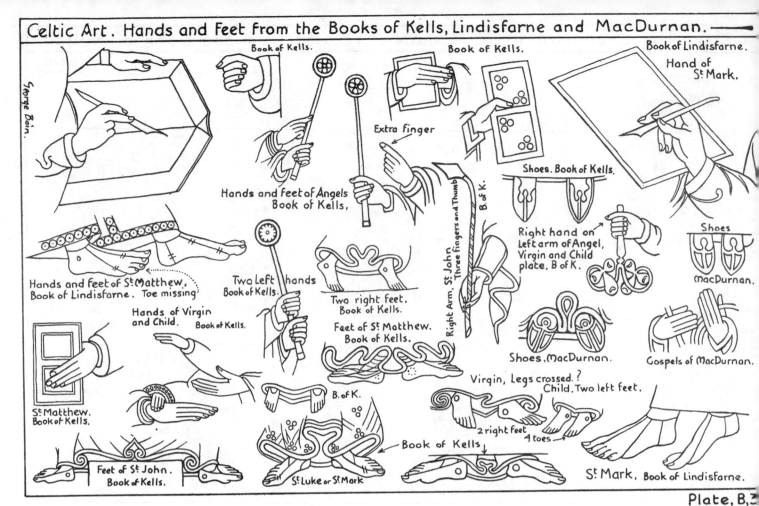

George Bain

Book of Kells.

Book of Kells.

Extra finger

Book of Kells.

Book of Lindisfarne. Hand of St Mark.

Hands and feet of Angels Book of Kells.

Two Left hands Book of Kells.

Two right feet. Book of Kells.

Feet of St Matthew. Book of Kells.

Right Arm, St John, Three Fingers and Thumb

B. of K.

Shoes. Book of Kells.

Right hand on Left arm of Angel, Virgin and Child plate, B of K.

Shoes MacDurnan.

Shoes MacDurnan.

Gospels of MacDurnan.

Hands and feet of St Matthew, Book of Lindisfarne. Toe missing

Hands of Virgin and Child. Book of Kells.

St Matthew. Book of Kells.

Feet of St John. Book of Kells.

B. of K.

Book of Kells

St Luke or St Mark

Virgin, Legs crossed.? Child, Two left feet.

2 right feet 4 toes

St Mark, Book of Lindisfarne.

Plate, B.

George Bain

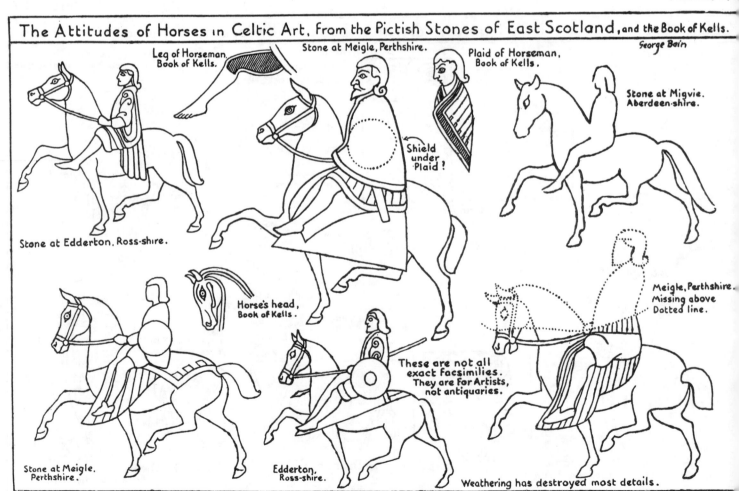

Leg of Horseman, Book of Kells.

Stone at Meigle, Perthshire.

Plaid of Horseman, Book of Kells.

Stone at Migvie. Aberdeen-shire.

Shield under Plaid?

Stone at Edderton. Ross-shire.

Horse's head, Book of Kells.

These are not all exact facsimilies. They are for Artists, not antiquaries.

Meigle, Perthshire. Missing above Dotted line.

Stone at Meigle. Perthshire.

Edderton, Ross-shire.

Weathering has destroyed most details.

Plate, B.

130

Applications

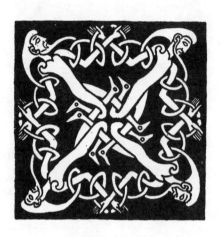

Applications of Celtic Art, Ancient and Modern

THE many processes and technicalities necessary for the various crafts to which the methods of construction of Celtic Art may be applied will not be described in this book.

Most craftsmen have such knowledge and students who wish to acquire it, have the libraries, artcraft classes and the craftsmen in their own districts to aid them.

The mathematical formulae methods of construction for knotwork, keys and spiral patterns, that enable the student to draw intricate designs for many purposes, with simplicity, must be translated into charts to suit the requirements of knitting, carpet making and weaving. A system suitable for knitting may be the subject of a separate text book. The examples of knitwear illustrated herein were knitted from charts of this system.

The old testament is a reliable source of information for the bronze age processes of metal workers', jewellers' and embroiderers' arts. A reference to brass casting in 1st Kings, 7th Chap., 46th Verse, states "and all these vessels, which Hiram made to King Soloman, in the plains of Jordan did the King cast them, in the clay ground between Succoth and Żärthen". In the preface to Zöomorphics mention is made of ornaments carved on the bones of deer, and sheep (found in an Irish Crannog). Their probable uses were as models to make moulds for casting small panels in metals for jewellers' art. A "squeeze" in a moist clay or in some other plastic material would make such a mould. If the ornament had been carved upon a curved surface of bone, it could be flattened by being laid upon a flat surface, with no injury to its carved details. Moulds carved in stone were used for casting bronze spear-heads and hammers in the earliest bronze-age.

Great art and technical skill are expressed in Ecclesiesticus, Chap. 65, Verse 12, "He set a crown of gold upon the mitre wherein was engraved *Holiness* an ornament of honour, a costly work, the desires of the eyes, goodly and beautiful".

There are references to embroidery (greásta), to engraving (breac), and to wrought metal (cumhdaigh, fair-wrought), in the Dean of Lismore's Book and in other collections of Gaelic literature.

> "Da bhfaicthea na catha is na bratacha gréasta."
> "If you could see the battalions and the embroidered banners."
> "Ni roibh i Nalmhain na lann inbreac."
> "There was not in Almhain of engraved blades."
> "Iomdha cathbharr, cumhaigh caomh."
> "Many a helm, fair-wrought and fine."

The following quotations referring to Jewellers art are from the Gaelic Norwegian Ballad "Seurlus an Dobhair" (Son of the King of Bergen) "and there was found on the maiden's fingers the gold, locked up like taileasg (draughtboard squares), and there were the nine sets of stones of victory (amber) on each side of the vulture of her ring". "The maiden girdle . . . so full of conquering power and artful stratagems of jewels set in gold," . . . and sooth, the ring with the yellow stones she left round the finger of the King of Bergen's Son." "Brought to him was the true seer, who came from the countries of the world to inspect the spell ornaments (garrlannaibh)."

British and Irish jewellers, of the Pagan and the Early Christian periods, used thin hammered plates and bent and twisted wires as in Cloisonné, where the design is made in compartments of wires so that they may be filled with different metallic colours mixed with a vitreous paste, which when fired showed the splendour of the colours and probably fixed the wires to the plates.

Other Celtic methods were, by beating the metal into a thin plate and then raising the ornament by tooling it from the reverse side (repoussé) and by lowering the background parts, that were to be filled with metallic colours, by cutting out with tools (champ-levé). The "Battersea Shield," with its repoussé curves and spirals and anti-sunwise swastikas in 27 small circles that are points of the spirals or centres of bosses, belongs to the same pre-Roman Celtic period of British culture as the enamelled and engraved bronze hand-mirrors with cast bronze

handles. These mirrors are unique in beauty and craftsmanship. Their backs are engraved with designs of spirals and scrolls that were filled in with enamel colours. The first stages of the construction of such designs would probably be the arranging of symmetrical groups of various sizes of circles by the use of discs. The selection of the shapes to be filled in with enamel colours would be chosen as the artist-craftsman developed his design. Outlines would then be deeply engraved and the shapes to be coloured would be lowered by punches or cut out by gravers. These sunken parts would be covered with groups of engraved short lines at all angles to give the necessary textures to hold the enamel colours when fired (as a plasterer scarifies a surface to make plaster adhere to it). The enamel colours and bronze back of the hand-mirror would be polished as one surface.

Leonardo da Vinci, Albrecht Dürer and Michelangelo were engaged in a renaissance of the Byzantine forms of Celtic knotwork. Vasari says that " Leonardo spent much time in making a regular design of a series of knots so that the cord may be traced from one end to the other, the whole filling a round space ". The example of his work shown herein cannot be the one that Vasari had traced its line from end to end, for it has a number of lines. The student can find how many. The designs by these most famous artists were engraved and printed for the use of painters, goldsmiths, weavers, damaskeeners and needleworkers.

The few surviving prints show conclusively that these great artists were aware of some of the differences of the methods of construction of Celtic Art from the methods of construction of the other great arts in which they excelled. The portrait of Henry VIII of the School of Holbein, the Younger, in the Walker Gallery, Liverpool, has interlacing designs embroidered and braided on the garments and curtains that were probably done by craftsmen who had used designs made by Leonardo da Vinci or Albrecht Dürer.

An engraving by Du Pérac in 1569, of Michelangelo's Capitol, Rome, shows in the foreground, a quadrangle filled with a circle, containing a continuous pathway, probably in mosaics, leading from the circumference where it touches twelve points to the centre where it touches twelve points of a star where an equestrian figure on a pedestal occupies the prominent position. This design is probably based upon the labyrinth and if the sides of the spaces made by the intersecting courses of the pathway were built high, and with only one entrance from the outer circumference, and one to a point of the inner star, with a few minor adjustments it would be most difficult to enter the centre star and to return to the outer entrance again.

There will soon be available, a facsimile edition of the world's greatest monument of Celtic Art, the " Book of Kells," edited by Peter Meyer, Lecturer at the University of Zurich, who has kindly presented a few reproductions of its plates to the author. This great and costly replica will be an exact copy from which scholars will be able to make important studies and discoveries, at their own firesides, that will result in new valuable contributions shedding light upon the hitherto obscured truths of Celtic achievements in Art and other Cultures.

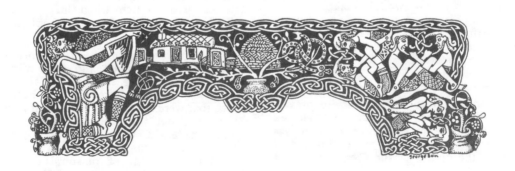

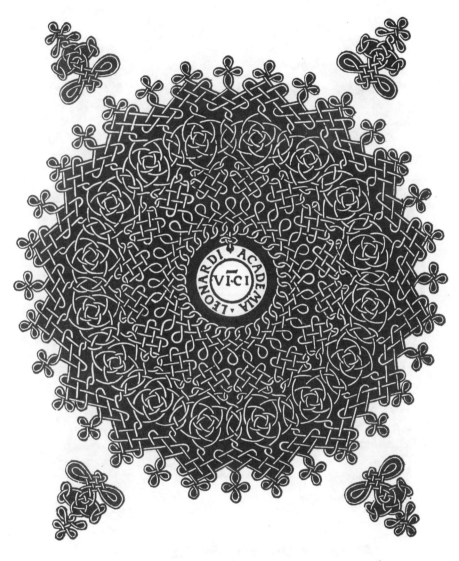

Leonardo's "Concatenation."

Plate 1

One of Leonardo da Vinci's designs for the
use of craftworker.

Albrecht Dürer's "Sechs Knoten."

Plate 2

A design by Albrecht Dürer for the use of craftworkers.

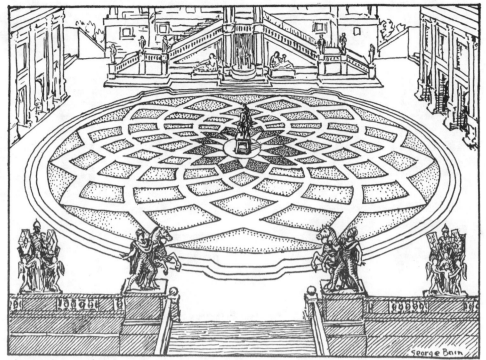

Michelangelo's design of a continuous pathway in quadrangle
of the Capitol, Rome, from an engraving by Du Pérac in 1569.

Plate 3

Plate 4
Bronze champfrein from Torrs, Kirkcudbrightshire
a beautiful example showing the great skill of the
pre Roman Celtic craftsmen of Britain.

137

Bone Carvings, probable models for moulds for castings. (Irish crannogs, Stokestown and Lagore.)

Plate 5

V.—THE TRELAN BAHOW MIRROR.

Plate 6

DOORWAY OF FLAA CHURCH, HALLINGDAL

Plate 7

Celtic Art. Wire-Work from "Tara" Brooch, "Ardagh" Chalice and Buckle, "Sutton Hoo" hoard.

Tara Brooch.

Tara Brooch.

Tara Brooch.

Underpart of Ardagh Chalice.

Panels of Tara Brooch

Head of Pin →

Sutton Hoo Buckle.
(Probably Scandinavian.)

Wire unit.

Tara Brooch.

George Bain.

Plate 8

Plate 9

Design for magazine cover. This is almost entirely made
by variations of keypattern order 1·8·1 see keypattern
plates 1, 11 and 14, pages 75, 80 and 81.

22ⁿᵈ INTERNATIONAL P.E.N. CONGRESS EDINBURGH

1950

FAREWELL DINNER

AM BIADH

MENU

COILLEAGAN IS
FEUSGANAN

BREAC
MARA

EOIN FHRAOICH IS
MUILEAGAN

EUN IS
CREAMH-
GARAIDH
OHRICH

"Cockieleekie"

DEARC
FHRANGACH
"Fool"

Seoras Oan. George Bain · DRUMNADROCHIT·

Plate 10

141

designed by George Bain, with acknowledgements to an unknown artist of the "Book of Lindisfarne"

Gum biodh Èòin Gràidh nan Gaidheal
fillte ri dealbh do bheatha.

May the "Birds of Friendship" of the Gael be ever woven into the web of your life.

Plate 11

Design for Greeting Card.

Plate 12
Design for Greeting Card.

Plate 13
Design for New Year Greeting Card.

Plate 14

Design for Greeting Card.

Early British Enamel from Somerset

Plate 16

Early British Enamel from Canterbury

Plate 17

Jum ꝼosꝻlaꝺh ꝺorus na bliaꝺhna
ùire chum sìth, sonas is sàmchair.

MAY THE DOOR OF THE COMING YEAR OPEN FOR YOU
TO PEACE, HAPPINESS AND QUIET CONTENTMENT.

Plate 18

" Doorway " design for New Year Greeting Card.

GUN TILL DO CHEUM, AS GACH CEÀRN,
FO RIONNAG-IÙIL AN DACHAIDH.

Follow your Pathway.

MAY YOUR STEPS RETURN FROM
ALL CORNERS OF THE GLOBE UNDER THE
GUIDANCE OF THE STAR THAT POINTS TO HOME.

Design by Searge Bain.

Plate 19

Design for Greeting Card.

146

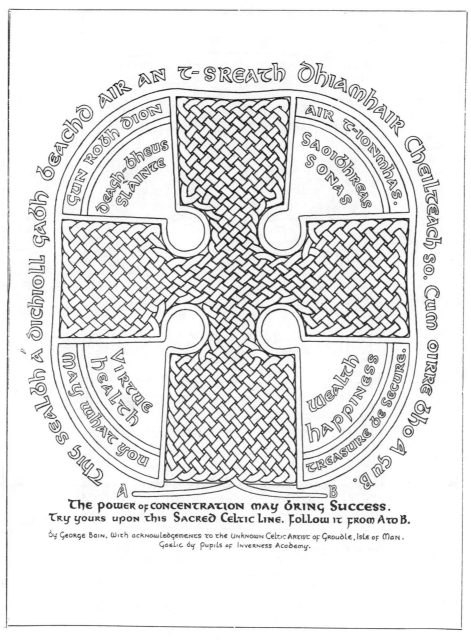

Plate 20

Greeting Card adapted from Groudle Stone
Isle of Man.

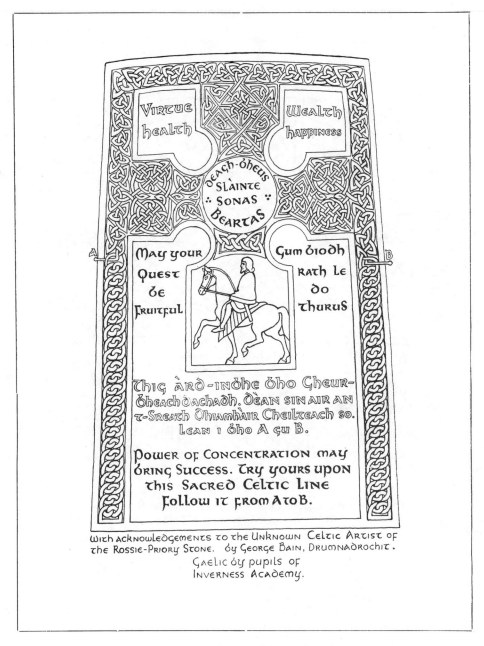

Plate 21

Greeting Card adapted from the Rossie-Priory Stone. It is probable that the stone was similarly coloured in its own day, the Celtic artist being famed for his love of colour.

148

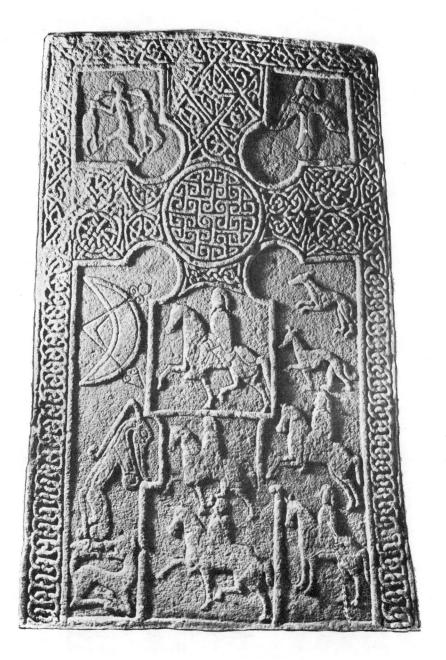

Plate 22

The Rossie Priory Stone.

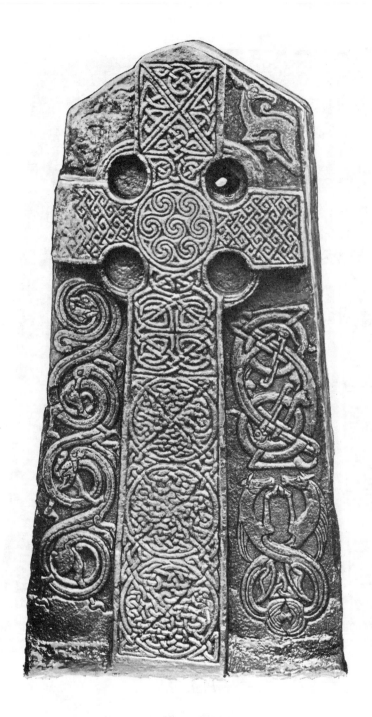

Plate 23

Aberlemno Stone.

Plate 24

Hilton of Cadboll Stone.

Plate 25

*The author sketching the Hunt at the
Nigg Stone.*

Plate 26

Rosemarkie Stone.

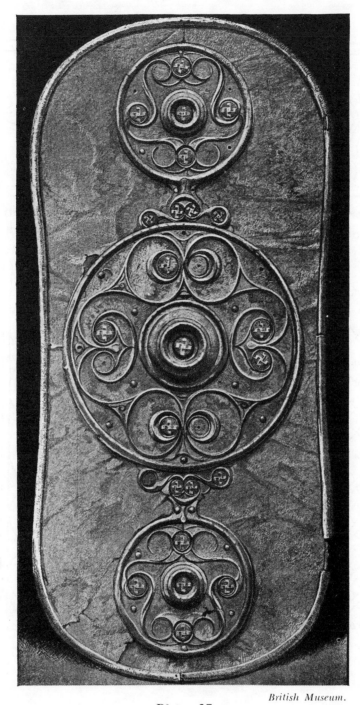

Plate 27

The Battersea Shield.

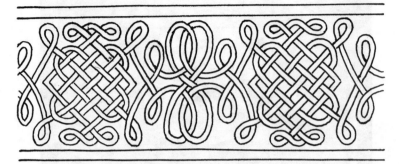

Border on Cape and Sleeves of Henry VIII portrait in
Walker Gallery, Liverpool. School of Holbein yr. 1497-1543.
All-Over pattern on Curtain in same. on tunic.

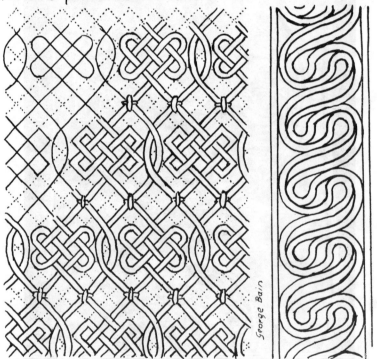

George Bain

Probably executed from designs by Leonardo da Vinci

Plate 28

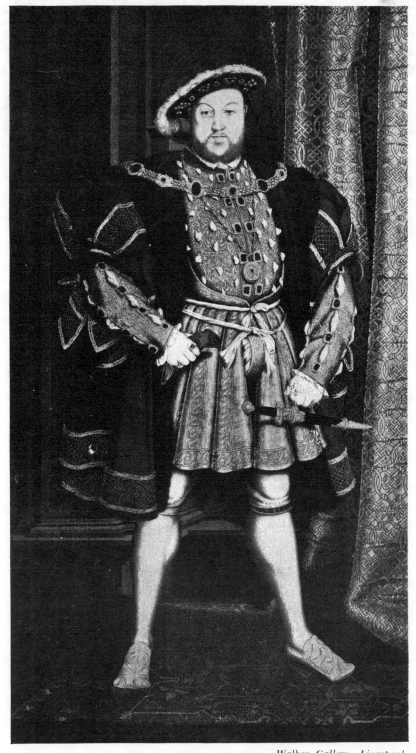

Plate 29

King Henry VIII by School of Holbein the Younger.

Plate 30
A portion of a Celtic carpet showing the interlacement
of Zoo-morphic forms in a pleasing all-over pattern.
Manufactured by Quayle and Tranter, Kidderminster.

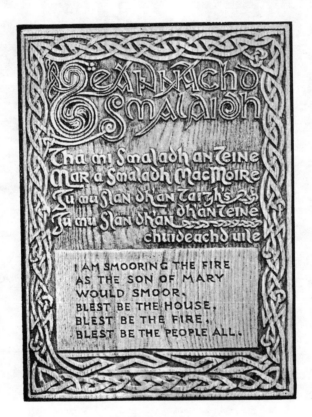

Plate 31
The fireplace panel of the blue-room
of " The Binns " Linlithgowshire.
Designed and carved by the author.

Plate 32
Designed by girl aged 16 years, based upon motifs from Book of Kells etc. Embroidered by girls under 14 years.

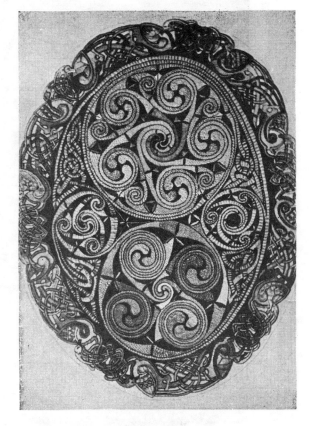

Plate 33
Embroidery designed and worked by school-girls.

Plate 34
All-over carpet design by the author. Manufactured by Quayle and Tranter, Kidderminster.

Plate 35

Articles by the author and pupils.
Figures by the author, left " The Continuity of Life," Hippopotamus
tooth ; ebony base. Centre " The last work of the Creator" ; wood.
Right " Deirdire and Naoise," Bone ; Lignum-Vitae base and
cigarette box ; wood.

Plate 36

Articles by the author and pupils.

159

Plate 37
Design and model by the author. Sand Casting in bronze by Messrs. Macdonald and Creswick, Edinburgh.

Plate 38

The manufacturer (left) and the designer (right) at the British Carpet Manufacturers' Exhibition, Horticultural Hall, Westminster.

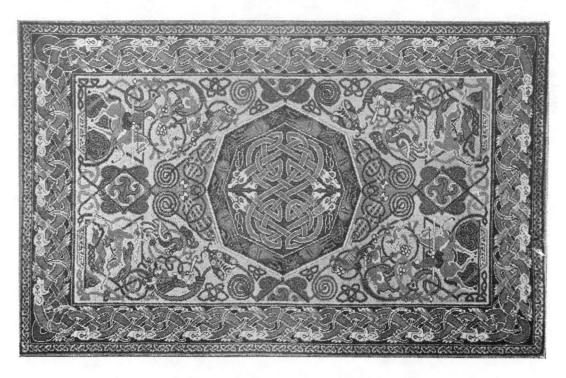

*A Celtic Hunting Rug, designed by the author.
Manufactured by Messrs. Quayle and Tranter, Kidderminster.*

Plate 39

*Examples of Celtic Art in knitwear, embroidered house dress,
embroidered hand-bags, sporran, etc.
By pupils, from charts and designs by the author.*

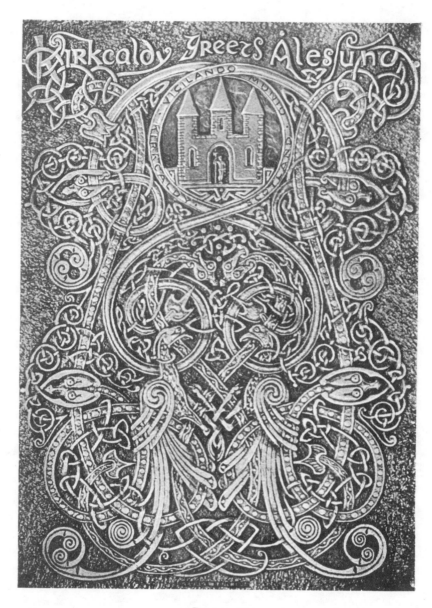

Plate 40

Reproduction of Bronze Plaque designed and carved
by the author. Sand Cast by Messrs. Macdonald and
Creswick, Gorgie, Edinburgh.